Dear Nancy,

Sharing the

Beauty!

[signature]

PRIMAL
BEAUTY

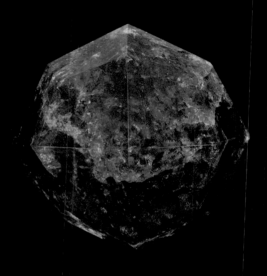

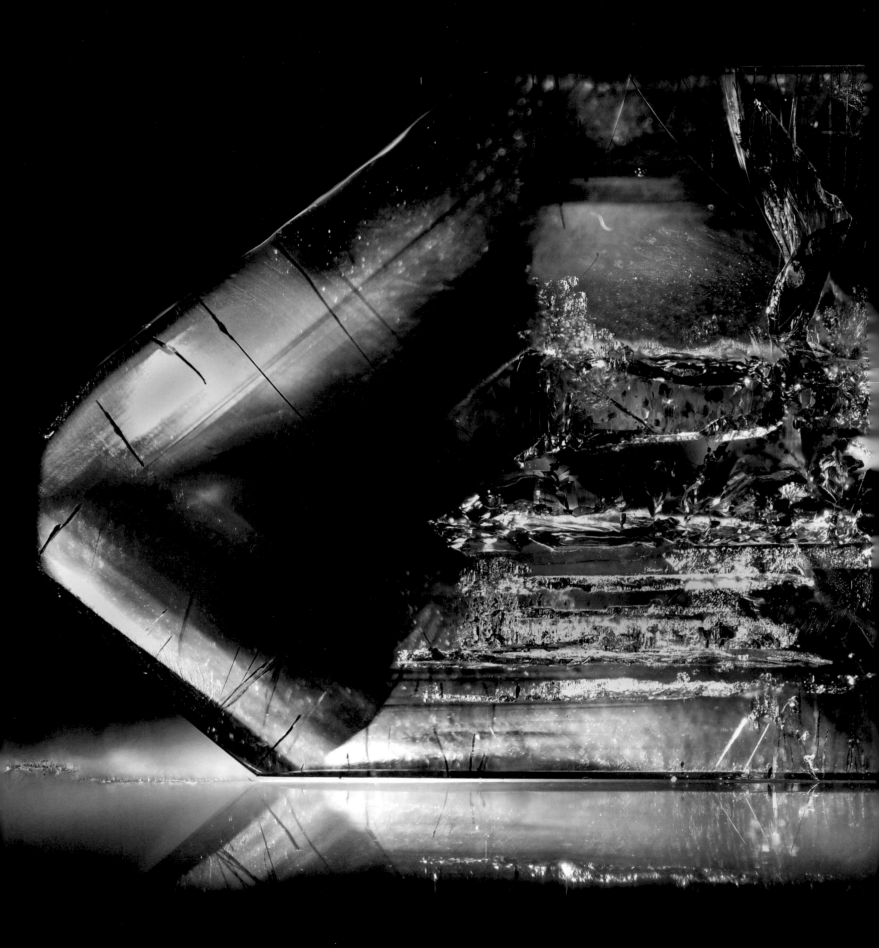

Primal — first; original; eras before the appearance of life on Earth

BEAUTY — Being Enraptured in Appreciation that Unexpectedly Transforms You

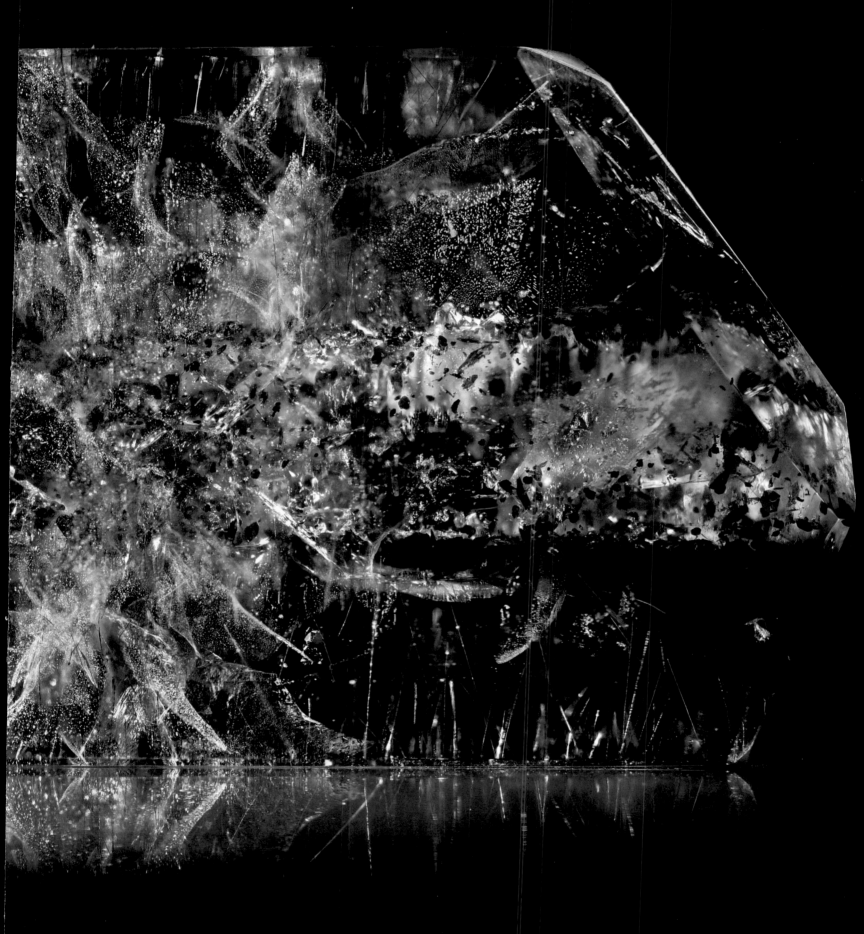

Madagascar amethyst crystal with lepidolite and central growth of internal secondary crystal, and other exotic mineral inclusions, 2″ (l)

"I found I could say things with color and shapes that I couldn't say any other way—things I had no words for."
~ GEORGIA O'KEEFFE

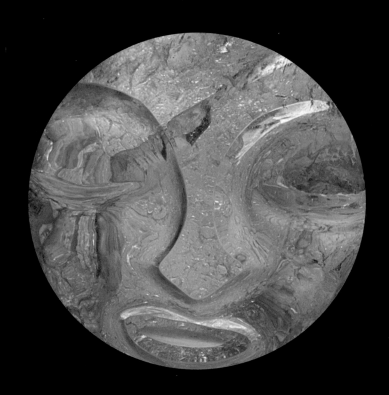

Wizard (detail), carved citrine

To my seen and unseen friends,
Who have joined me in this co-creating endeavor,
Some hands-on, some with generous appreciation:
You've added your imprints to the beauty contained within.
I have been exceedingly fortunate,
And with deep gratitude, this book is dedicated to you.

~ LS

PRIMAL BEAUTY

THE SCULPTURAL ARTISTRY OF CRYSTALWORKS

LAWRENCE STOLLER

Photography by GARY ALVIS

Book design by IAIN R. MORRIS

CAMERON + COMPANY
Petaluma, California

Sacred Falls (detail), Namibian indicolite tourmaline

Beauty must have existed before our planet came into being,
her presence spanning time as she welcomed the first life-forms to emerge on Earth.
Beauty is eternally new, yet we have known her forever.
Omnipresent, she waits patiently to be noticed.
She resides in every aspect of our physical reality,
has no shape of her own and can adopt any form,
emerging and growing exponentially with appreciation.
She appears as one manifestation,
shape-shifts and re-forms as something else.

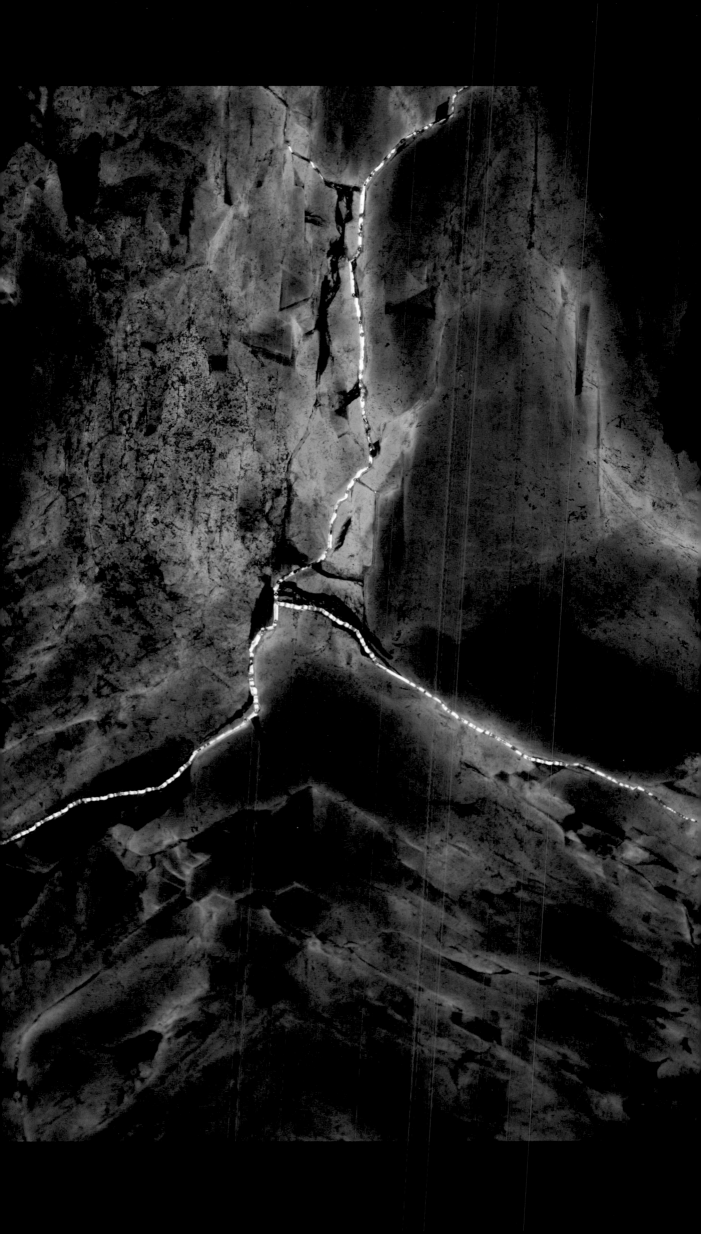

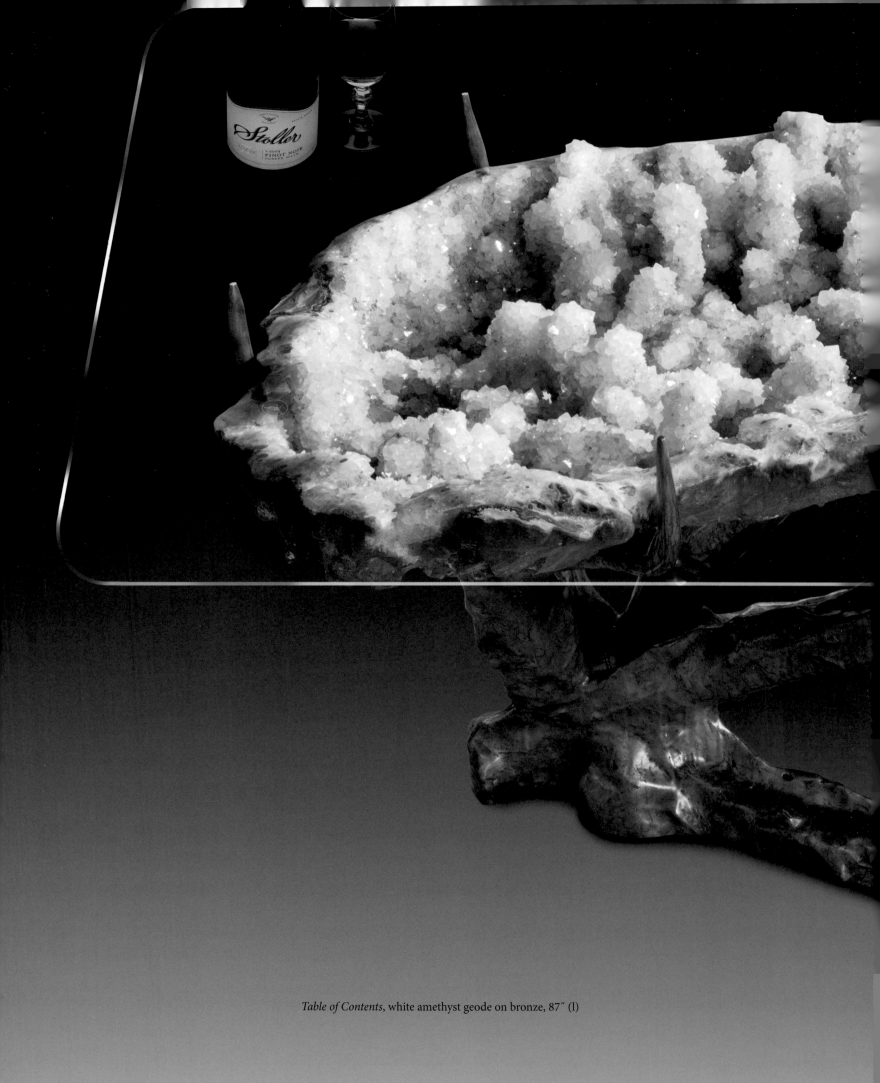

Table of Contents, white amethyst geode on bronze, 87″ (l)

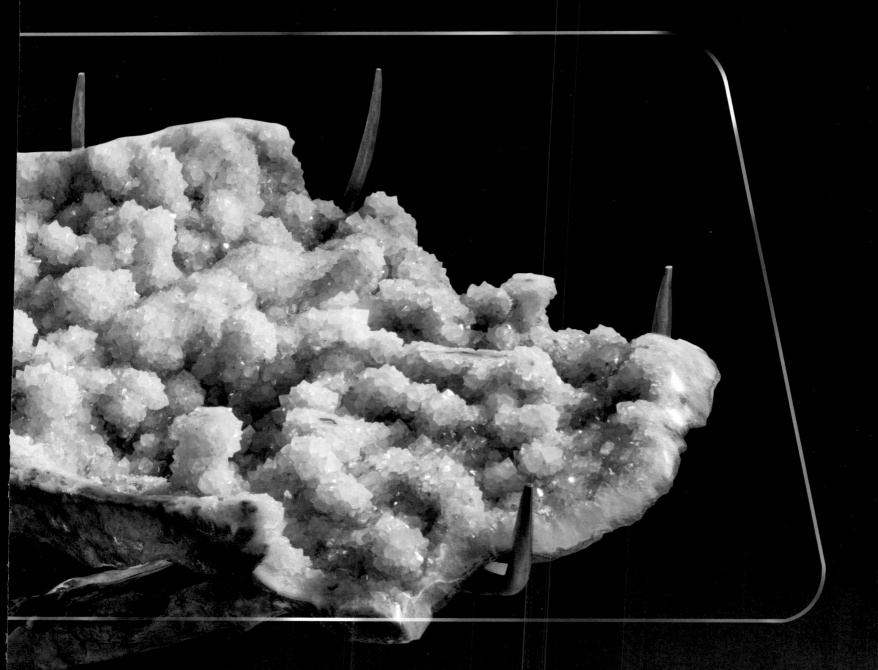

CONTENTS

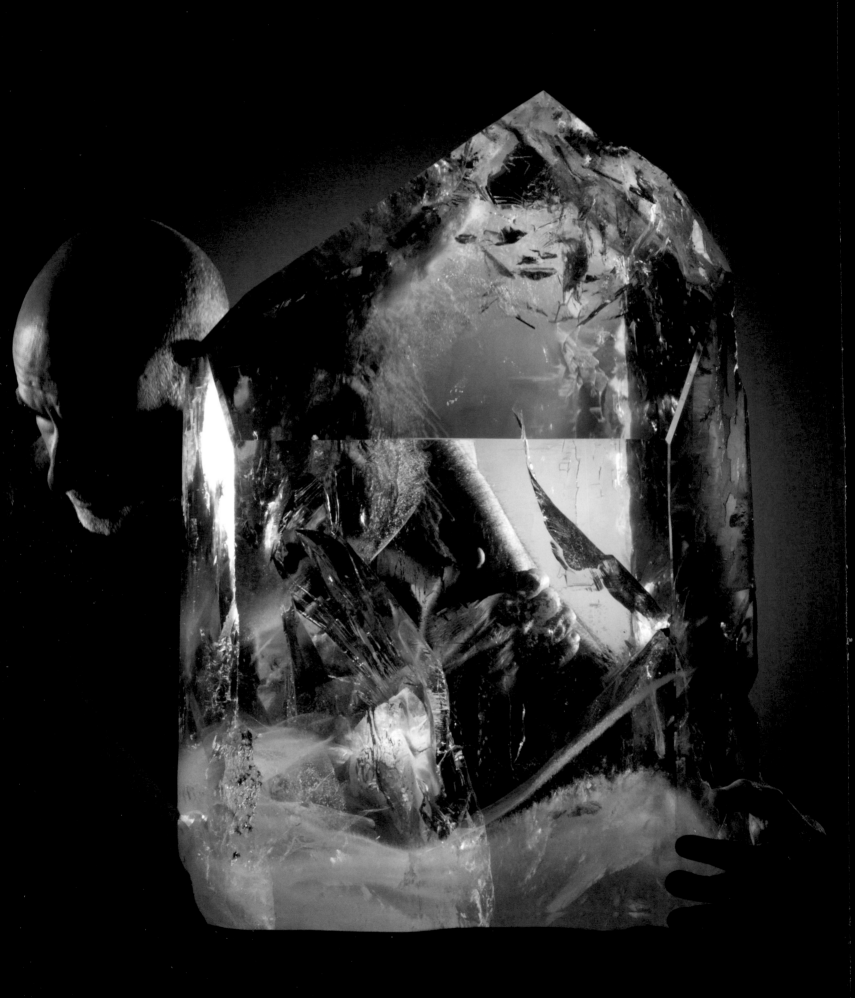

The Muse, Madagascar quartz, 360 pounds

The beauty of Nature inspires the heart to pursue the nature of beauty.

INTRODUCTION

Why are crystalized minerals so alluring, captivating, and compelling?

After years of conversations, investigations, and inspirations from the fields of mineralogy and technology, the world of art, and metaphysical discoveries, I have concluded that at the heart of their multitude of interests and uses, minerals possess a primal beauty with far-reaching impact.

A child picks up a "magical" rock and instantly connects with his or her own personal Earth, awakening to the planet they live upon and connecting to a magical world living inside it.

This awakening and connection occurs in the wonder of the free child who resides in each of us.

Fascination, inspiration, and wonder feed the soul at every age.

We walk upon Earth, often with little awareness that we are of Earth.

~

Fifty-nine percent of Earth's crust is made up of silicon dioxide, commonly referred to as quartz. Silica is a fundamental element of our planet. It is the sand of our beaches as well as a seminal component of our technological and computer-driven reality. There is no (human) life without silica. Silica plays an essential role in many of the body's physiological functions, and is a vital trace mineral for our health.

There must be a resonant "ancestral" connection between the minerals circulating in our bodies and the mineral inhabitants within the crust of our planet.

Minerals are used in industry and technology, for healing, and as metaphysical tools. They are prized and collected for their rarity and are a dynamic medium for art. But minerals are not simply here to serve humanity.

While there are wide-ranging uses, I find that at its essence, the mineral kingdom is a reservoir of latent beauty and a gift from Earth to humanity.

Embedded in the minerals is a primordial geological life force that has existed from the beginning of time and continues timelessly—a primal beauty, a genetic coding of resonance in the DNA of Earth.

Beauty embodies the experiences of wonder, fascination, inspiration, splendor, attraction, delight, and exquisite magnificence. It is a force of Nature, whose influences can only be contained and measured by one's heart.

Our stewardship of Earth is mirrored in our relationship with the mineral kingdom. Respect and appreciation activate and nurture the seeds of beauty, awakening the regenerative forces of a beauty-full Earth.

Beauty is at the heart of all things sacred and revered.

~

When we first meet, the raw crystal and I begin conversing in the languages of geometry, refracted light, and attraction. I feel called by the crystal, seduced by its rough natural beauty and the promise of what it can become. Its future speaks to me, and together we devise a plan to bring it to its fullest expression.

My team of artisans and I spend from a few days to several years hand-cutting and sculpting each raw gem-crystal, exposing its radiance and majesty.

Like rubbing sticks together to create fire, the lapidary process subjects the crystal to an arduous cutting and polishing progression, shaped by diamond tools that impose intense friction, designed to fashion pristine windows of faceted light that ignite beauty at its molecular level. The work is guided by relentless focus and attention to detail. In the end, the crystal experiences a metamorphosis that awakens the resonance and reverence of Beauty.

Once complete, the finished crystal is wedded to sculpted bronze and illuminated, creating an entity that projects the light of its essential nature.

This is bio-resonant art that amplifies the spectrum of beauty. It is perceived by the eye and sensed by the electromagnetic impact on all of the senses.

Humans and crystals reflect the light of appreciation in one another.

~

I have selected quotes from distinguished voices to accompany images of the sculptures. The profound words of these luminaries embed the images further into our imagination. The synergy of the pictures and the words forms a passageway into the domain of Beauty that can touch one's core being.

Beauty's ancient and vast world is far grander than my imagination, a wilderness I can travel forever in search of that which is more real.

My encounters with the elemental majesty of primal beauty have forever changed me, and it is with grateful appreciation that I share this art with you.

Lawrence Stoller
Bend, Oregon

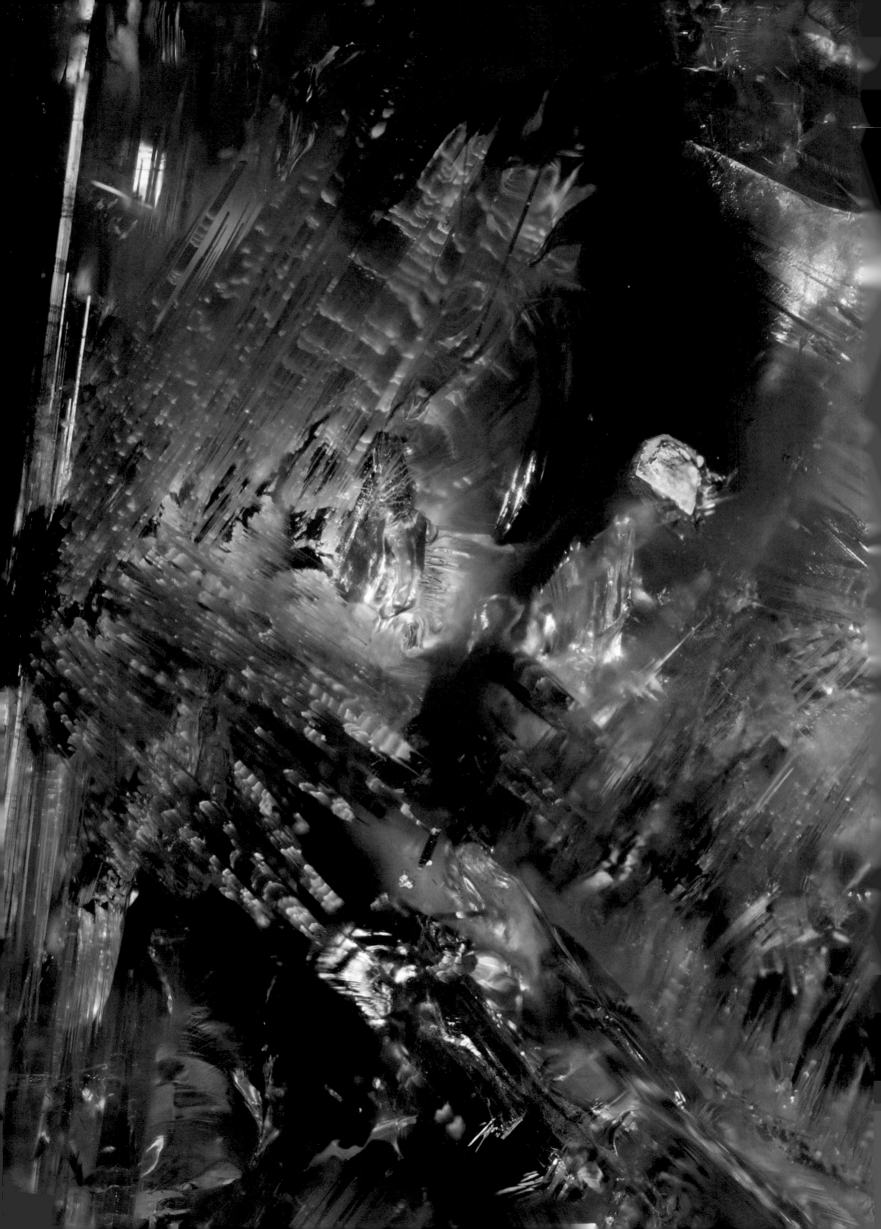

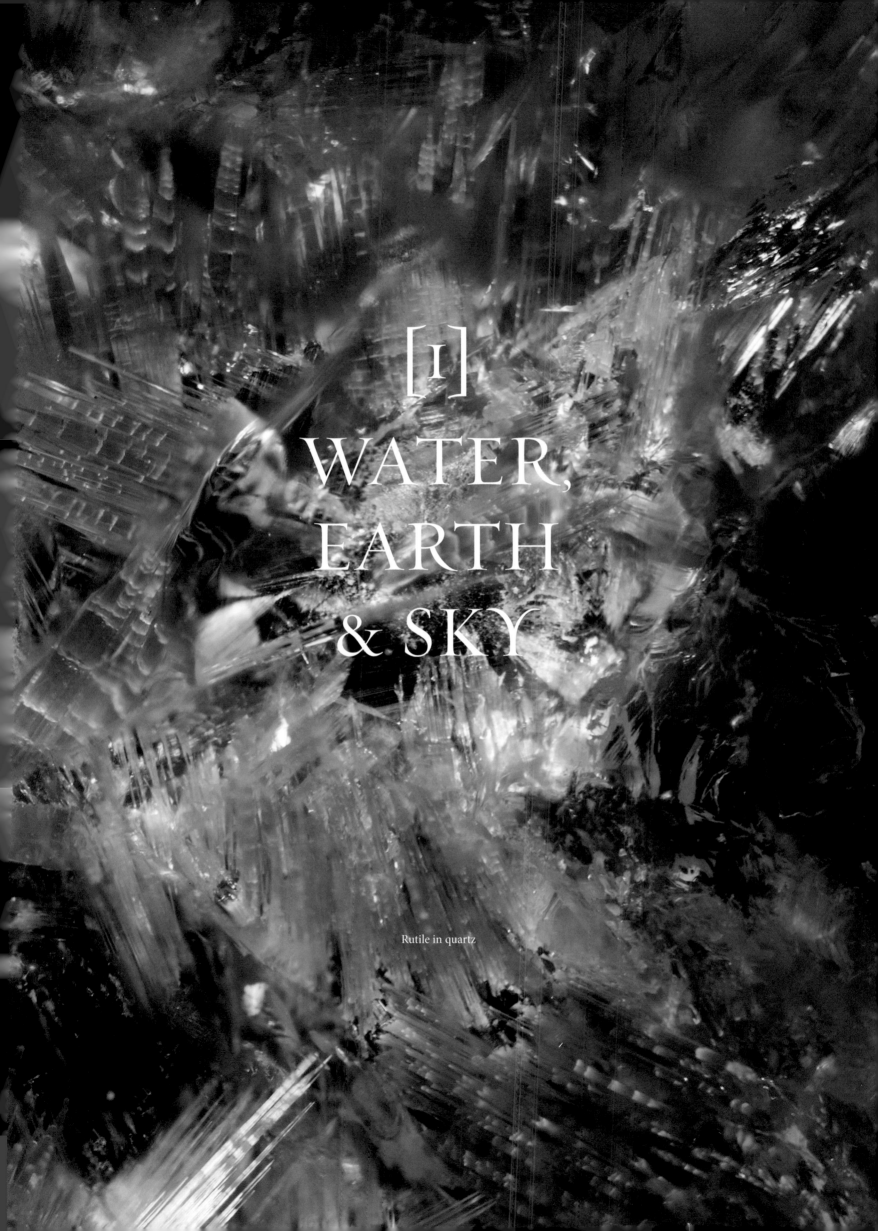

[I]

WATER, EARTH & SKY

Rutile in quartz

EVOLUTING 2.0

To investigate theories of evolution, creation, and the nature of reality is illuminating.
To wonder, challenge, reassess, upgrade, and change my own beliefs is freeing.

~

Crystals may be the first (silica-based) entities to inhabit Earth—inseminated, incubated, gestated, born, and grown.

A concentrated mass of silica, fertilized with a supersaturated sperm of oxygen and assorted molecules, tempered in the furnace of a subterranean womb.

Cultivated in a nurturing environment, they congealed from gravitational forces and the exotic forces of electrical attraction, accessing the dimension of time to gestate and grow.

In addition to their mineralogical definitions, crystals symbolize the eternal on Earth.

Crystals are hard, dense Earth matter, and at the same time, they are transparent frozen light and a reservoir containing beauty.

Does beauty become present only after it is observed, or does it exist whether it is observed or not? Where does it come from, why is it here, why are we so captivated by it, actively seeking it in our lives? And why are we more alive when we find it?

~

Before the first crystalline structures grew in the skin of our freshly formed Earth, time can only be imagined in the broadest brushstrokes, using universal and galactic increments.

With the formation of crystals comes the concept of measuring change on Earth by the growth of this primordial life-form.

An evolutionary quantum leap, a departure from the metamorphic, volcanic gurgitations that the formative planet belched forth during its genesis. Crystals grow with a sophisticated lattice that bears the DNA of a divine intelligence that transcends time.

Crystallized minerals are manifest geometric forms, an organized structure of matter in the paradigm of a fractal universe.

They form from a complex design, both repeatable and predictable, yet each one possesses individual characteristics.

Before there were eyes to see, their transparent crystalline bodies became vessels holding vibrant concentrations of primal, eternal color.

~

The intelligence that fashioned these minerals used them as starter batter, blueprints for a continuum of evolution.

After millions of years of stillness, the aboriginal crystal inhabitants were joined by evolving plants and trees, to share terra firma with carbon-based (organic) life-forms, which, in turn, are composed of mineral-based compounds:

One life-form precipitating a new cycle of life.

And an essential element woven into Earth's evolving nature is the eternal nature of beauty.

[ABOVE] *Work in Progress,* Brazilian quartz cluster on bronze, 5′6″ (h)

[OPPOSITE] Amethyst
"Are you willing to step beyond your humanness and speak to us as consciousness?"
~ THE MINERAL KINGDOM, channeled by ANNIE BOSSINGHAM

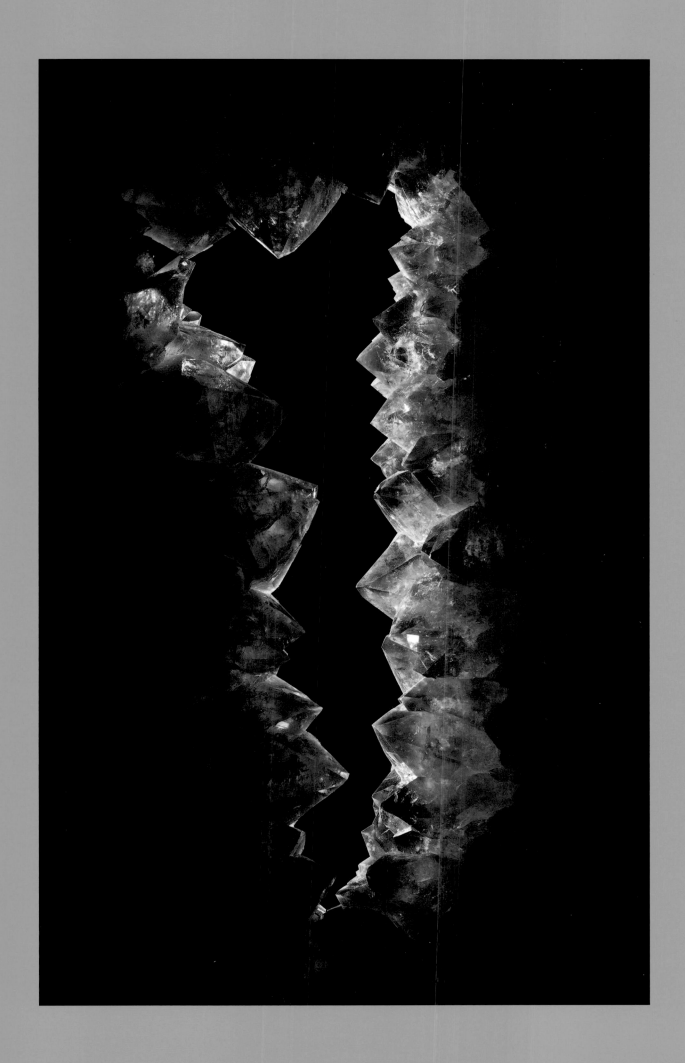

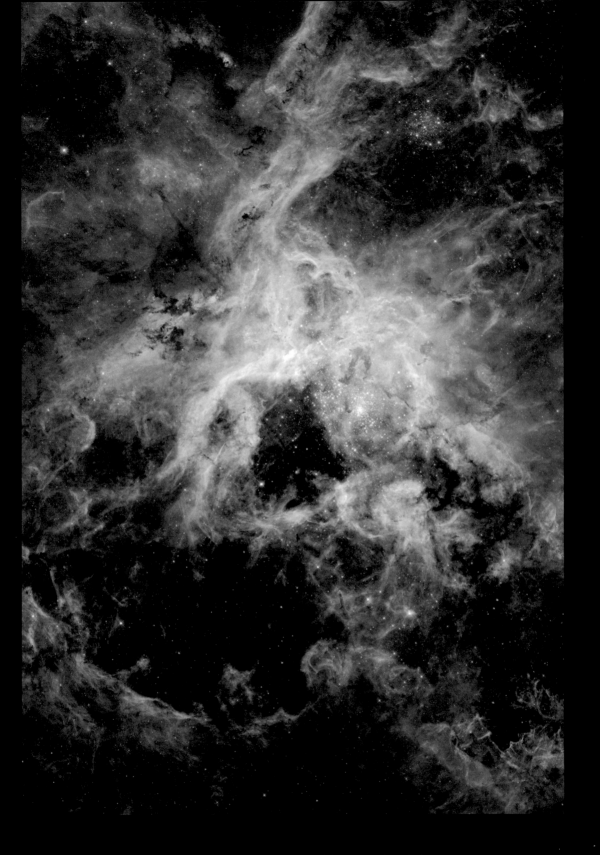

Imagination, NASA photograph of the Tarantula Nebula

ble telescope condenses our astronomical cosmos into an image of dancing lights; look up and become more

"Dwell on the beauty of life. Watch the stars, and see yourself running with them."
~ MARCUS AURELIUS, *Meditations*

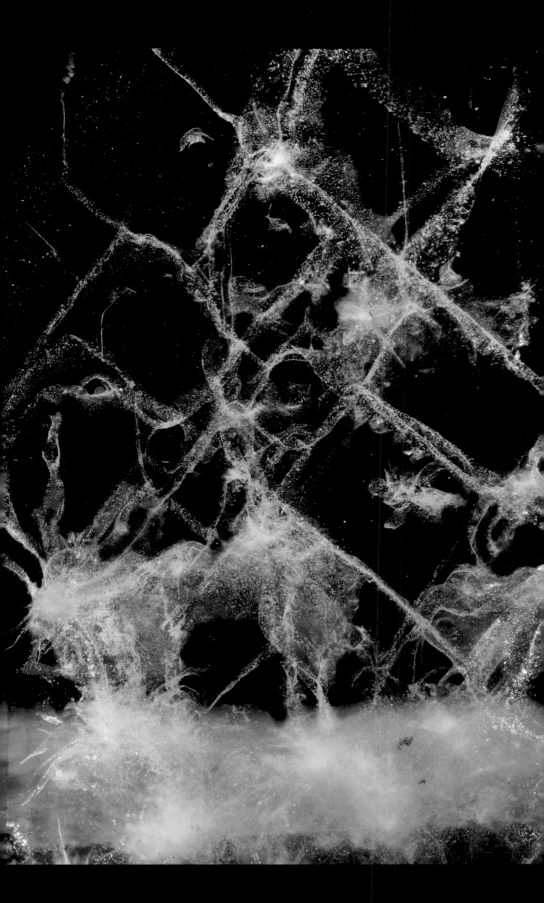

Introspection, micro image of quartz crystal veil inclusions

Photographic magnification of the reflective universe inside a quartz crystal.
Looking deeper into the more real,
Imagination and Introspection are on a continuum between the known and the unknown.
Outer Space and Inner Space share the awe of beauty.
Imagination and Introspection connect us to universes within, and Beyond.

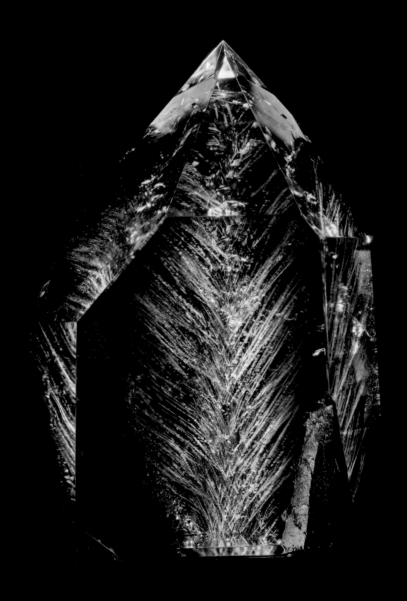

Green gold citrine with blue needle inclusions

"Let there be light." ~ GENESIS 1:3

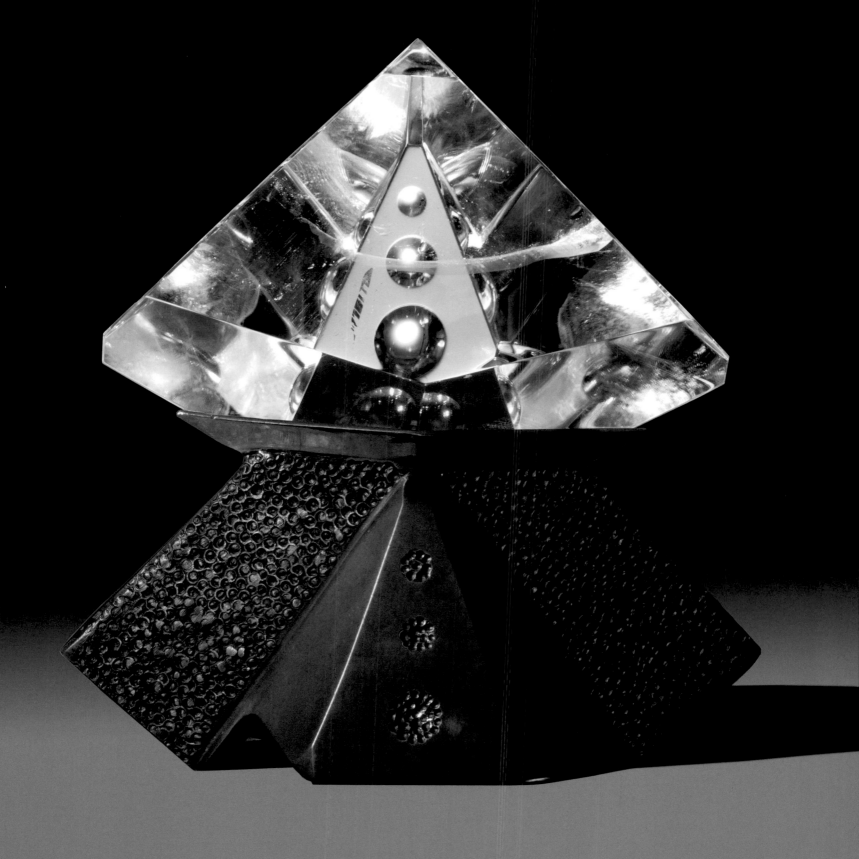

Samurai, carved quartz on lighted bronze base, 8″ (h)

"Astronomy compels the soul to look upwards and leads us from this world to another". ~ PLATO, *The Republic*

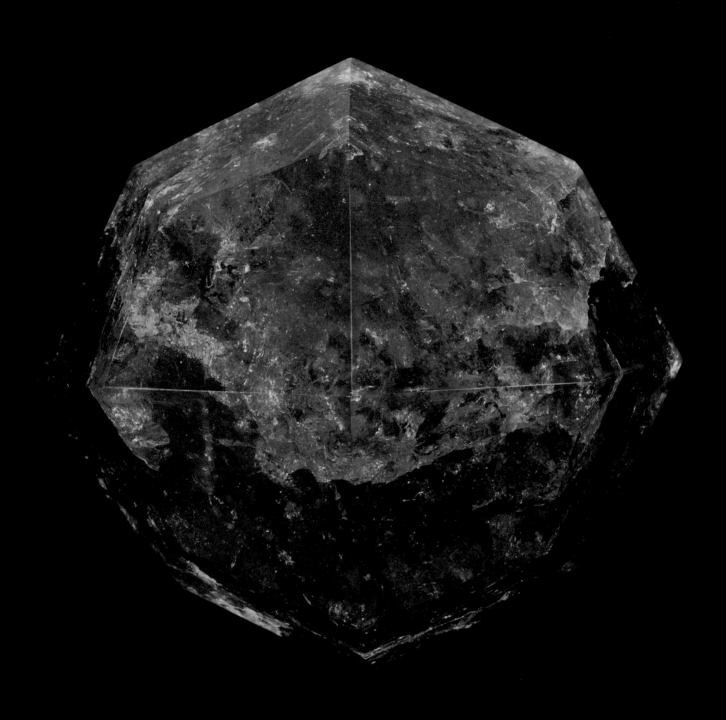

Faceted hessonite garnet, 3,410 carats

"Even after all this time, the sun never says to the earth,
'You owe me.' Look what happens with a love like that, it lights the whole sky."
~ DANIEL LADINSKY, *The Gift: Poems by Hafiz*

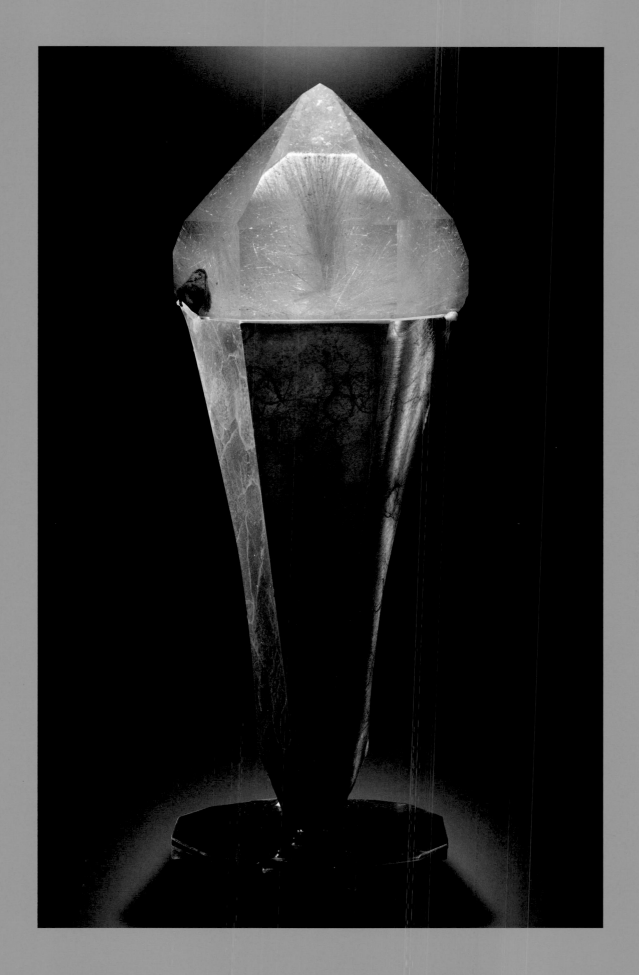

Sun Torch, golden rutile in quartz on lighted bronze base, 15″ (h)

"Three things cannot be long hidden: the sun, the moon, and the truth."
~ THE BUDDHA

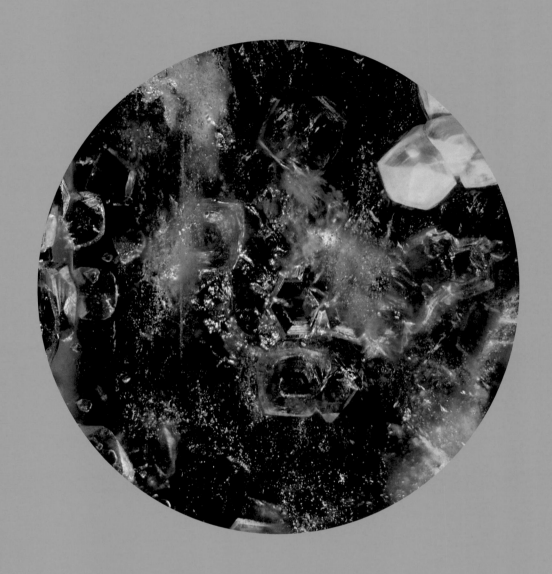

[ABOVE] Florite in quartz, Madagascar

"The universe is under no obligation to make sense to you."
~ NEIL deGRASSE TYSON, *Real Time with Bill Maher*

[OPPOSITE] *Across the Universe*, clear carved quartz on lighted bronze base, 24˝ (h)

"Limitless undying love which shines around me like a million
suns it calls me on and on across the universe."
~ JOHN LENNON

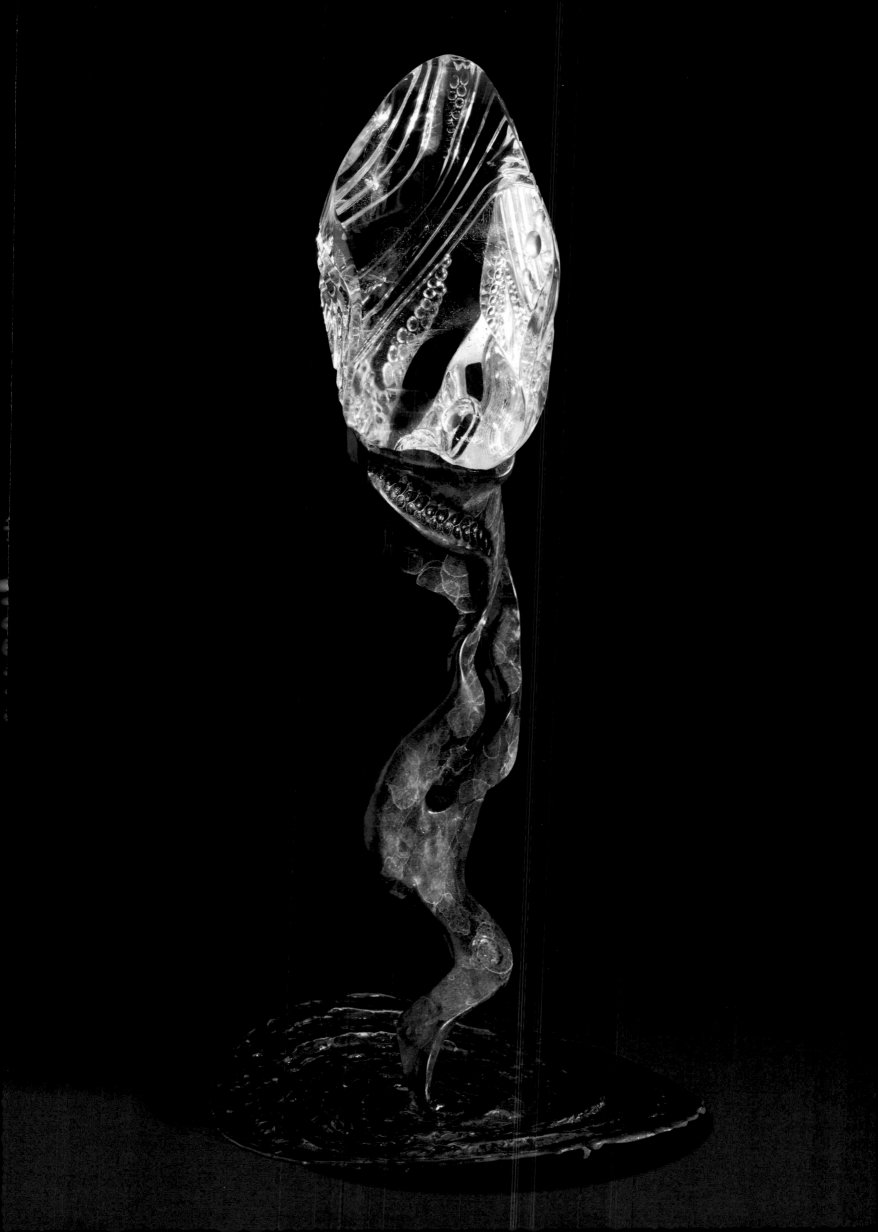

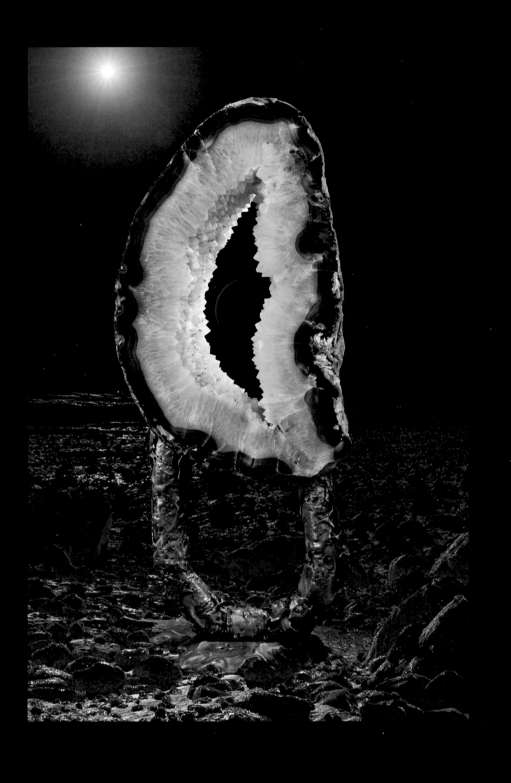

[ABOVE] *Moon Garden*, Brazilian agate slab on bronze, 42″ (h)

are going to the moon that is not very far. Man has so much farther to go within himsel
~ ANAÏS NIN, *Diary*

[OPPOSITE] *Moon Walk*, Madagascar river-tumbled quartz on lighted bronze base, 12″ (h)

"it was the kind of moon / that I would want to / send back to my ancestors / and gift
to my descendants / so they know that I too, / have been bruised ... by beauty."
~ SANOBER KHAN, *Turquoise Silence*

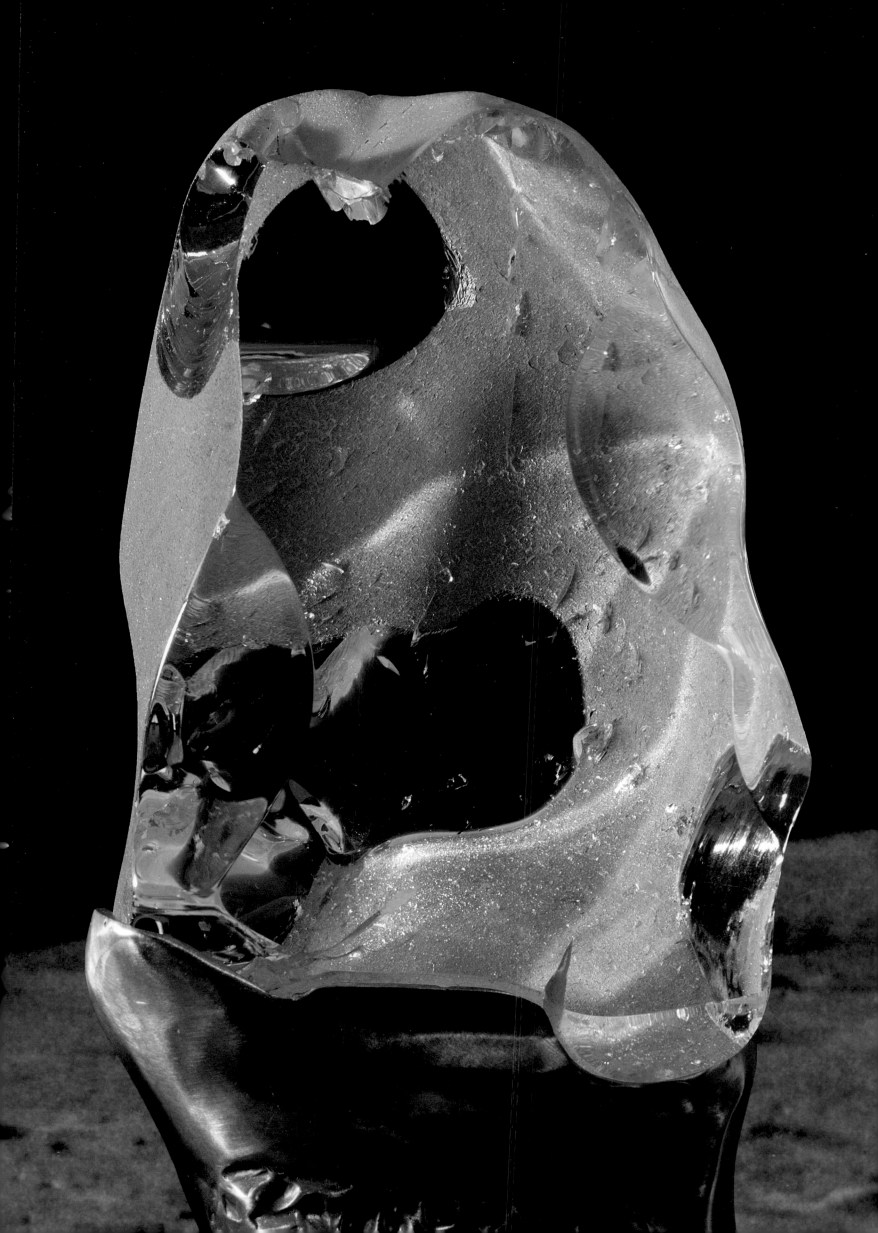

NASA Lens

I received an email from a woman who had inherited a 117-pound stone from her father. It had been in the family for decades and, in the way only a rock can, had taken up residence on her living room floor.

The woman's father had been an engineer for NASA. In the 1960s, he had procured this crystal in Brazil, thinking it might be optically transparent enough to be cut into a lens for space-viewing technology. The NASA scientists must have concluded that this crystal, when shaped, would not meet the specs they required, and as a result, it became a nearly immovable doorstop.

Forty-plus years later, with a new baby in the house and a shrinking living room, the rock had to find a new home. And I was presented with an out-of-the-blue opportunity. As I listened to her describe the crystal and the story of its potential use by NASA, I concluded that it most likely contained great visual clarity and hidden mineralogical inclusions. When she asked if I knew what to do with it, I paused, contained my excitement, and quietly said yes.

When I unpacked the crystal, it looked as advertised, like a big crusty rock.

The hardened mineral coating on the skins of the crystal spun my wondering mind to imagining what my eyes would see once I uncovered the buried treasure inside.

As the first slice of my diamond-bladed saw removed the millions-years-old crust, the light and beauty trapped inside were released. Under the weatherworn and broken surfaces was a crystal with massive transparency. The internal structure of the quartz included some marvelous multicolored chlorite formations. After the initial shaping, my assistant Tim Turco spent the next several months refining the large planed surfaces with an immaculate polish, allowing the eye to enter a previously unattainable world.

Its destiny revealed, it became a lens to view a fully preserved prehistoric otherworld of majestic beauty and wonder.

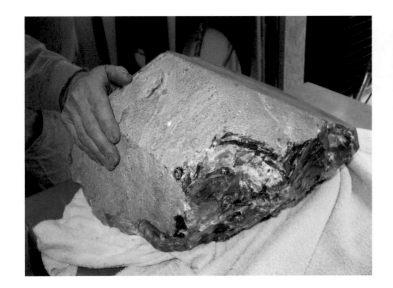 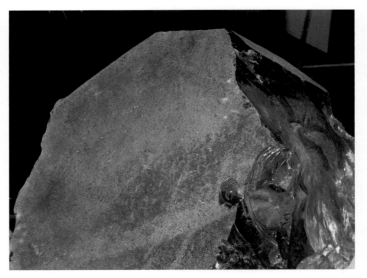

[ABOVE] *Nasa Rough,* raw crystal coated with iron

[OPPOSITE] *NASA,* Brazilian optical quartz with chlorite inclusions on lighted bronze base, 120 pounds, 31″ (h)

NASA — **N**ature **A**ppreciated **S**timulates **A**rt

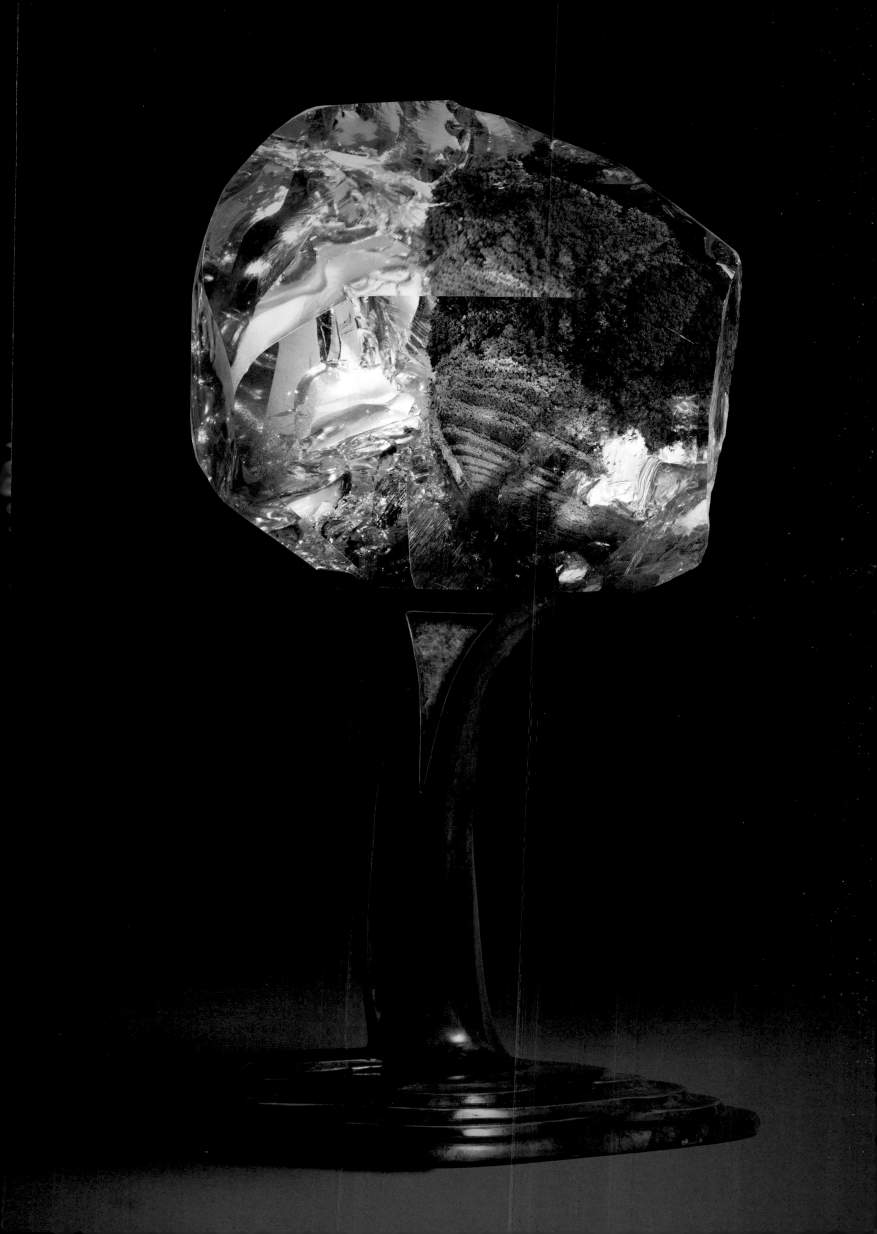

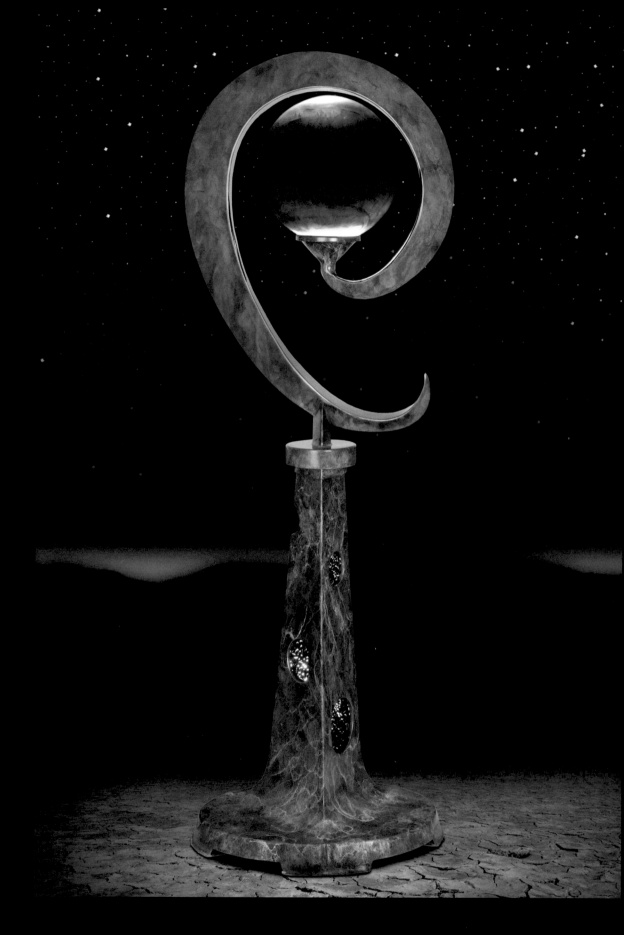

Red Planet, 14"-diameter rose quartz sphere on lighted bronze base, 72″ (h)

"Mathematics expresses values that reflect the cosmos,
including orderliness, balance, harmony, logic, and abstract beauty."
~ DEEPAK CHOPRA, *War of the Worldviews*

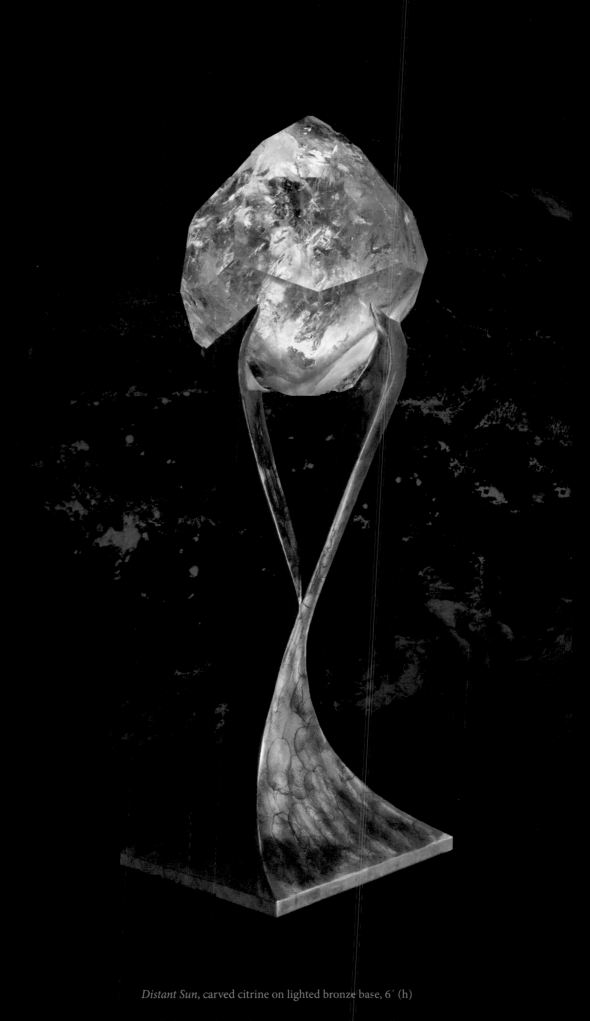

Distant Sun, carved citrine on lighted bronze base, 6' (h)

"The Earth is what we have in common."
~ WENDELL BERRY, *The Art of the Commonplace*

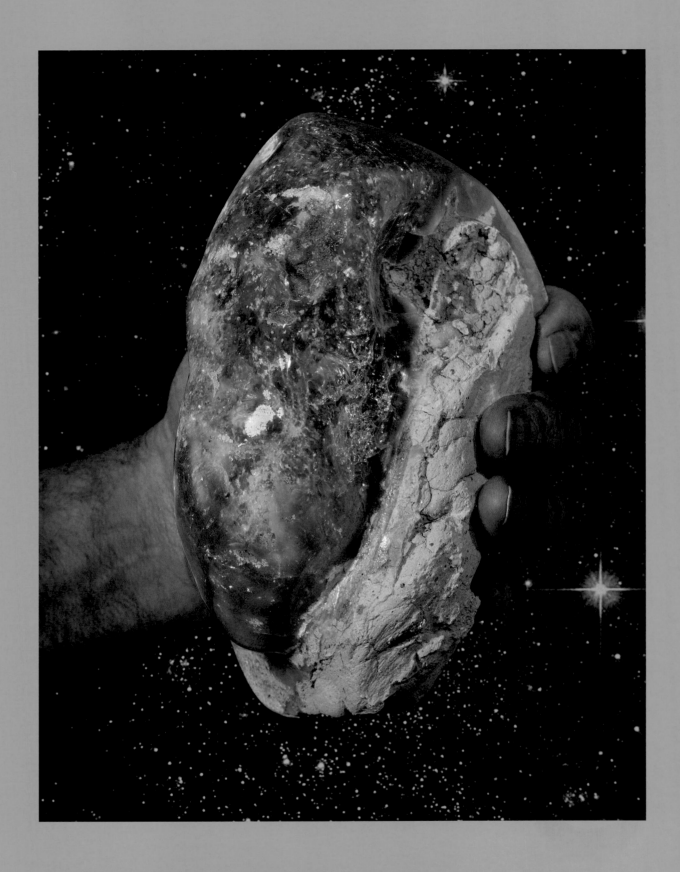

"The world is not given by [our] fathers, but borrowed from [our] children."
~ WENDELL BERRY, *The Unforeseen Wilderness*

"Everything has beauty, but not everyone sees it."
~ CONFUCIUS, *Analects*

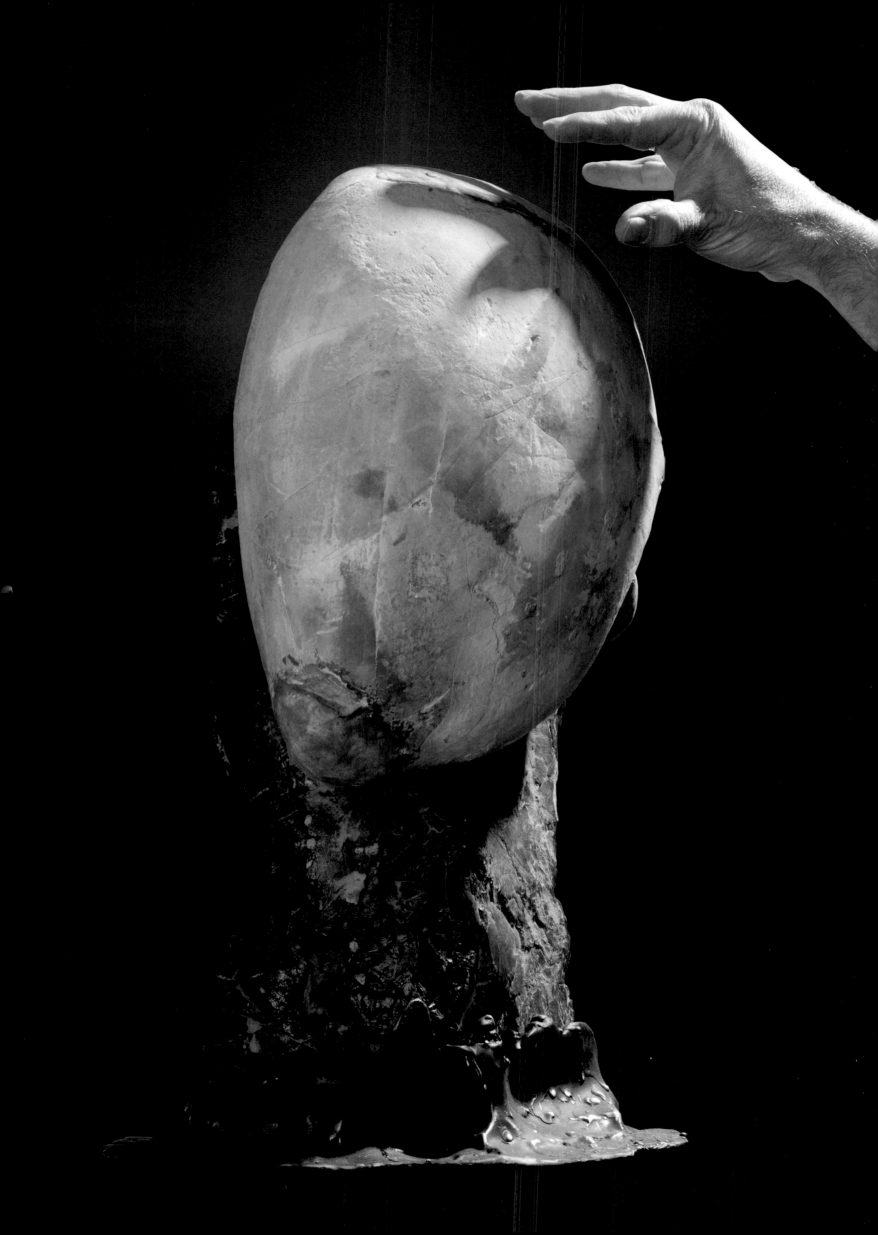

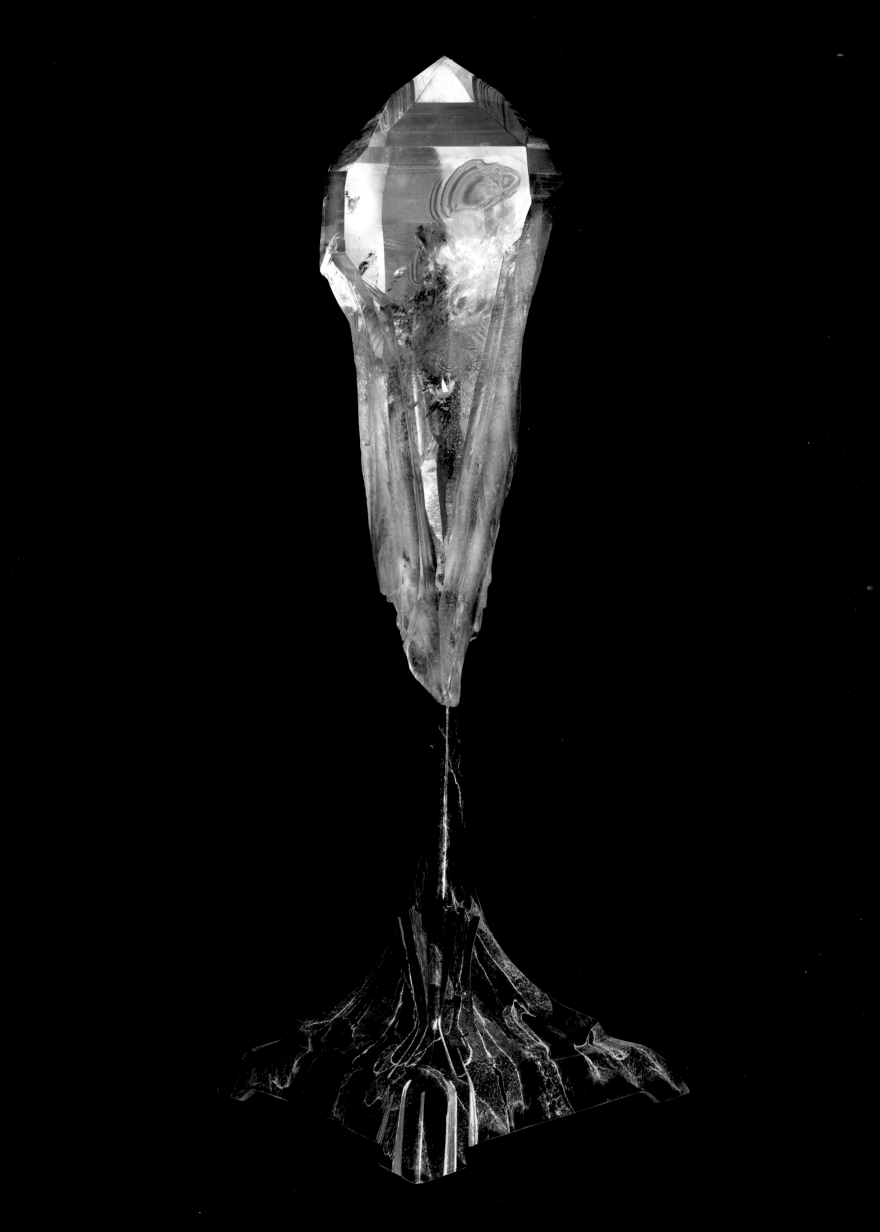

[ABOVE] *Rainbow Waterfall*, refractive rainbow in 8″ Brazilian quartz crystal sphere (detail)

[OPPOSITE] *Lemurian Rainbow,* Brazilian natural "Lemurian" quartz on lighted bronze base, 25″ (h)

Rainbows were not invented by the sky alone,
Nature conceived the spectrum of colors and concealed them in minerals for eons as Earth formed.

Canadian fossilized ammonite sea shell on bronze, 6″ (h)

"In one drop of water are found all the secrets of all the oceans;
in one aspect of you are found all the aspects of existence."
~ Kahlil Gibran, *Tears and Laughter*

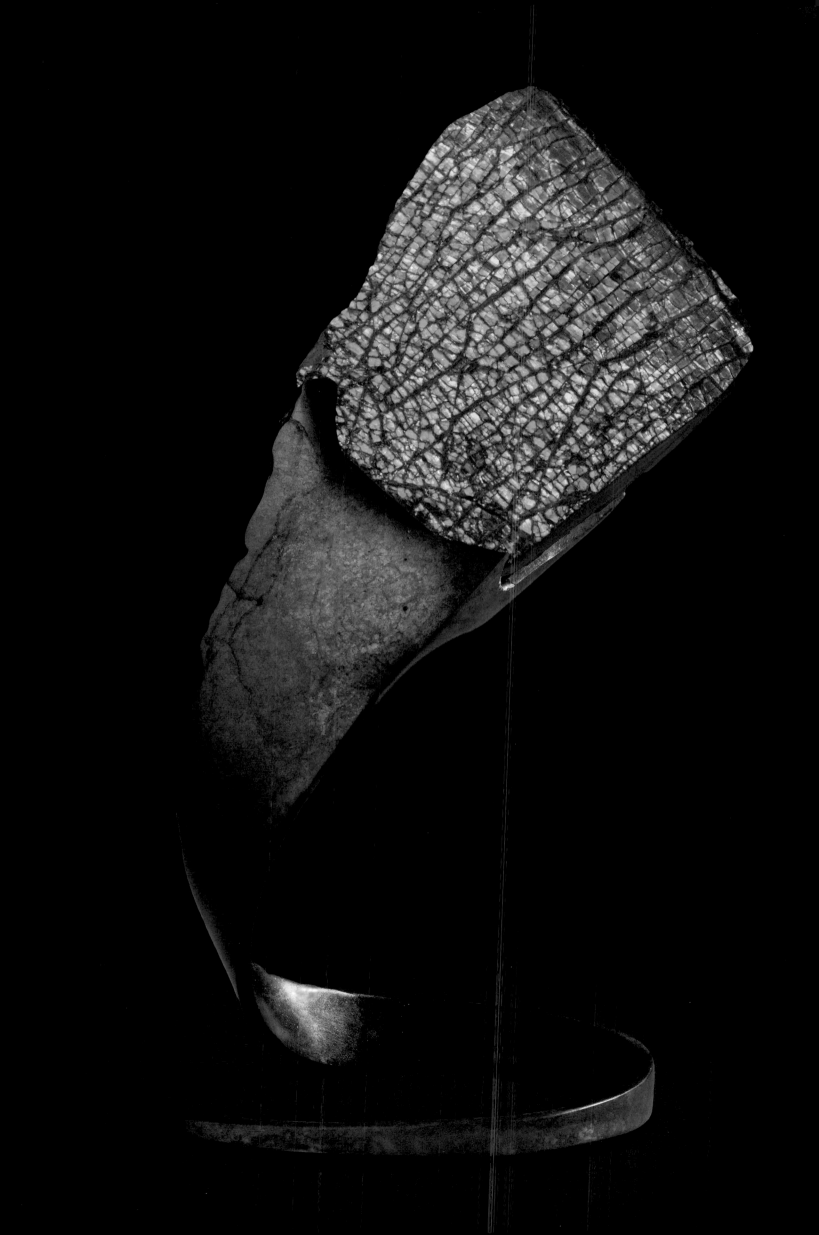

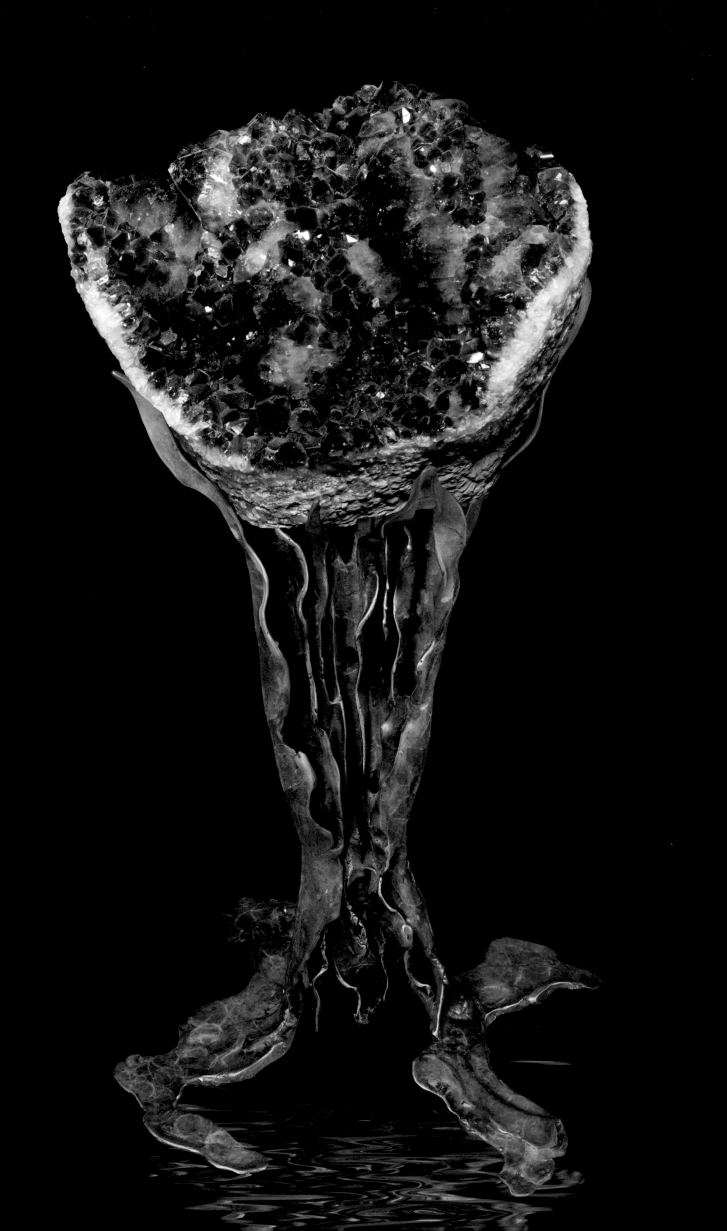

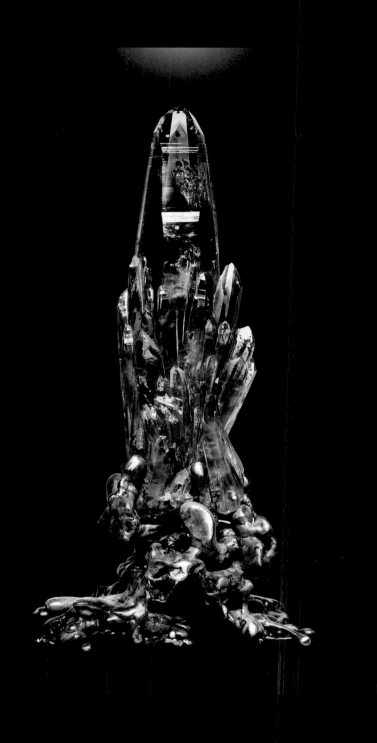

[ABOVE] *Purple Sage*, amethyst specimen on bronze, 7.5″ (h)

[OPPOSITE] *Cup Runneth Over*, amethyst geode on bronze, 26″ (h)

"Water is the most versatile of all elements. It isn't afraid to burn in fire or fade into the sky, it doesn't hesitate to shatter against sharp rocks in rainfall or drown into the dark shroud of the Earth. It exists beyond all beginnings and ends. On the surface nothing will shift, but deep in underground silence, water will hide and with soft fingers coax a new channel for itself, until stone gives in and slowly settles around the secret space. Death is water's close companion, and neither of them can be separated from us, for we are made of the versatility of water and the closeness of death. Water does not belong to us, but we belong to water: when it has passed through our fingers and pores and bodies, nothing separates us from Earth."
~ EMMI ITÄRANTA, *Memory of Water*

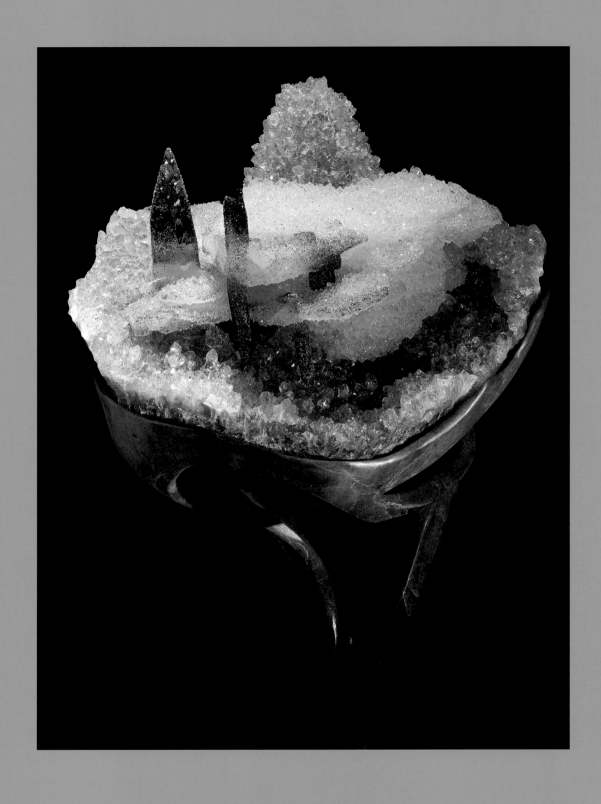

Origins of Architecture, Uruguayan druze amethyst over calcite specimen on bronze, 22″ (h)

"It is a wholesome and necessary thing for us to turn again to the earth and
in the contemplation of her beauties to know the sense of wonder and humility."
~ RACHEL CARSON, *The Sense of Wonder*

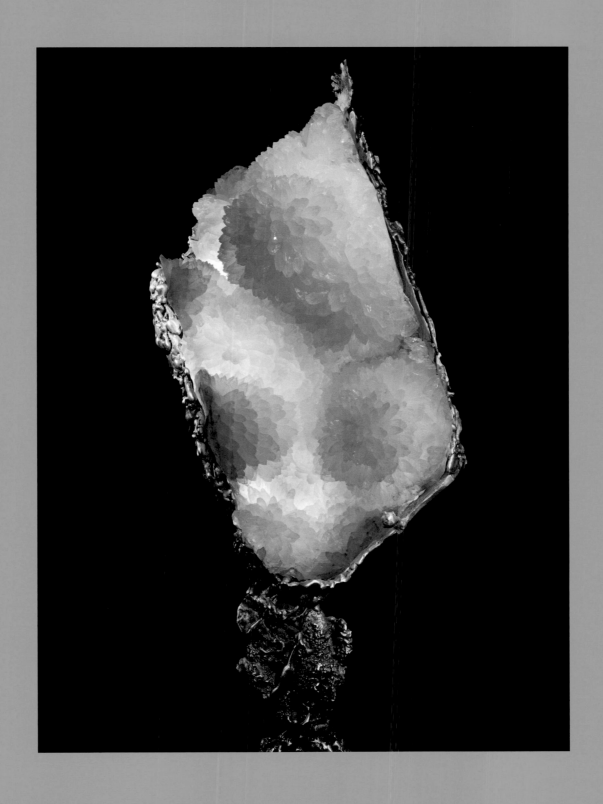

Chrysanthemum, quartz flower on lighted bronze base, 47″ (h)

"True beauty is a ray that springs from the sacred depths of the soul,
and illuminates the body, just as life springs from the kernel
of a stone and gives color and scent to a flower." ~ RUMI

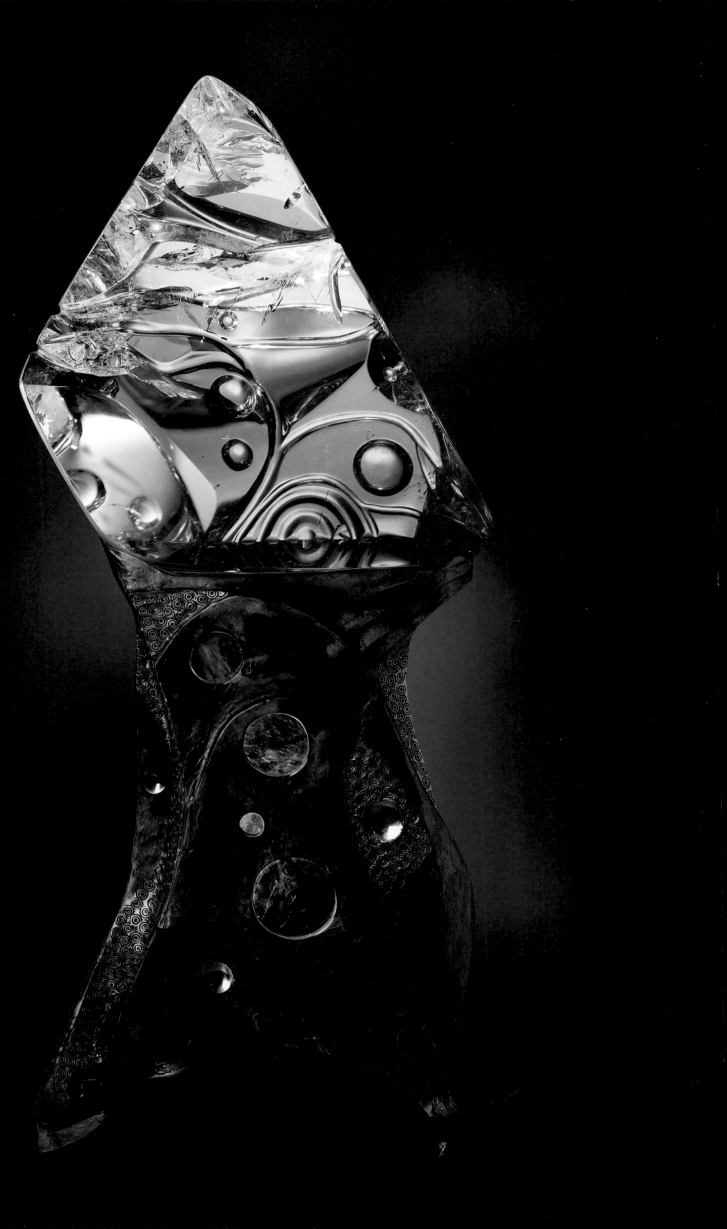

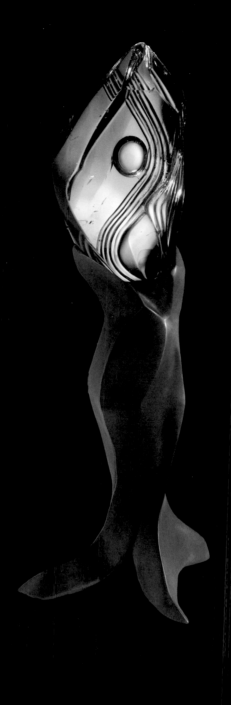

[ABOVE] *Sunriver*, carved citrine on lighted bronze base, 16″ (h)

"Have you also learned that secret from the river; that there is no such thing as time?
That the river is everywhere at the same time, at the source and at the mouth, at the waterfall, at the
ferry, at the current, in the ocean and in the mountains, everywhere, and that the present only exists
for it, not the shadow of the past nor the shadow of the future."
~ HERMANN HESSE, *Siddhartha*

[OPPOSITE] *Oceania*, carved citrine with Namibian indicolite tourmaline on lighted bronze base, 27″ (h)

"There's nothing wrong with enjoying looking at the surface of the ocean itself,
except that when you finally see what goes on underwater, you realize that
you've been missing the whole point of the ocean."
~ DAVE BARRY, author

Phoenix Rising, amethyst geodes held by bronze, 7′ (h)

"Everything is connected. The wing of the corn beetle affects
the direction of the wind, the way the sand drifts, the way the
light reflects into the eye of man beholding his reality. All is
part of totality, and in this totality man finds his *hozro*, his
way of walking in harmony, with beauty all around him."

~ TONY HILLERMAN, *The Ghostway*

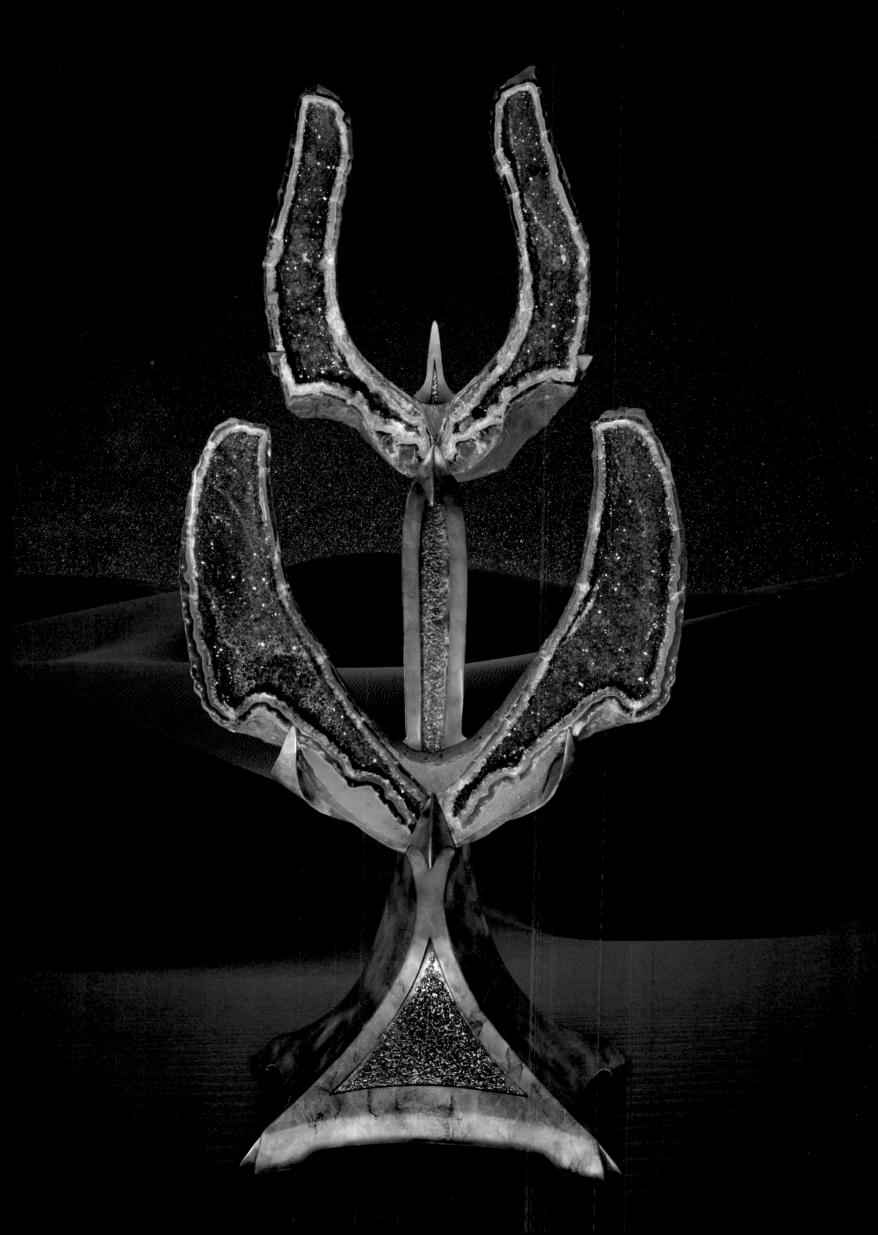

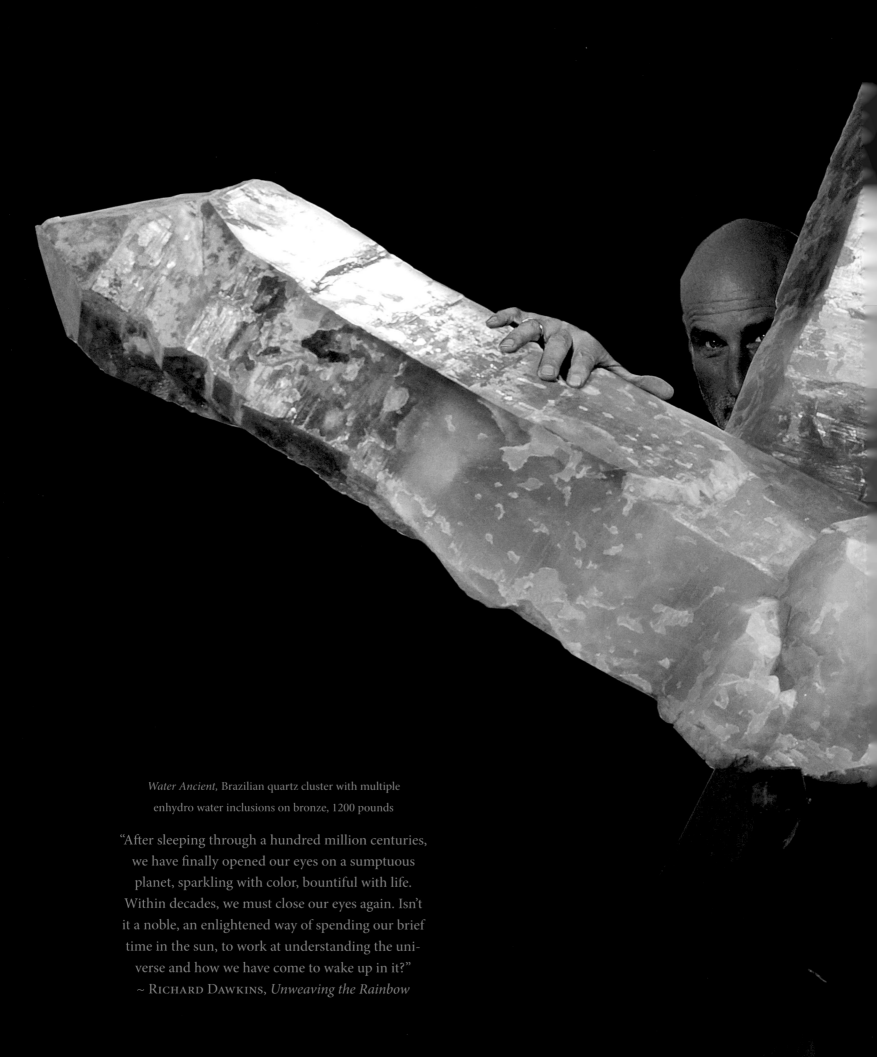

Water Ancient, Brazilian quartz cluster with multiple
enhydro water inclusions on bronze, 1200 pounds

"After sleeping through a hundred million centuries,
we have finally opened our eyes on a sumptuous
planet, sparkling with color, bountiful with life.
Within decades, we must close our eyes again. Isn't
it a noble, an enlightened way of spending our brief
time in the sun, to work at understanding the uni-
verse and how we have come to wake up in it?"
~ RICHARD DAWKINS, *Unweaving the Rainbow*

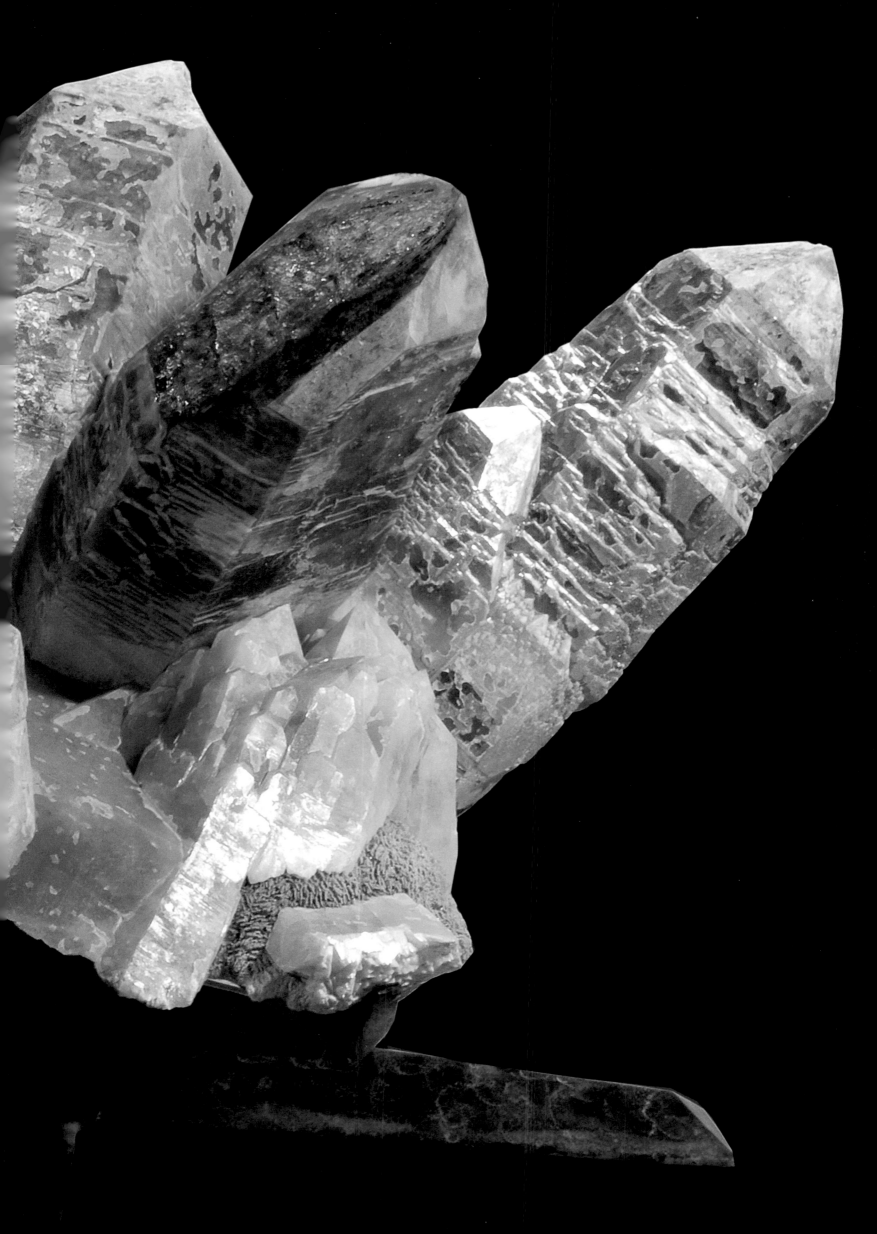

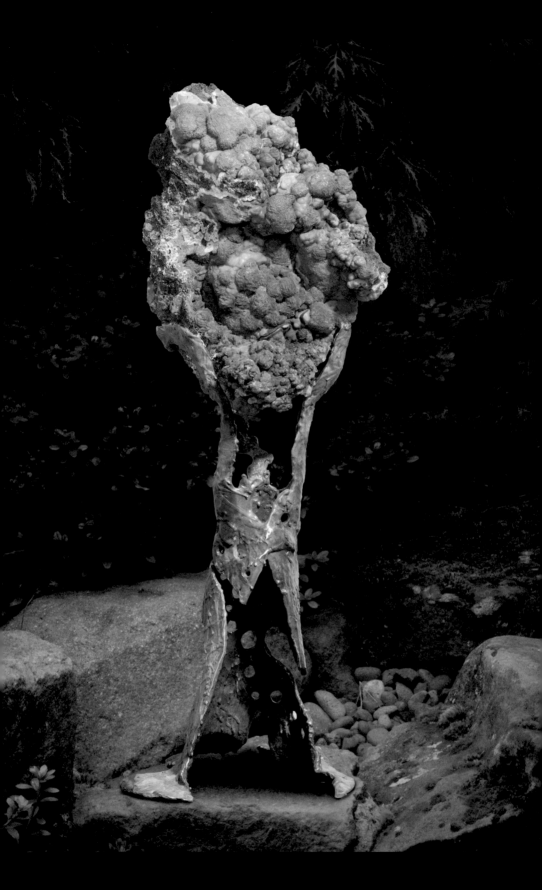

Garden Dweller, Brazilian chrysocolla on bronze, 24″ (h)

"Nature alone can lead to the understanding of art,
just as art brings us back to nature with greater awareness.
It is the source of all beauty, since it is the source of all life."
~ Eugène Carrière, French Symbolist artist

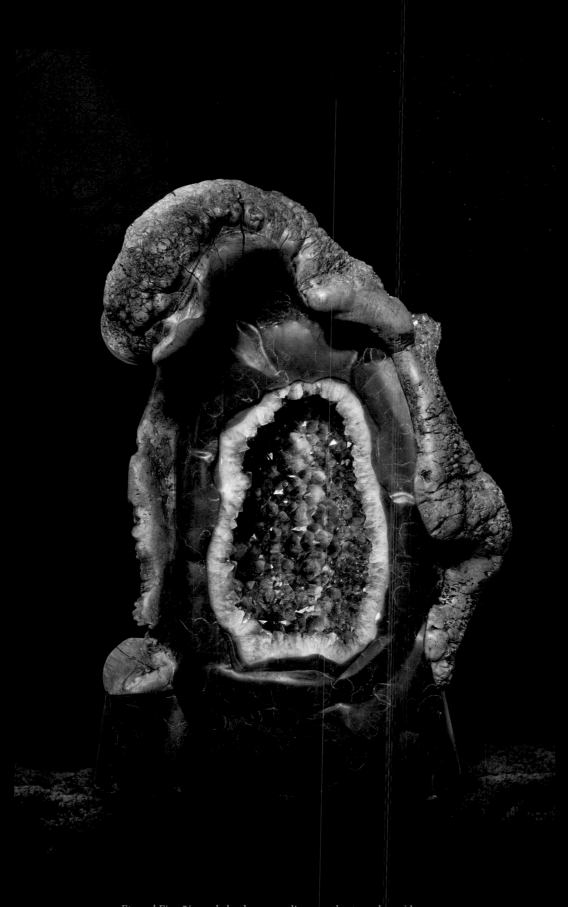

Eternal Fire, 5′ maple burl surrounding amethyst geode and bronze

"When people first discover beauty, they tend to linger.
Even if they don't at first recognize it for what it is."
~ SHERWOOD SMITH, author

Yosymmetry, Madagascar quartz on bronze and black walnut pedestal, 73″ (h)

"A few minutes ago every tree was excited, bowing to the roaring storm,
waving, swirling, tossing their branches in glorious enthusiasm like worship.
But though to the outer ear these trees are now silent, their songs never cease."
~ JOHN MUIR, *My First Summer in the Sierra*

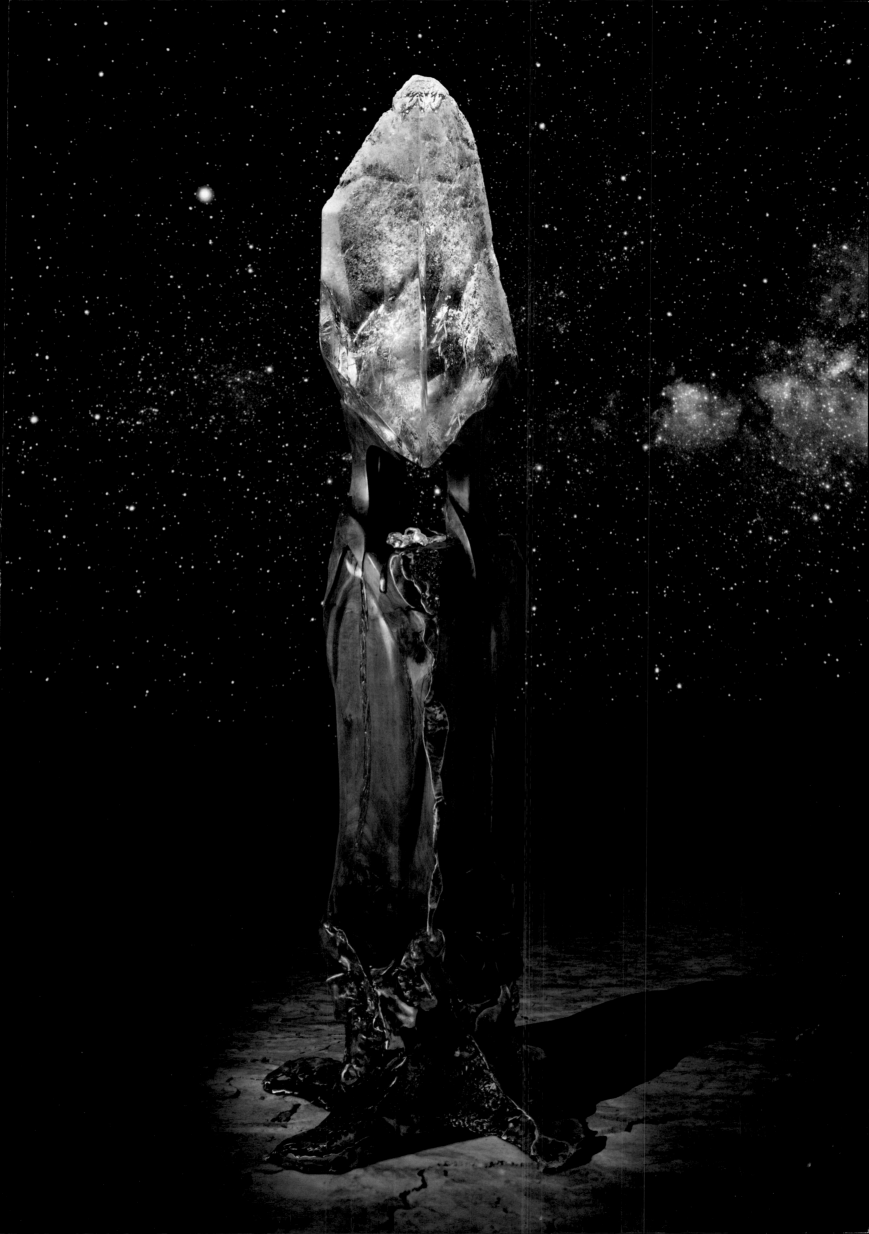

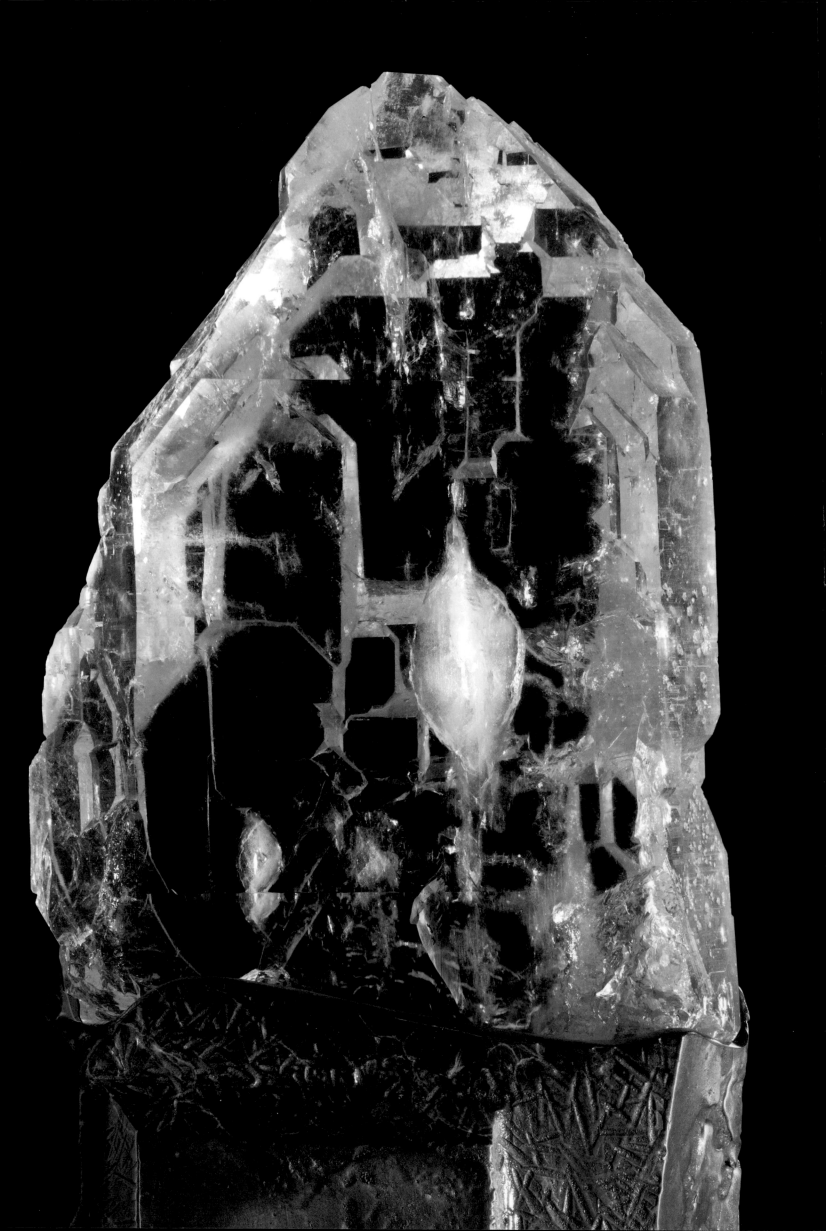

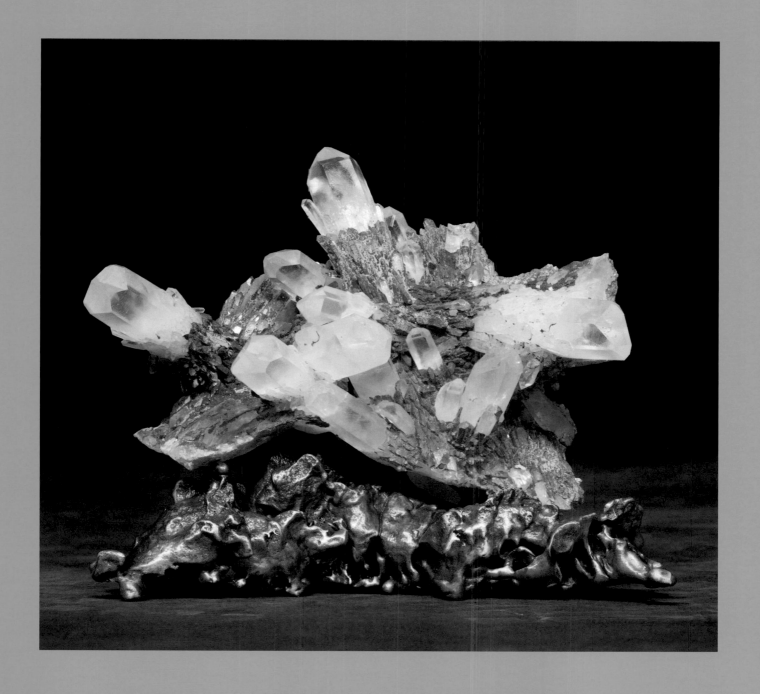

[ABOVE] *Old Growth*, quartz crystal cluster with iron on bronze, 5″ (h)

"Sometimes, I guess there aren't enough rocks." ~ FORREST GUMP

[OPPOSITE] *Ancient H₂O*, castled quartz with enhydro water bubble on lighted bronze base , 13′ (h)

Deep within the stone lives a voice.
Deep within the voice is a sound that can't be heard.
Deep within that sound lives the stone.

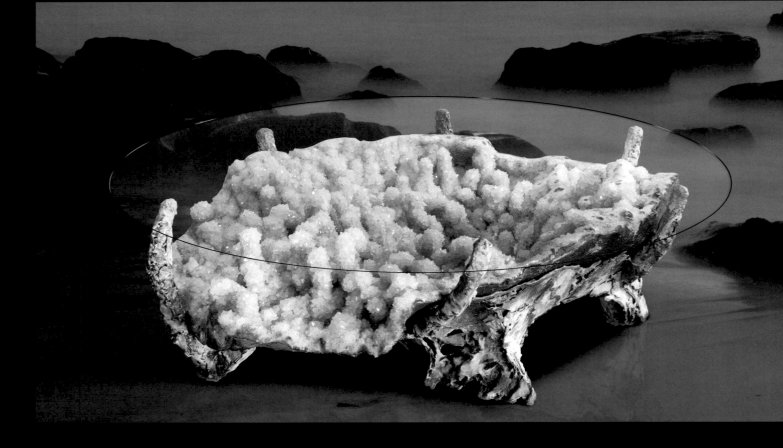

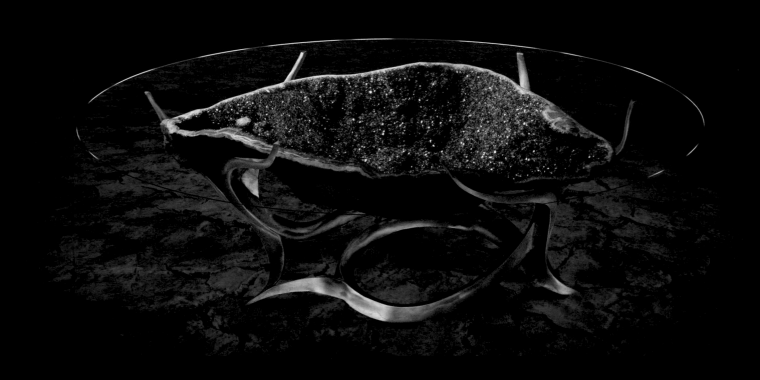

[TOP] *Coral Reef*, white amethyst geode on bronze, 7´ (l)

[ABOVE] *Dining on La Playa*, amethyst geode on bronze, 7´ (l)

Enter Here, amethyst geode on bronze, 5′6″ (h)

Beauty is in the eye of the beholder … rendering you beholden.

Down the Rabbit Hole, druze geode on bronze, 78″ (h)

"Through the looking glass

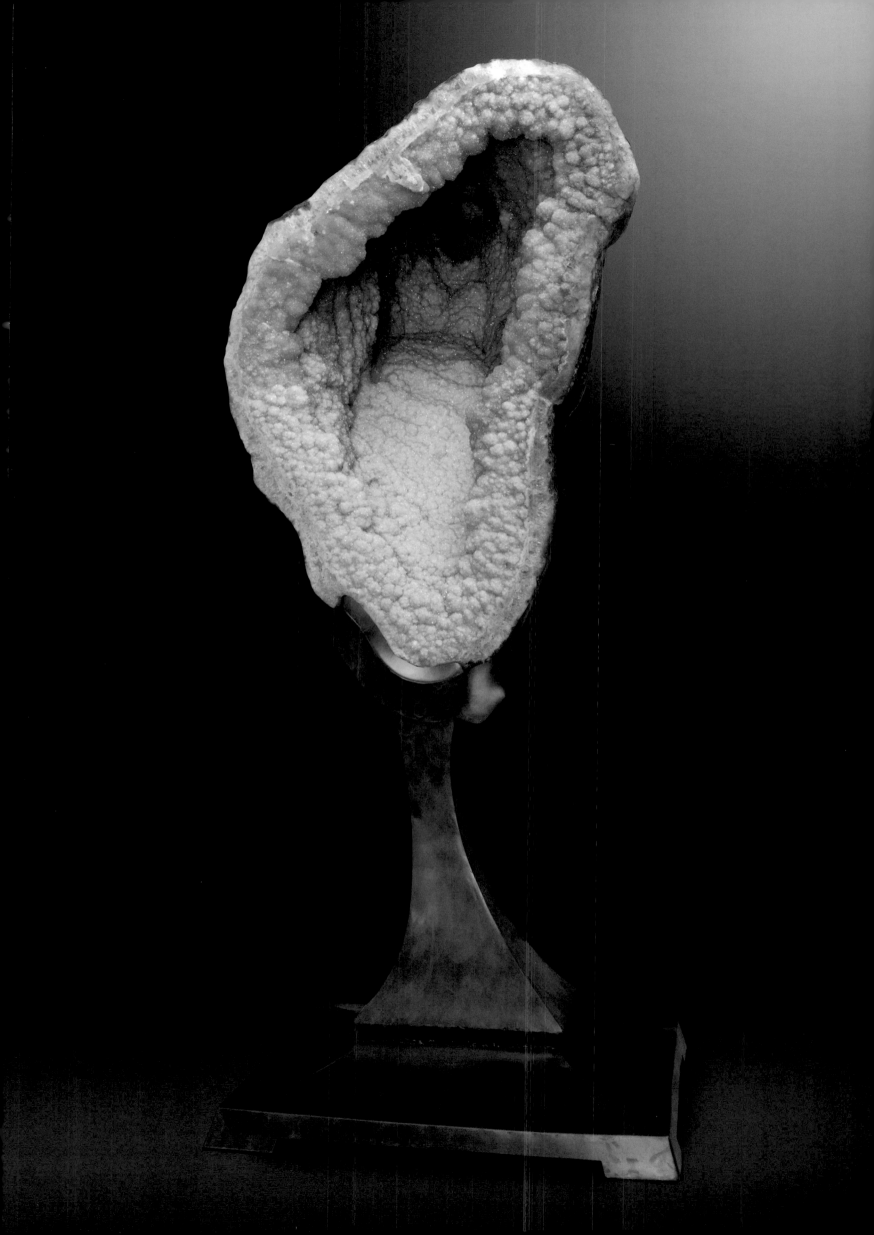

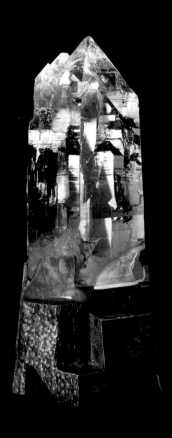

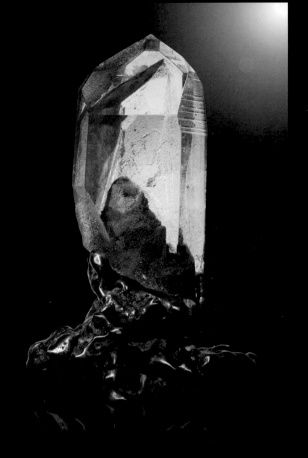

Inner Light, Pakistan castled quartz on lighted bronze base, 21″ (h)

Multicolored Brazilian chlorite phantom on bronze, 5″ (h)

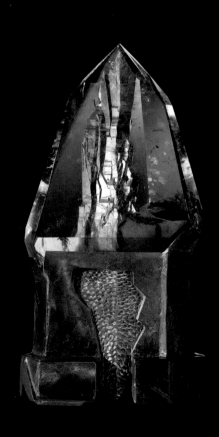

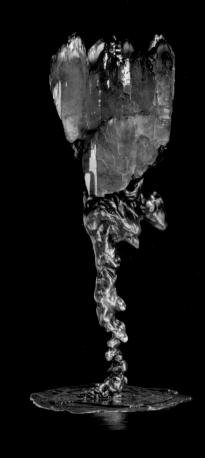

Cathedral Rock, smoky citrine quartz on lighted bronze base, 18″ (h)

Patagonia Range, Brazilian smoky quartz formation on bronze base, 23″ (h

"Wilderness is not a luxury but a necessity of the human spirit . . ." ~ EDWARD ABBEY, *Desert Solitaire*

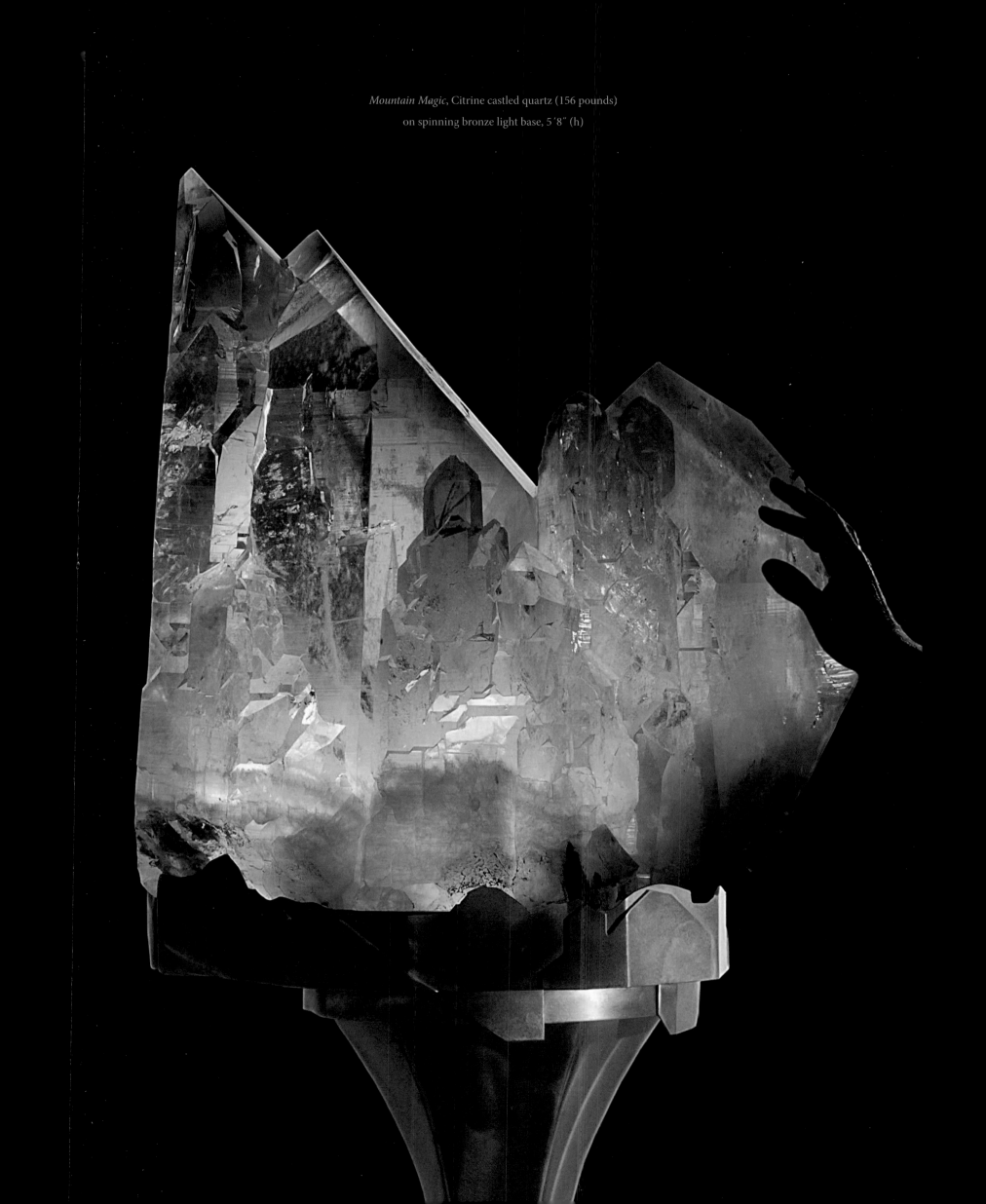

Mountain Magic, Citrine castled quartz (156 pounds)
on spinning bronze light base, 5′8″ (h)

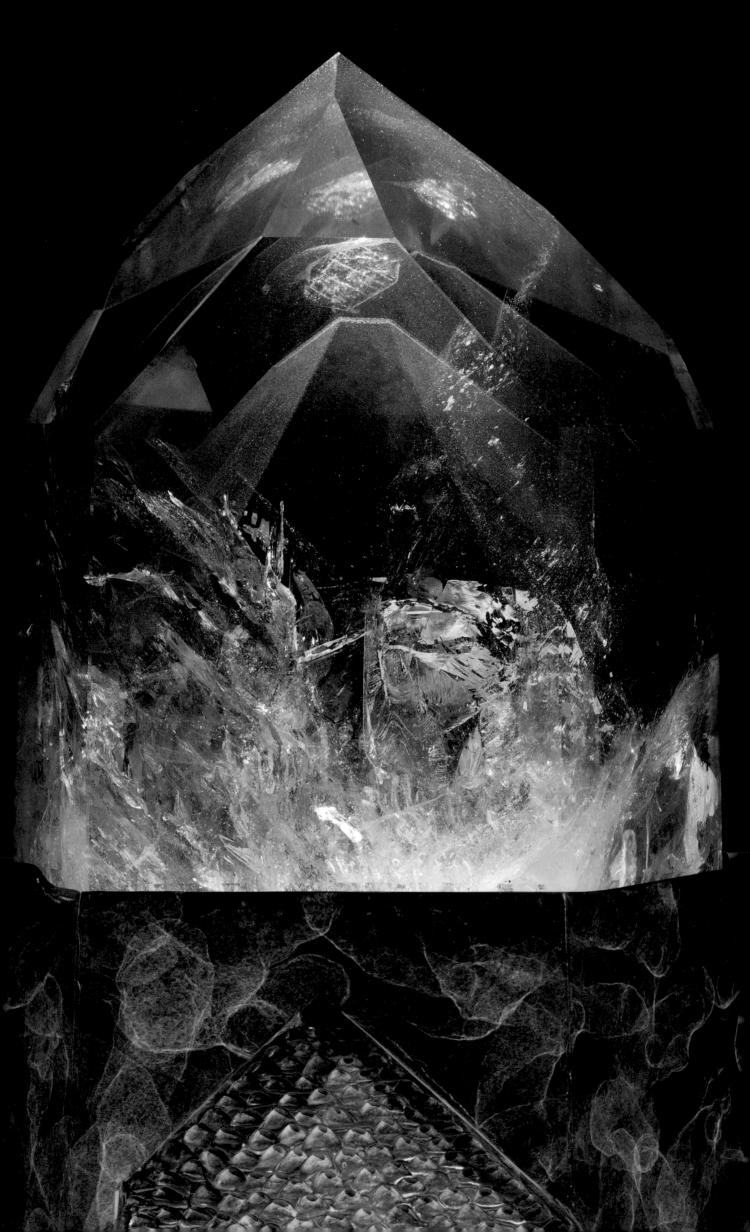

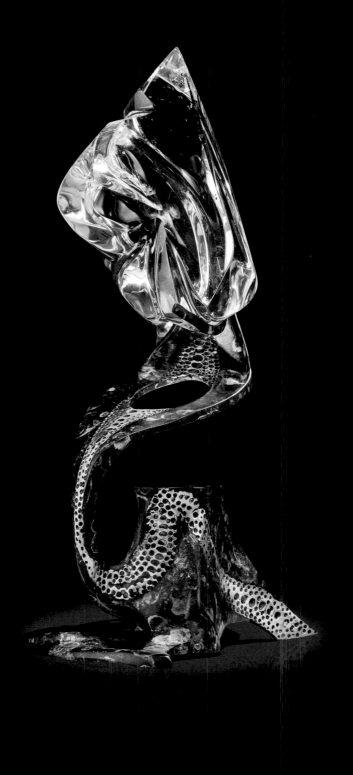

[ABOVE] *Snake Charmer,* carved optical quartz on lighted bronze base, 9.5″ (h)

[OPPOSITE] *Hologram*, Brazilian quartz with multiple phantoms on lighted bronze base, 15″ (h)

"While in the presence and grace of Beauty,
if I become very still and listen,
Beauty whispers to me.
She shows me her face.
And I weep."
~ JACH PURSEL

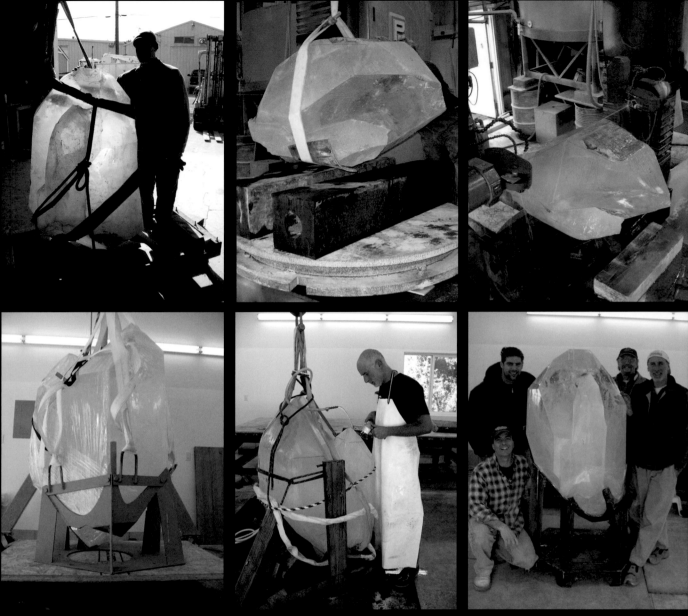

[ABOVE, BOTTOM RIGHT] Patrick (kneeling), L TO R: Timothy, Peter, and Lawrence.

The cutting and polishing process of the crystal named *Generations* took over two years of constant work, sawing, grinding, pre-polishing, polishing, and basing.

[OPPOSITE] *Generations*, 2,502-pound Brazilian quartz with penetrating crystal "Earth keeper," with Lawrence and Talia

"How many things … are looked upon as quite impossible until they have actually been done?"
~ PLINY THE ELDER, *Naturalis Historia*

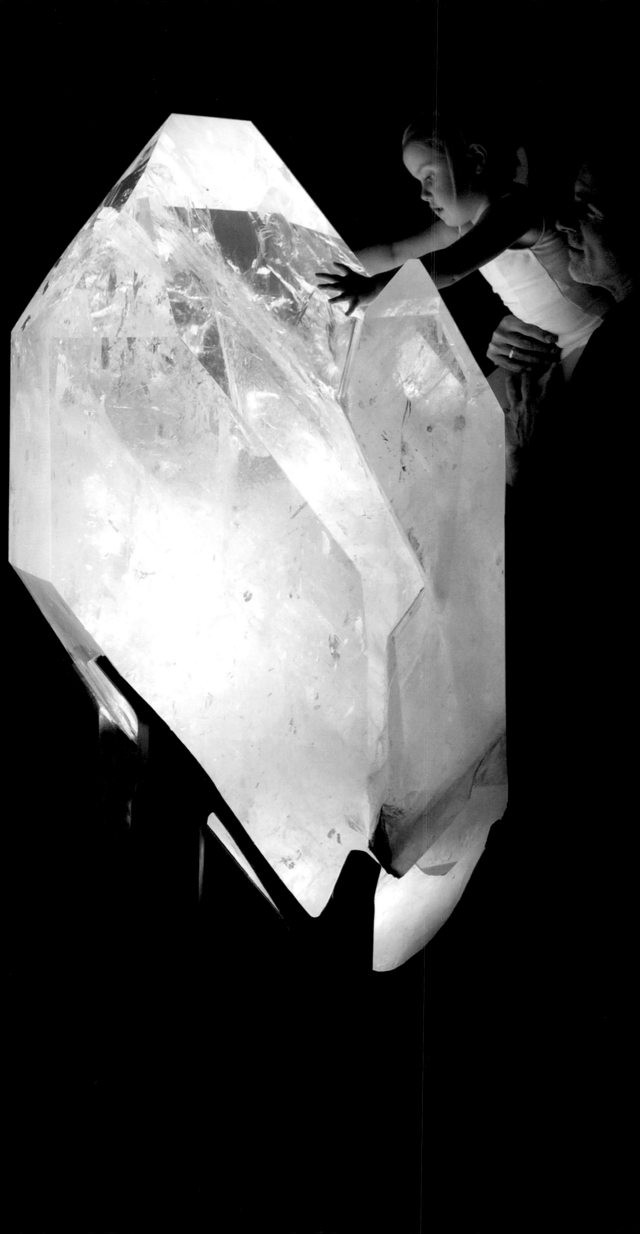

[ABOVE] Dogtooth calcite pseudomorph in quartz

"What we call wilderness is a civilization other than our own."
~ HENRY DAVID THOREAU, *Journal*

[OPPOSITE] *Alpenglow*, Brazilian citrine generator on lighted bronze base, 65 pounds

I have never climbed a mountain that didn't take my breath away

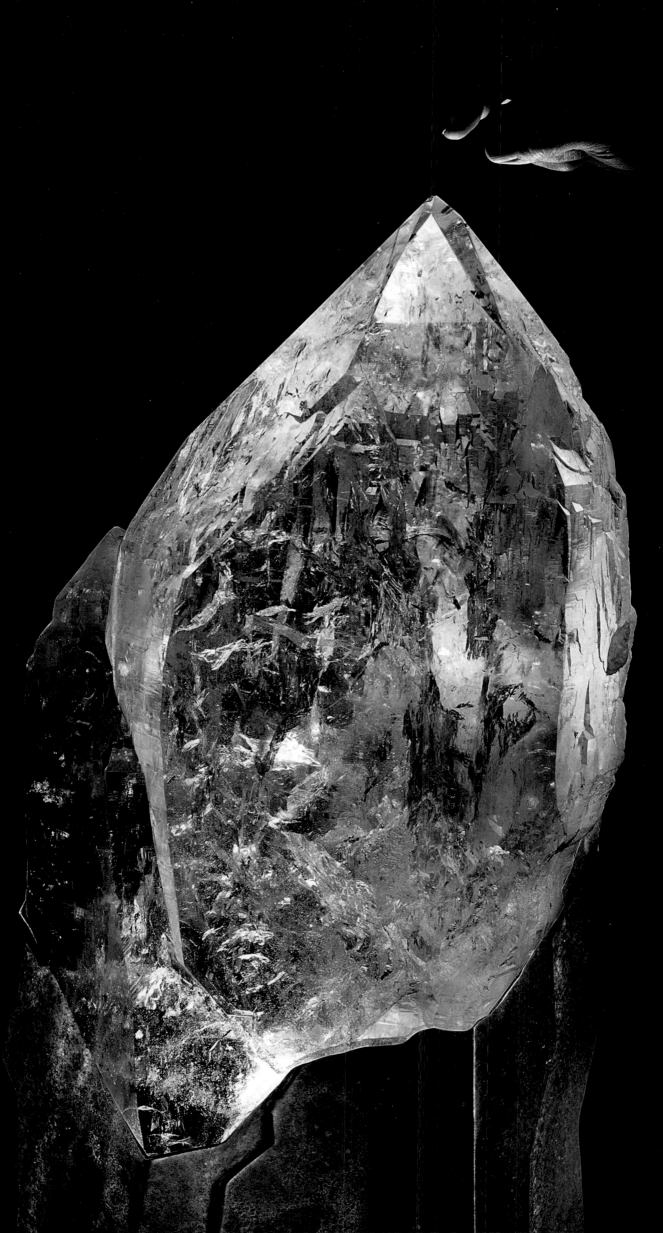

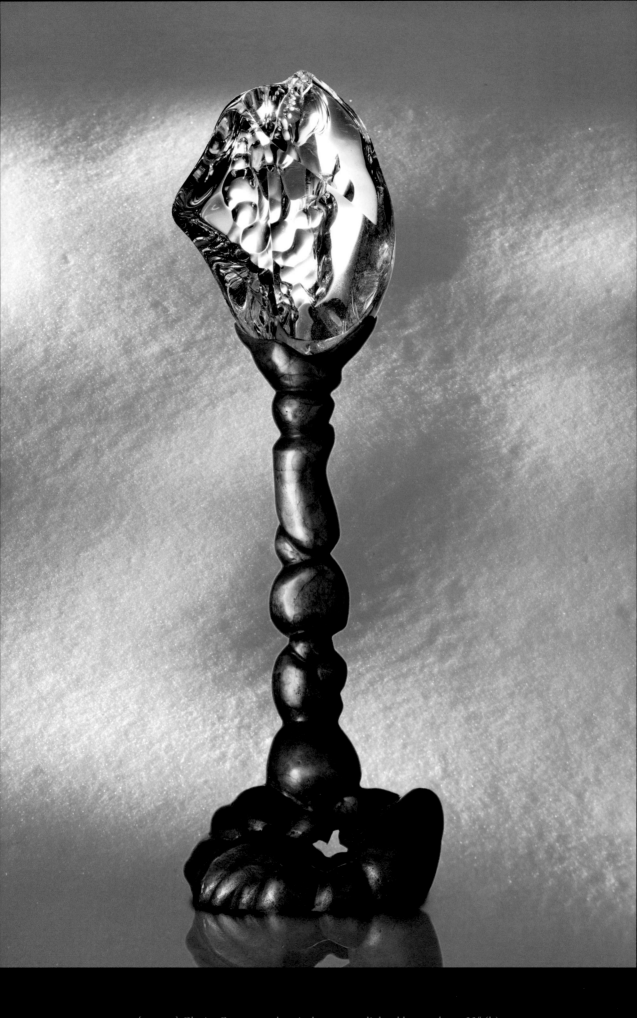

[ABOVE] *Glacier Cave*, carved optical quartz on lighted bronze base, 23˝ (h)

[OPPOSITE LEFT & RIGHT] Eddy repelling Cerebus Moulin, Pure Imagination Cave

GLACIAL CHANGE

I was invited by my friends Barb Williams and Eddy Cartaya to accompany an expedition to newly discovered glacier caves on Mt. Hood's Sandy Glacier; the trailhead is about a three-hour drive from my home in Central Oregon. The expedition was organized to document the dazzling underbelly of this ancient glacier as it forms, melts, re-forms, and changes. The team included cavers, climbers, geologists, glaciologists, and other scientists. I don't fit any of those descriptions; I'm just a tourist hanging out with people who have one foot firmly rooted in this reality and one that's dangling over the lunatic fringe.

The climb to the glacier was arduous, as I expected. Once at higher elevation and after the trail ended, I became acutely aware that everything below, above, and around me was moving. This sensation was amped by the fact that life on a mountain exists at a vertical pitch, and the relentless gravitational drag is merciless. Slippery undergrowth led to shifting and sliding boulder fields, followed by ice floes covered by oozing mud flows; all the while, I danced from purchase to foothold, not wanting to linger too long on the perpetually shifting crush of this warming season. As I took a moment to steady my body, I became aware of a bouncing boulder, its crashes echoing in the massive amphitheater. Finally reaching the sloping glacier anchored my appreciation of solid ground, if you can call standing on a mass of ice "solid." I kicked my boot into the sun-softened surface, finding the sense of stability that had eluded me for hours.

rity the hard ice conveyed could give way in a crushing collapse of this inner world, a phenomenon that occurs with regularity during this warmer time of year.

With my guides, Brent McGregor and Kara Mickaelson, we climbed our way through a broken ice field. To enter the icy mouth of the Pure Imagination Cave, I skidded down a frozen shoot to avoid randomly falling rocks dropping from the cave's open lips.

Once inside, my eyes began adjusting to darkness as they fixed on the boulder floor and then gazed up at the cup-patterned concave icy dome above. Using my headlamp to survey the ceiling immediately above me, I looked for rocks of all sizes that over years had bored their way from the top of the glacier 150 feet above to the bottom of the inner ice ceiling of the cave. These rocks would periodically free-fall 30 feet to the bouldered riverbed below. Car-size ice masses that we climbed over and around had, until recently, been side walls or the cave ceiling. Brent pointed out that there was a moulin, an opening up-mountain at the top of the cave, as well as the opening we had entered at the bottom.

In many ways the feeling of being deep under the glacier was akin to the feelings I have had in crystal caves. Only instead of hot, dense South American oxygen, there was a constant high elevation chill blowing through this wind tunnel.

I observed that the glacial ceiling was composed of different kinds of ice: most was milky and translucent, with pockets of large boulder-size formations that were harder

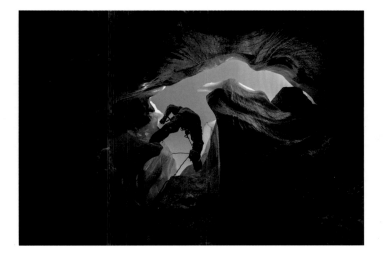

Upon seeing the ice cave entrance, I swallowed a nervous chuckle as I grasped the defiance of gravity that happened as these explorers were excavating. To be the first to enter the frozen tombs must have been chilling, on all levels, knowing that at any moment the sense of secu-

looking and transparent. They contained a few floating, wispy veils composed of air bubbles. They looked like large blocks of transparent quartz, triggering my creative lobes to leap into action as I began to carve these crystalline blocks with my imagination. And I was reminded of

the European scientists of the 1800s who concluded, with the scientific certainty of their time, that quartz crystals found in the Swiss Alps were super-frozen ice, frozen so rock-hard as to permanently retain their solid crystalline structure. Modern science has since confirmed that crystal mineral growth occurs in a fundamentally opposite fashion: they form as a result of intense heat, pressure, and exotic chemical combinations.

As was the case for scientists of the 1800s, it is a human proclivity to invent beliefs to fill the void of logic, to provide meaning to our limited understanding of the enormities of life. Standing beneath the massive melting glacier, I took a moment to wonder how solid is the footing of my current beliefs. How much of what I think I know is merely a sheet of ice providing a temporary slippery footing of logic on which to justify a fragile existence? And I realized that understanding the glacier, like understanding the complexities of life, gives a fleeting sense of permanence and knowing that inevitably melts into the realization that life is perpetual change. Nothing is really solid, the quantum physicist explains. The illusion that is solid matter is

in fact made up of subatomic particles, composed primarily of space. Ice melts; new ice forms to melt again. Beliefs gel, become solid, and eventually melt and change so that new, more fruitful beliefs can gel and solidify.

We ascended deeper up the vertical throat of the cave, found comfortable rock seats, turned off our head lamps, straddling the suspended silence. Within seconds the mystery of blackness grasped me like an impassioned dream, as I became part of the fabric of a Devic underworld, no longer able to rely on my patterned senses. The absolute darkness illuminated my imagination. I peered into the visual void, asking my eyes to identify something within the solid blackness. After my eyes began to recalibrate, I could see a light-shadow creeping toward me from below. I turned 180 degrees, pointing my gaze up-mountain to see a descending light slithering toward me from the moulin above. As my eyes adjusted to the purity of darkness, the shadows of light danced toward me, projected along the ice walls, spirits of a parallel reality. I surrendered to the fleeting moments of relentless change, becoming grounded in the Eternal.

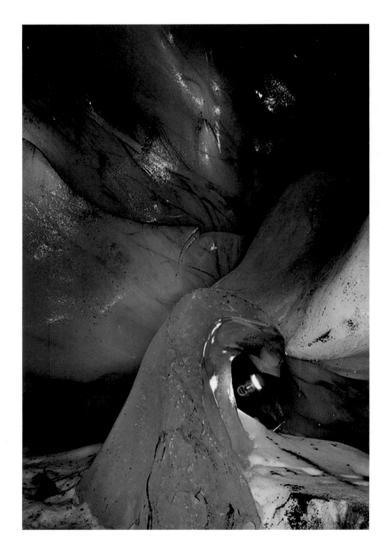 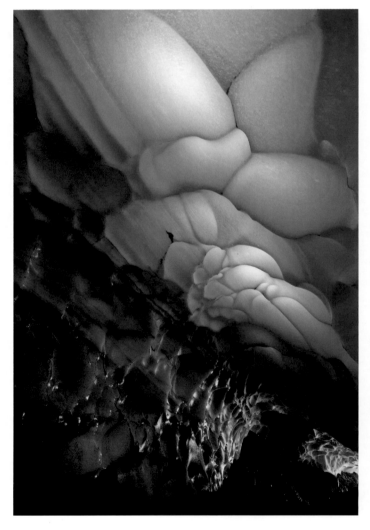

[ABOVE LEFT] Lawrence in Pure Imagination Cave behind naturally formed ice sculpture • [ABOVE RIGHT] Ceiling of glacier cave

[OPPOSITE] *Alluvial Grotto*, carved citrine quartz with black tourmaline on lighted bronze base, 9″ (h)

"This is temporary." ~ "STEPHEN HAWKING" in *The Theory of Everything*

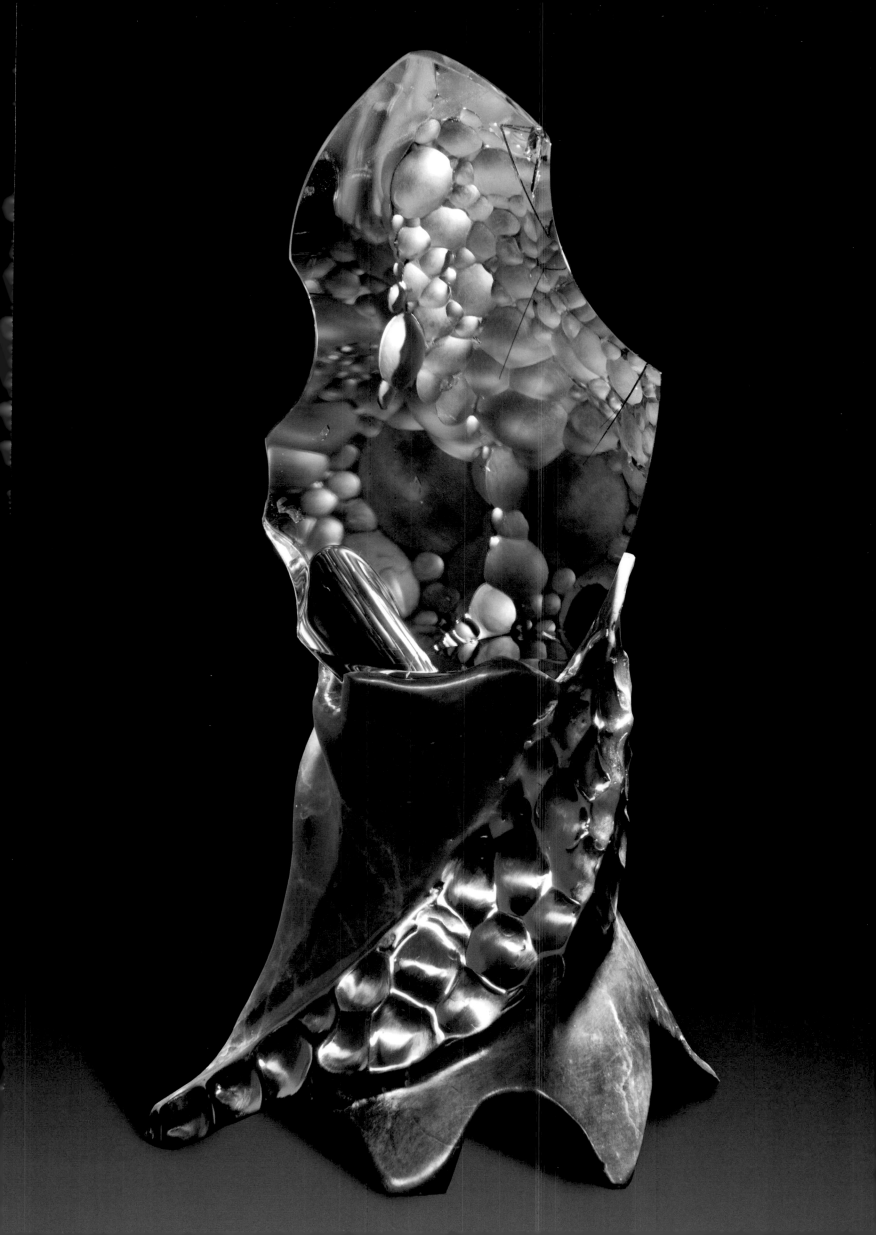

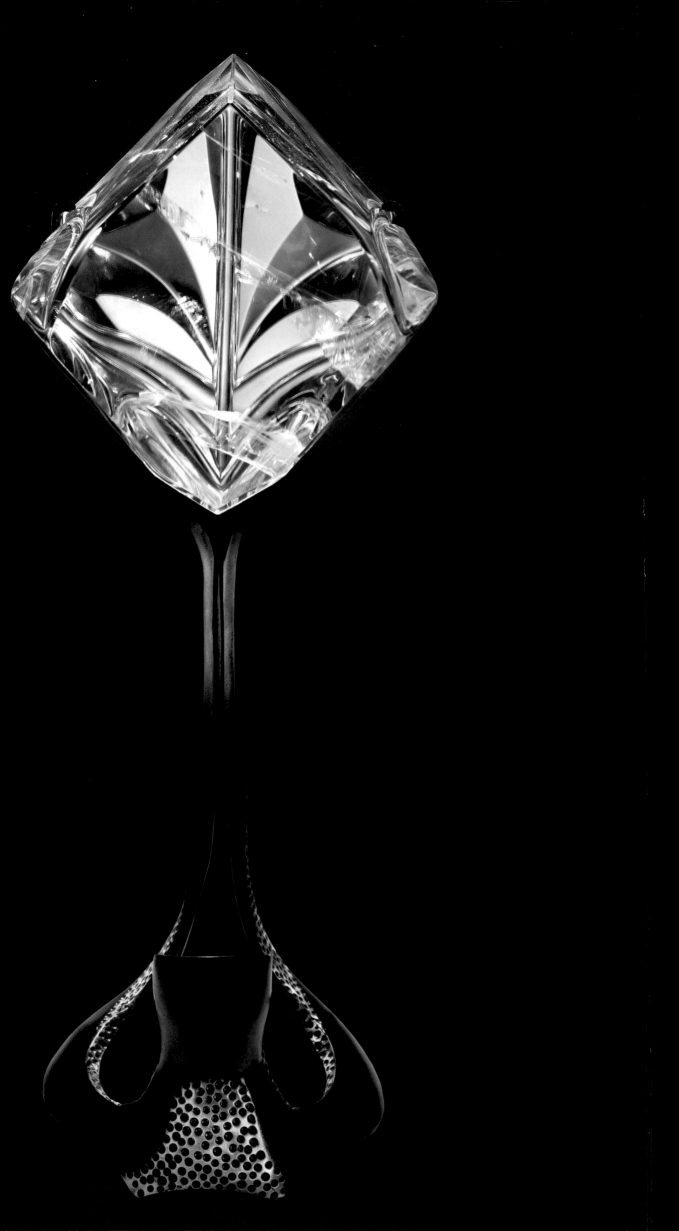

[ABOVE] Ice crystal, Aspen, Colorado

Art mimics patterns in Nature.

[OPPOSITE] *Winterblume*, carved clear quartz on lighted bronze base, 18″ (h)

"Excellence is never an accident. It is always the result of high intention,
sincere effort, and intelligent execution; it represents the wise choice
of many alternatives—choice, not chance, determines your destiny."
~ Attributed to ARISTOTLE

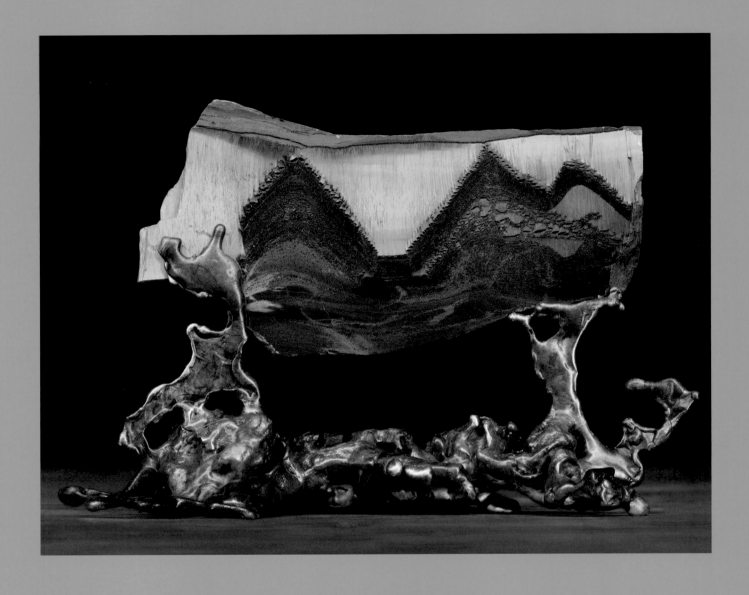

[ABOVE] *Three Sisters*, Australian tiger iron on bronze, 5″ (h)

"It is always the same with mountains. Once you have lived with
them for any length of time, you belong to them. There is no escape."
~ RUSKIN BOND, *Rain in the Mountains*

Every day I look out my studio window at the Three Sisters Mountains, part of the Cascade Range.

[OPPOSITE] *Gaudí's Nature*, 46-pound light citrine cathedral on light bronze base, 26.5″ (h)

"Form does not necessarily follow function". ~ Attributed to ANTONI GAUDÍ

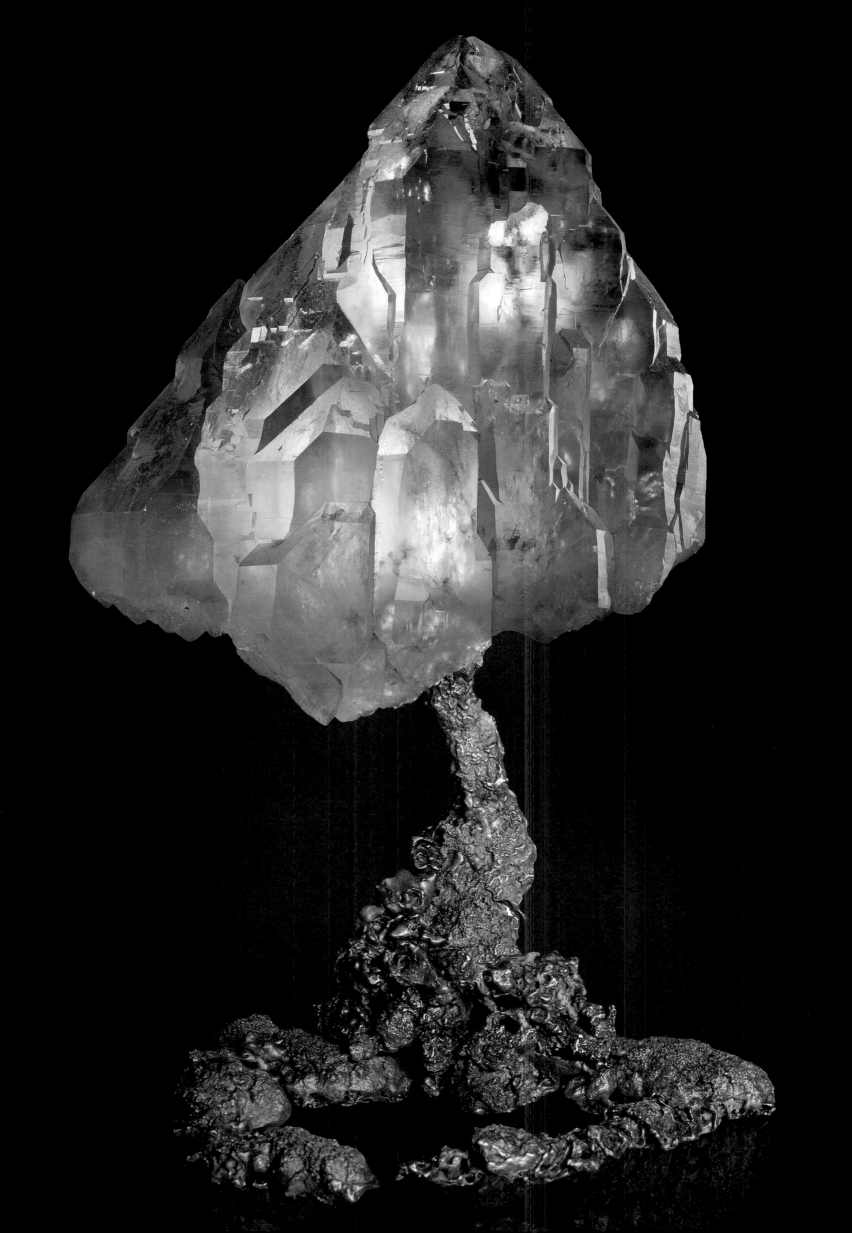

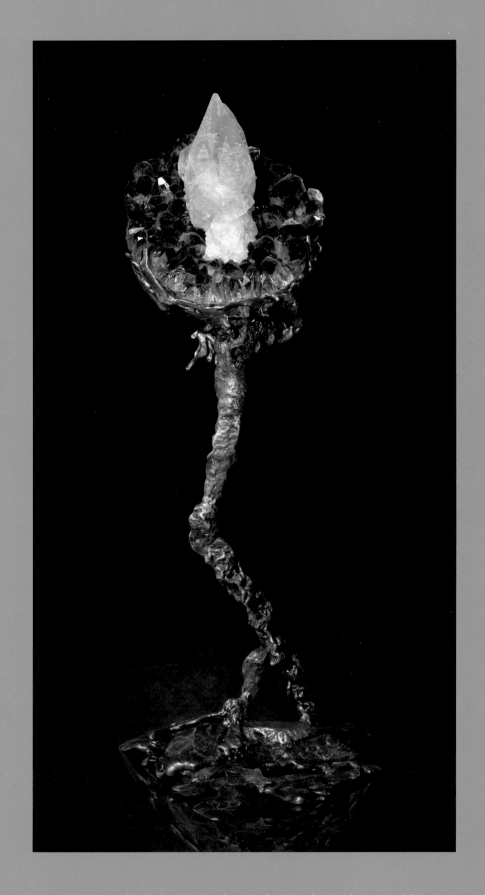

Faerie Realm, Uruguayan amethyst geode with calcite on bronze, 25″ (h)

"At some point in life the world's beauty becomes enough."
~ TONI MORRISON, *Tar Baby*

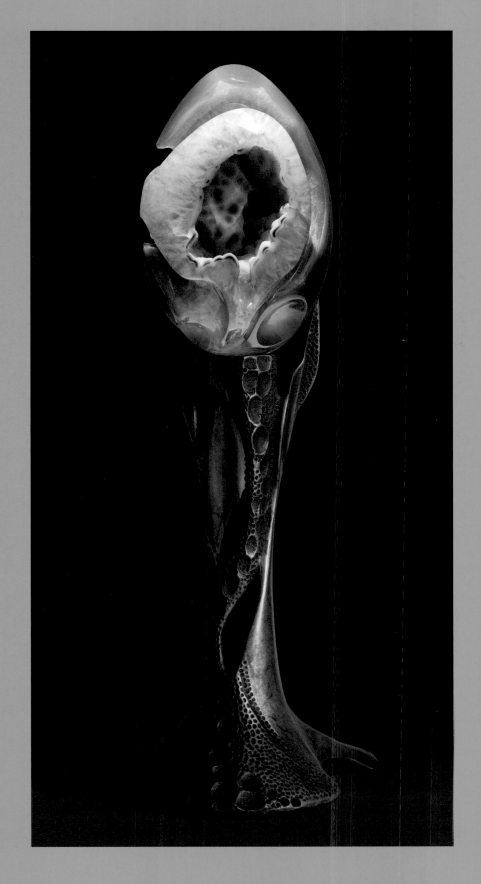

Blossoming, carved Brazilian druze agate on lighted bronze base, 18″ (h)

"A flower blossoms for its own joy."
~ Oscar Wilde, letter to Bernulf Clegg (1891)

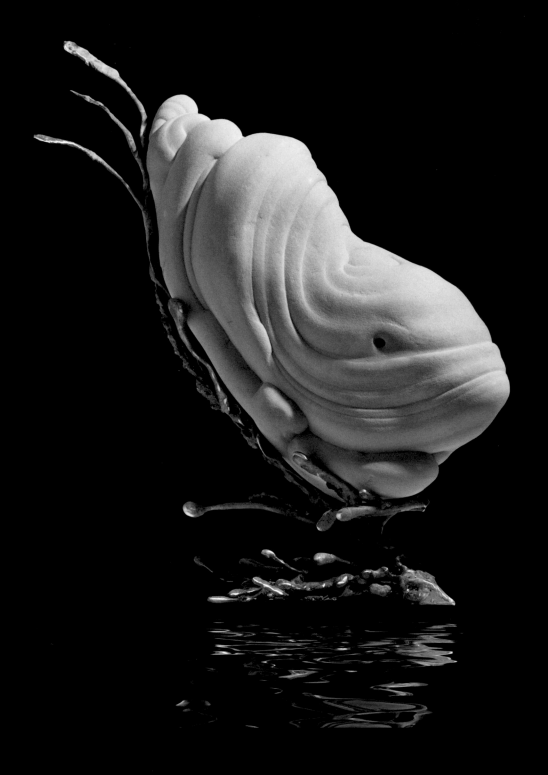

Whale, Fontainebleau concretion on bronze, 18″ (h)

"For most of history, man has had to fight Nature to survive; in this century he is beginning
to realize that, in order to survive, he must protect it . . . People protect what they love."

~ Jacques Yves Cousteau

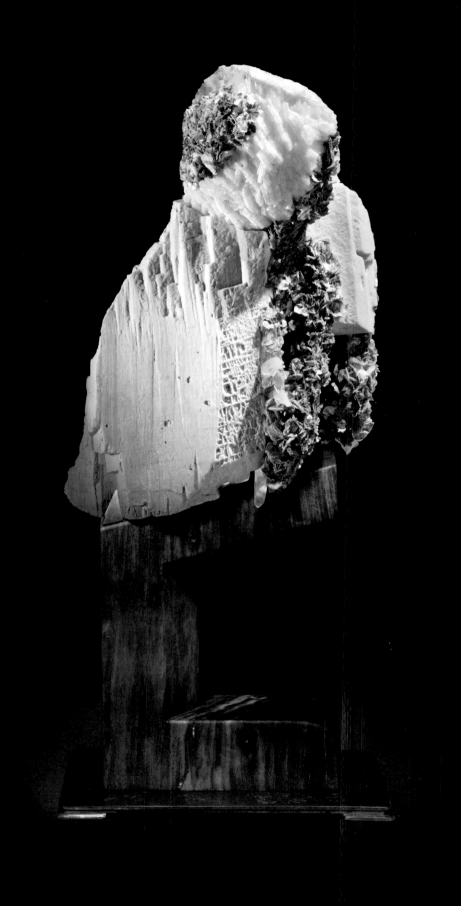

Snowy Owl; albite, clevelandite, mica, and quartz specimen on wood base, 18″ (h)

"This curious world we inhabit is more wonderful than convenient;
more beautiful than it is useful; it is more to be admired and enjoyed than used.
~ HENRY DAVID THOREAU, speech at Harvard (1837)

INDIGENOUS

Crystals are found in every region on Earth, and our collective fascination with them is a bond shared by all cultures. I was invited to Caracas, Venezuela, for a meeting with a group who proved eager to learn whatever knowledge I could impart to them about crystals, from mineralogy, art, and technological uses, as well as metaphysics and healing.

Crystals are transmitters of information from the mineral kingdom. And it was my job to translate some of this knowledge.

The few days we spent exploring the magic and wonder of crystals changed us. My wife, Sunni, and I felt like we had been with family we never knew existed. From science, mineralogy, art, and indigenous cultures, knowledge and unspoken mysteries of crystals are embedded in the collective psyche of humans from all over the world.

After the gathering, our host arranged for us to visit Canaima National Park in the south-east corner of Venezuela, bordering Guyana and Brazil. The park is the gateway to Salto Ángel (Angel Falls), the tallest waterfall on Earth.

The park can only be accessed by small plane, and the stewardship of the river system of this Earth treasure is managed by the indigenous Pemon Indians. We stayed on the banks of the roaring Gauja River and were awakened by our Pemon guide at 4:00 AM. We climbed in his log dugout canoe and pushed off at dawn to make our way 60 miles up the Gauja to Angel Falls. We floated by seemingly endless towering columnar rock plateaus rising vertically from the shore. I was entranced, as stories of the mythical legend of the crystal cities of Lemuria filled my imagination. The Crystal Cities were temples of learning and healing and could only be accessed by teleportation. You knew you belonged in the Crystal City if you had the ability to teleport your way from the bottom hundreds of feet up to the top. If you, in fact, teleported and found yourself on top, you had demonstrated your readiness to learn the mystical teachings available there.

Being in the overpowering beauty of the river and jungle allowed us to slip between the confines of time and space. When we finally grabbed the shore, we tied our canoe to a log on the bank and walked a short distance toward the impenetrable jungle. There a ribbon of path lay opened and quickly disappeared in a woven mass of vines and trees. As we stepped over roots, rocks, and wet black soil, the jungle was a beating heart with emotive presence. Here the Earth loves herself. Being in a remote, undisturbed vortex of beauty is where the world of normal ends, and a magical encounter and foray into the heart of Nature begins.

Our indigenous guide, Mamba, lives on the edge of the jungle and speaks five languages—six if you include speaking the langue of the Nature spirits.

At the end of the path, and after hours of hiking, the sky opened to the roaring splendor of Angel Falls. I bouldered around the bottom of the pounding fall and swam in a pristine pool below. To locate the top of the falls, I leaned backwards, pointing my eyes straight up. At the top of the water, I saw a plateau of stone, formed like a medieval fortress. The entire water source comes from rain that drenches the cliffs in an unending cycle, as if the gods pour water into clouds that hover on the top of the cliffs. They fill and overflow, and the water free-falls 3,212 feet to the bottom.

I sat at the bottom and closed my eyes in hopes of teleporting to the top …

~

We reenter the cocoon of the jungle, heading back down to the river—eyes darting and dancing—navigating rocks, vines, and water, stepping, leaping, hopping. I am acutely aware of the Earth breathing; the jungle is my outer skin, and the presence of "wilder-ness" tells me we are not alone. As I look down to help my feet navigate the trail, faces began appearing, projecting from the mossy stones as we pass. I point one out to Mamba; he nods. Suddenly, it was hard to take a step without one of us encountering another face of a rock spirit and proclaiming its existence. Bound in excitement, we careen down the path. In a moment's hush, we were seized by the silence of the jungle. Mambo took my arm, looked into my eyes, and said, "When I walk alone, sometimes I stop and listen to the silence, and there are a thousand eyes watching me."

Mamba had invited me into his world, and the Nature spirits had invited us into theirs.

~

His craggy profile lay motionless amongst a stack of sleeping quartz chunks in my studio; a time-chiseled face of silence glistened as if newly minted. Nature's endless creativity had fashioned this crystal to emulate a face, perhaps millions of years before the first human evolved into being. Crystals, after all, are the original inorganic, indigenous life-forms of Earth.

My job is to see visions and transform them into substance. But the raw countenance embossed in the abstract contours of stone was more than an apparition. Sharing a

memory of ancestry, we had a destiny to fulfill, and he had waited interminably for his transfiguration.

Of course, time does not exist for an original fragment of Earth's crust.

I chuckled and wondered how an inanimate rock becomes a kindred spirit. How a dormant icy chunk of quartz is personified as an incarnate descendant. As my eyes studied the geology of his warn exterior, my mind was imagining who he could become, after I simply removed the superfluous material around it (as Michelangelo never said, but should have). If I had simply seen a chunk of stone I would not have seen him.

All life appears inanimate until one recognizes its play of consciousness. This alchemy of awareness breathes spirit into matter.

After our first encounter, I moved his crystal face to a shelf in the studio. It was my way of saying, "I know you are there, but I'm not quite ready to start our relationship." To work on and with this entity as it emerged, we would each have to be ready to spend intimate time together.

The day I awoke with his spirit inside, I knew we were ready to begin.

And now I was his muse, called into service to give new definition to an archetypal form, an artist's ritual.

The first time I spoke to a crystal, it seemed contrived, awkward. To my surprise it talked back. It was not so much that I could interpret words, but more that I heard what it was saying. We each communicate with minerals differently. Some see dirt or broken shards of lifeless disregard, while others hear the language of a distant relative and speak mineral fluently. I think most of us understand the universal language of beauty that we share.

I picked him up and examined his proportions. The swirl of curving textures, conchoidal patterns, pooling and flowing as if they were made of transparent hair, formed by the forces of geological heat and pressure as it congealed from a supersaturated liquid to a crystalline solid. His face was fixed and pronounced, with a nose and eye sockets, begging for more detail from my diamond carving tools. I emulated the role of creator, knowing that I was merely navigating the process of co-creation. We were going under the blade, carving a remembrance of the wisdom of ancestry.

He was perhaps from Lemuria, or maybe Atlan-tis, Samaria, or Mesopotamia, no doubt a storyteller with secrets that time had forgotten but imprinted in his brailled features.

How can you be a head without a body …?

In another part of the studio sat a beautiful red chunk of Arizona petrified wood, waiting to become a hard and noble torso. It was so fiercely hard that after weeks of working on it, I considered the unthinkable, giving up. It was wearing out my diamond tools and my patience. With Sunni's coaxing, I surrendered to persistence and continued grinding. Soon the body emerged. Over the red torso was the cloak of a softer white mineral. As I worked the white mineral down a fraction of a millimeter at a time, the red head of a horse emerged.

I knew the spirit world was at play.

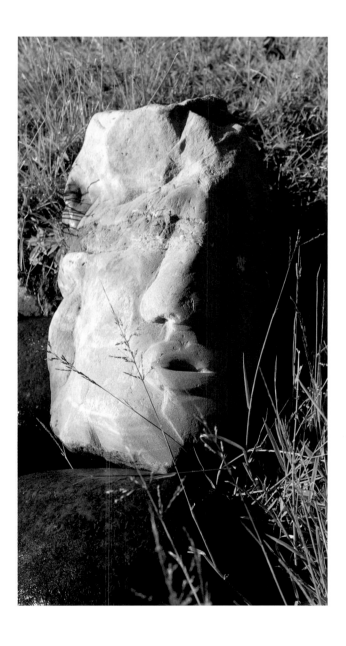

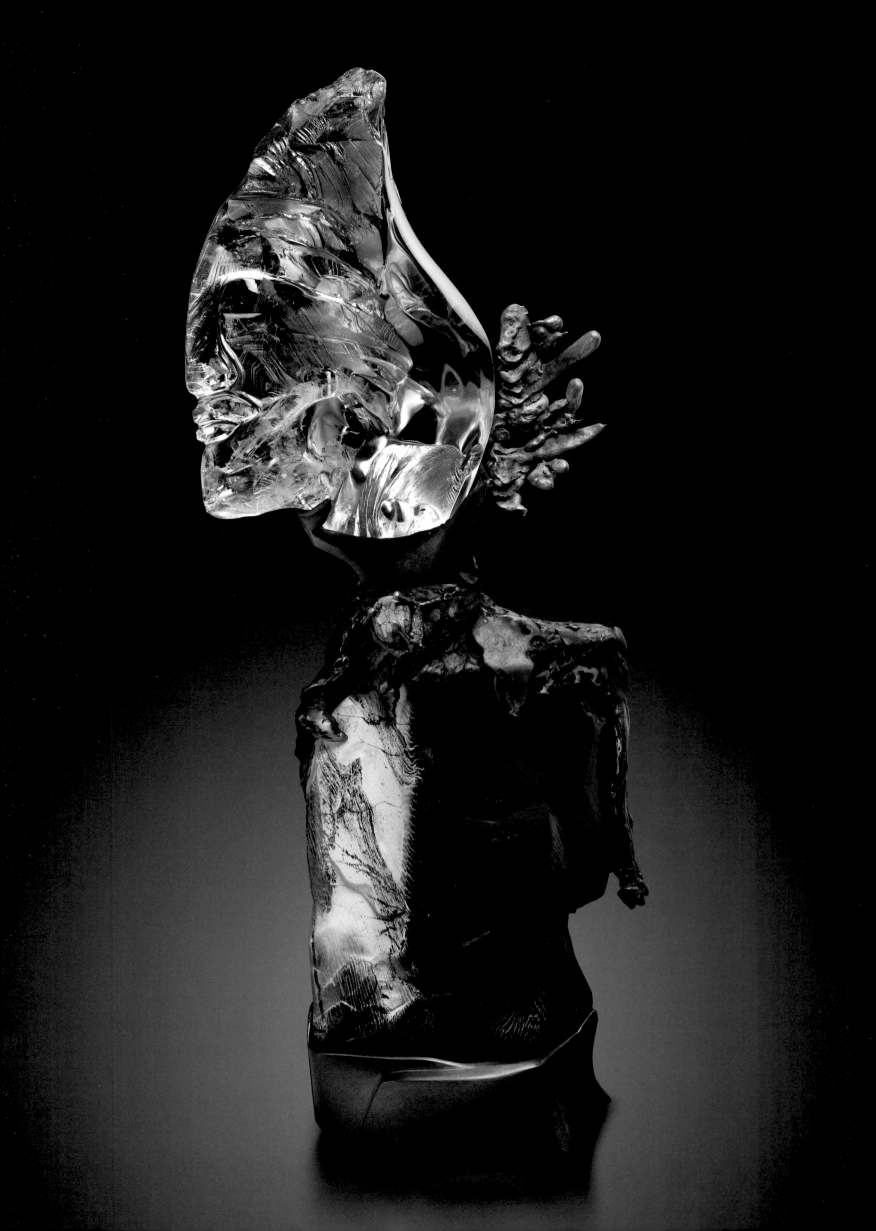

 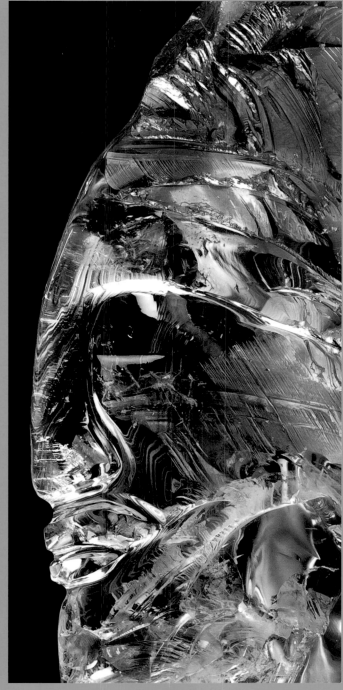

[ABOVE RIGHT] As I was carving the petrified wood blanket wrapped around the torso, a horse's head magically emerged.

[ABOVE LEFT] Carved optical quartz with numerous uniquely textured growth patterns

[OPPOSITE] *Indigenous*, carved optical quartz with natural textures, on carved petrified wood torso, with bronze, 22.5″ (h)

"It's no use going back to yesterday, because I was a different person then."
~ ALICE, in LEWIS CARROLL's *Alice's Adventures in Wonderland*

[2]
WISDOM

Micro-inclusion image of internal structure of Madagascar amethyst
crystal with trapped water bubble, millions of years old

Carved rose quartz, 4.5″ (h)

"How fragile we are."
~ STING

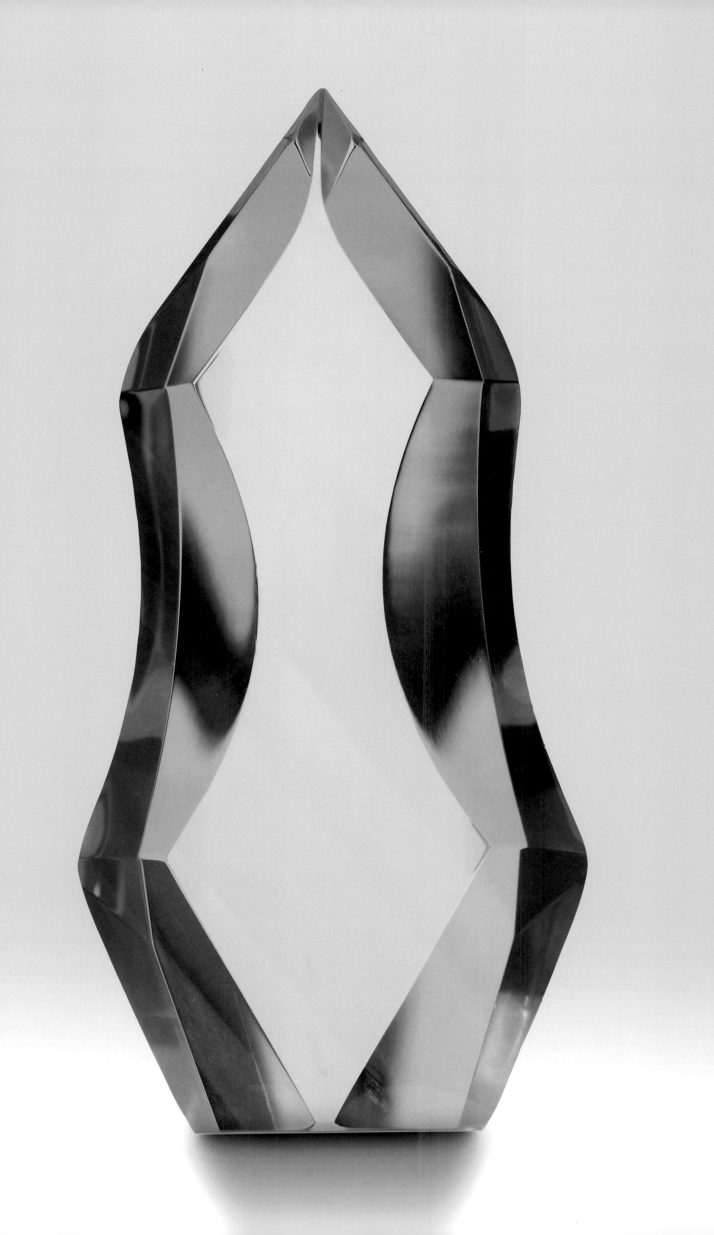

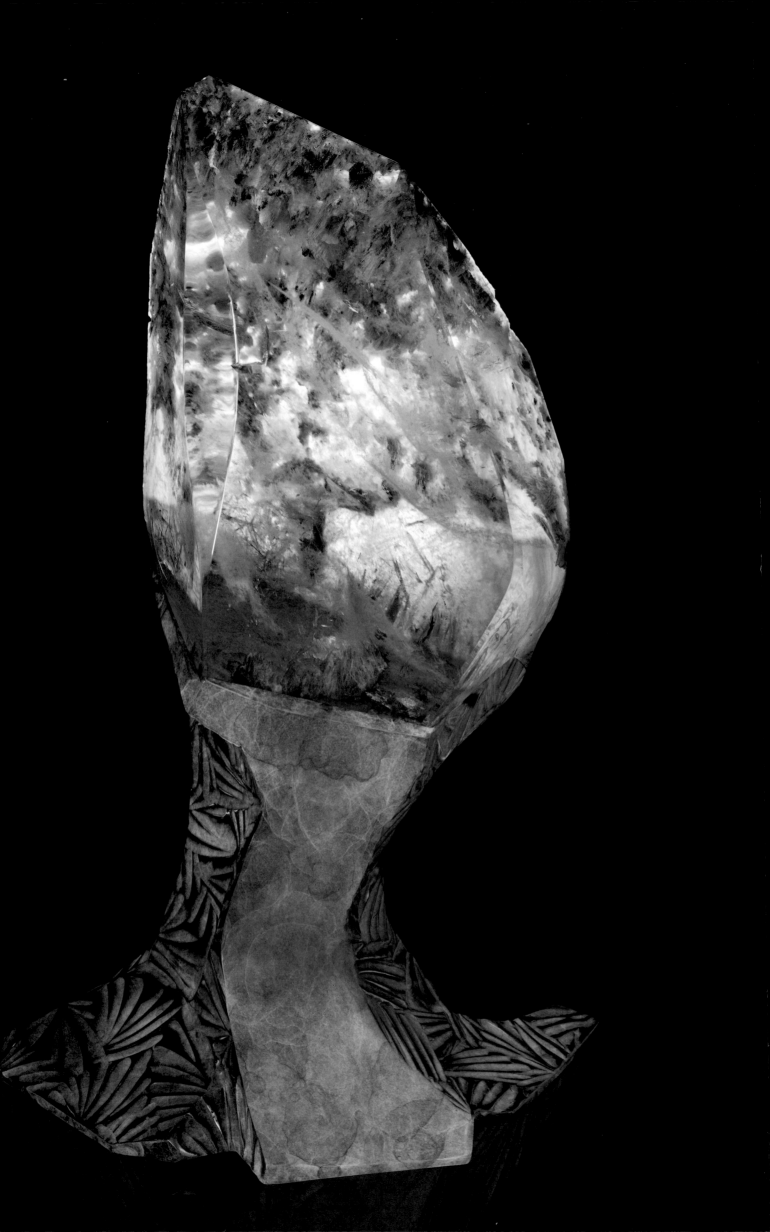

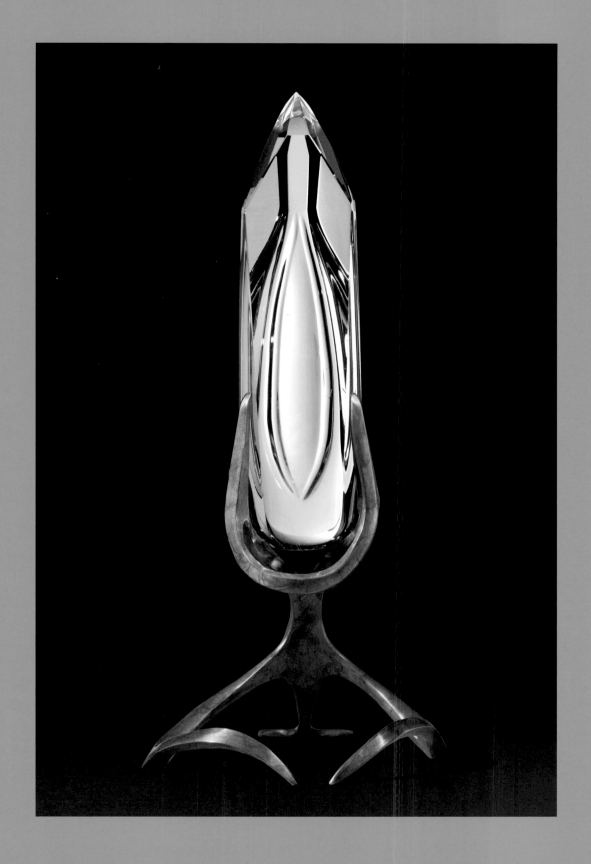

[ABOVE] *Praying Mantis*, carved clear quartz on bronze base, 9″ (h)

"Nothing changes till I do."
~ LAZARIS, channeled by JACH PURSEL

[OPPOSITE] *Tickled Pink*, montmorillonite in quartz on lighted bronze base, 19″ (h)

"Philosophy is a walk on the slippery rocks."
~ EDIE BRICKELL

Holy Smokes, smoky quartz generator on bronze, 84″ (h), Brazil

Life isn't about finding yourself. Life is about creating yourself.

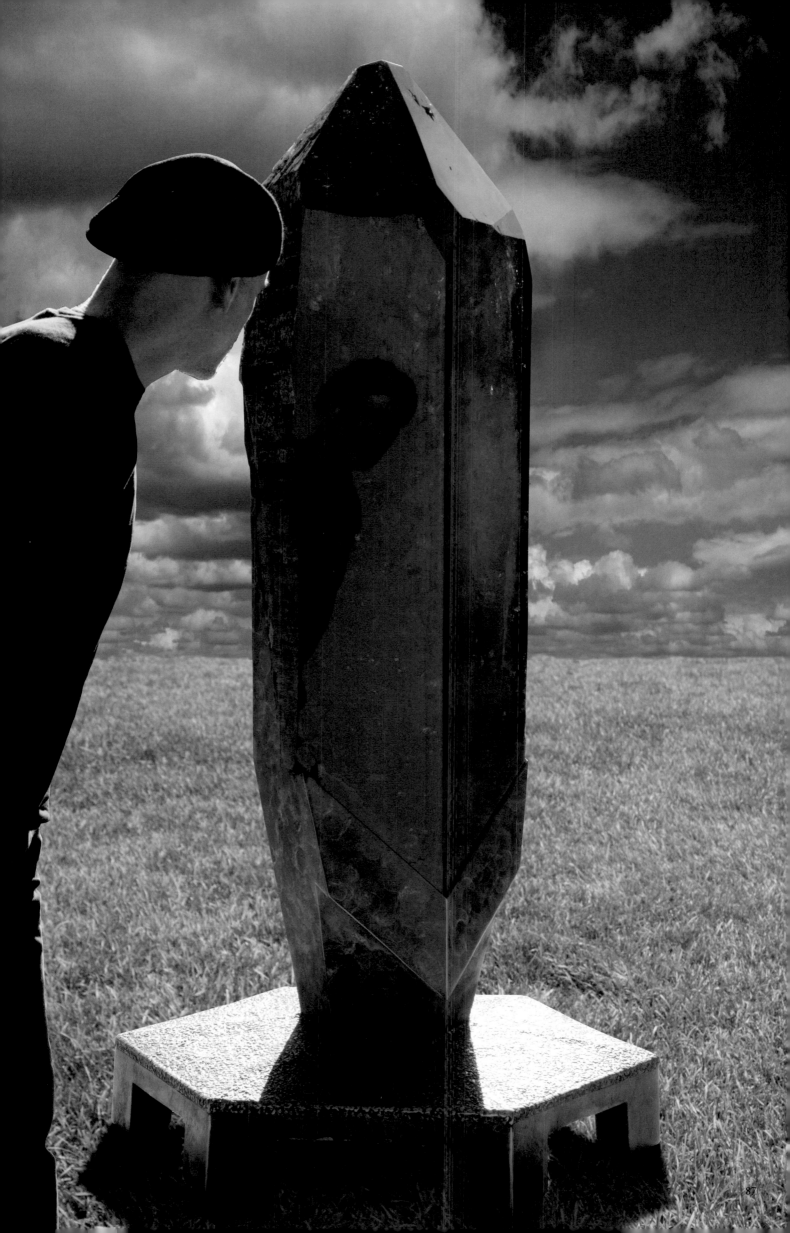

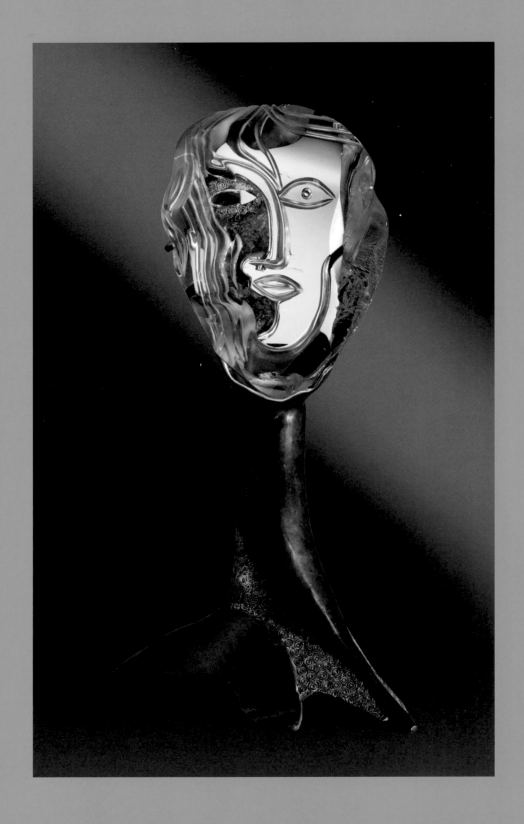

[ABOVE] *Calliope*, carved optical quartz on lighted bronze base, 18″ (h)

"One can have no smaller or greater mastery than mastery of oneself."
~ Attributed to LEONARDO DA VINCI

[OPPOSITE] *Crop Circles*, Madagascar red rutile in quartz on lighted bronze base, 32″ (h)

"You create your own reality." ~ WERNER ERHARD (and others)

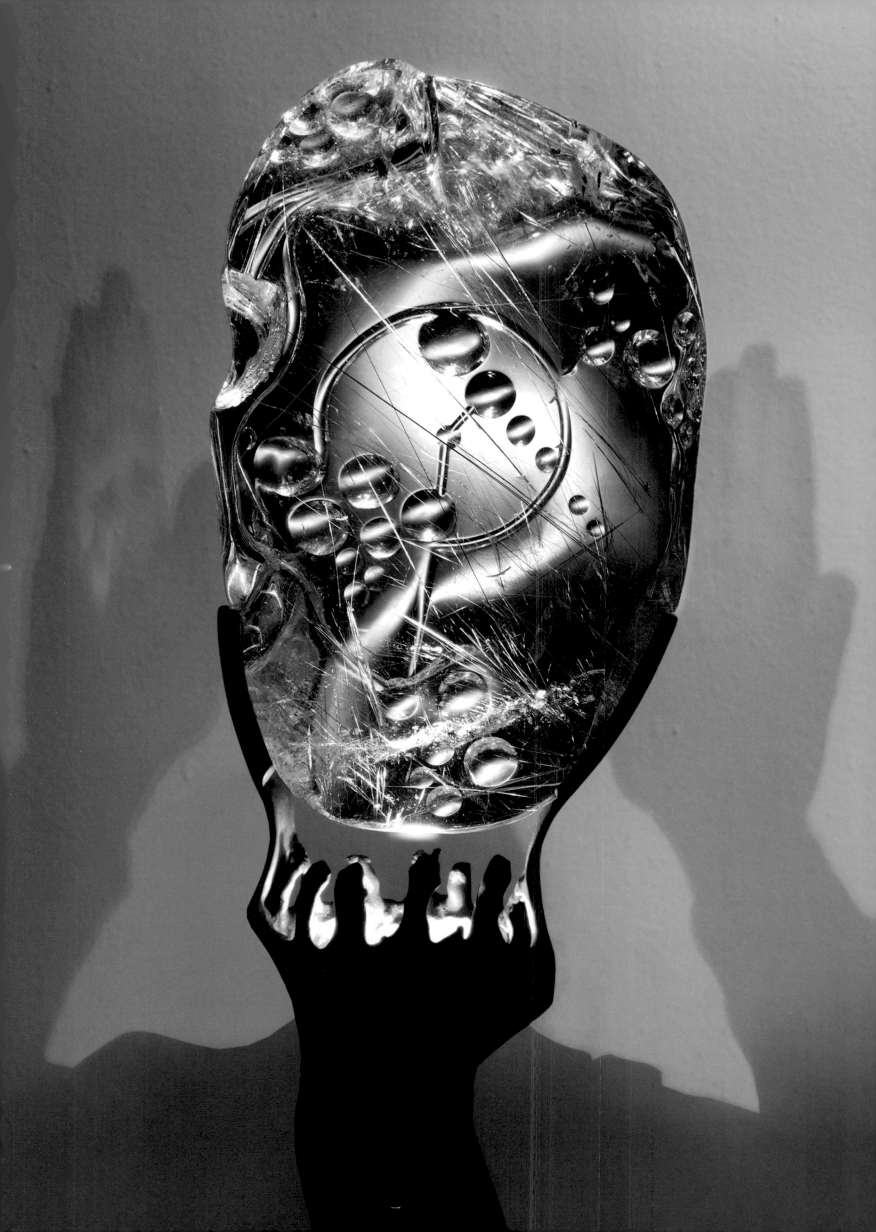

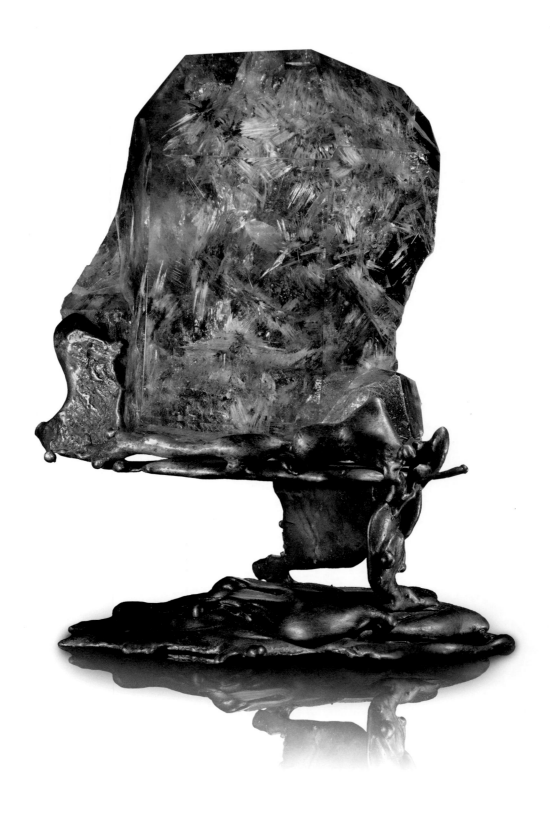

[ABOVE] *Bonsai*, Brazilian quartz crystal with rutilated star inclusions on bronze, 5.5″ (h)

[OPPOSITE] *Through the Veil*, Madagascar smoky quartz on lighted bronze base, 31″ (h)

"Beauty: something that brings about joy and peace simultaneously. Active and passive energy brought together. Exhilaration and serenity at the same moment. Beauty touches you and allows you to sense the eternal and immortal."

~ LAZARIS, channeled by JACH PURSEL

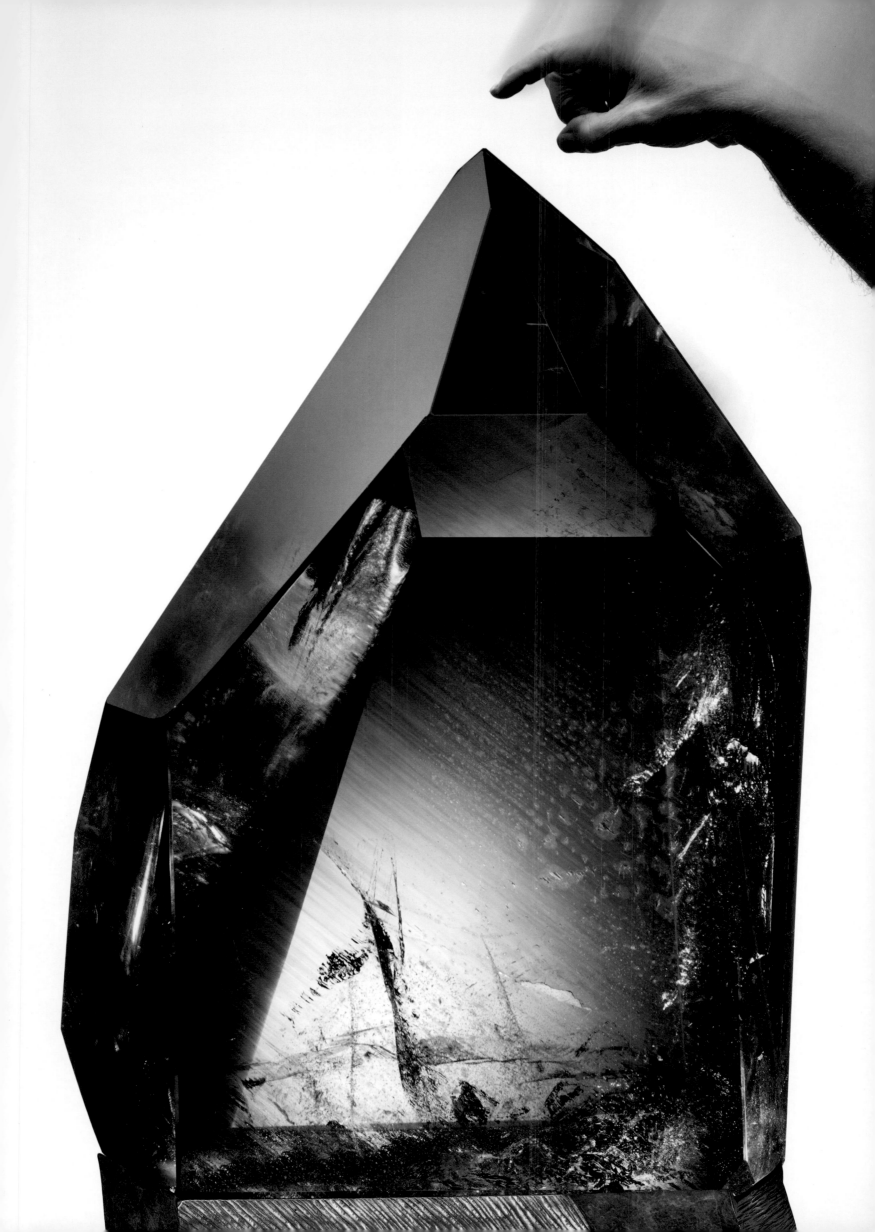

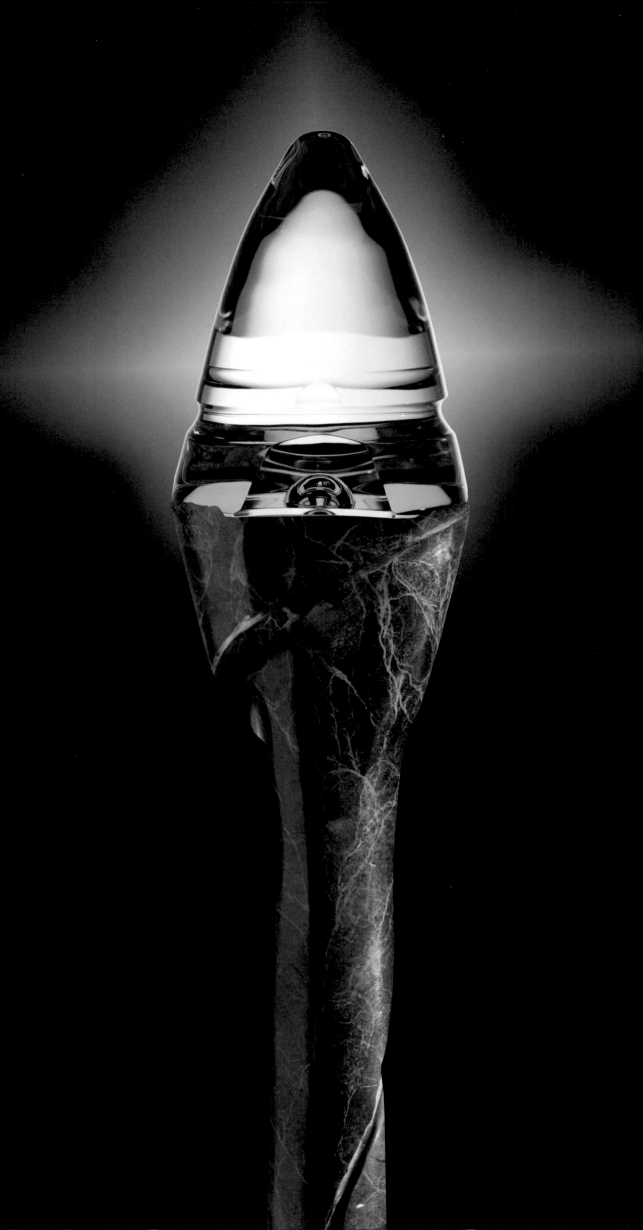

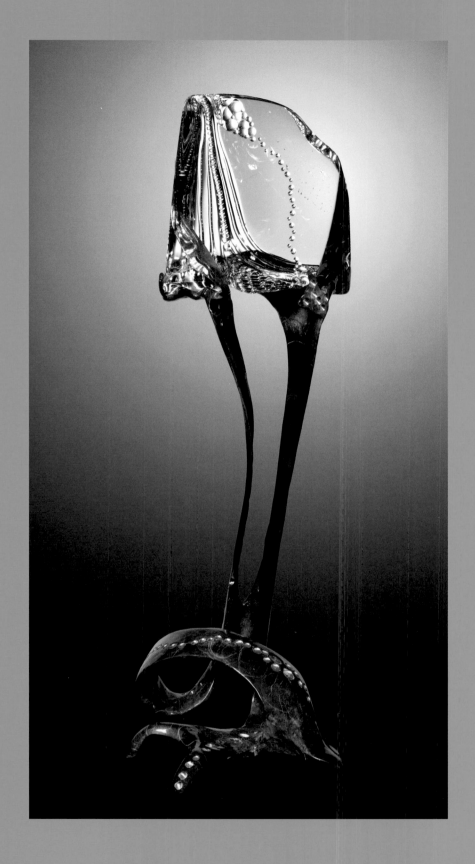

[ABOVE] *Neptune's Lair*, carved optical quartz on lighted bronze base, 22″ (h)

"The whole order of Nature evinces a progressive march towards a higher life."
~ HELENA BLAVATSKY, *The Secret Doctrine*

[OPPOSITE] *Luminous Flux*, carved quartz on lighted bronze base, 29″ (h)

"Enlightenment means taking full responsibility for your life."
~ Attributed to WILLIAM BLAKE

Secret from a Distant Star, clear quartz pentagonal star geometric carving on bronze, 16″ (h)

"Perfection is not attainable, but if we chase perfection we can catch excellence."
~ VINCE LOMBARDI

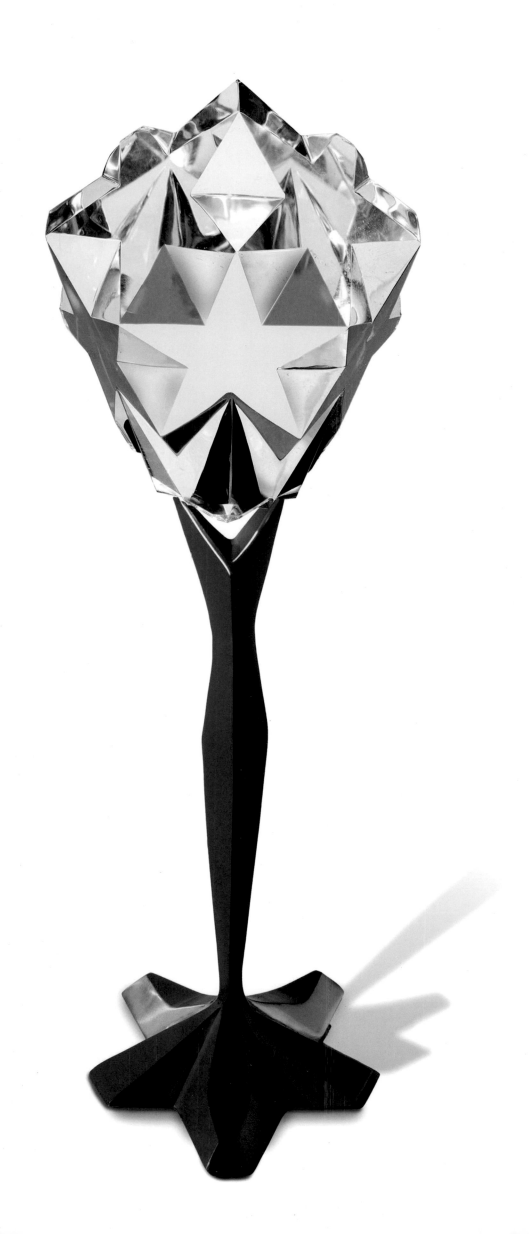

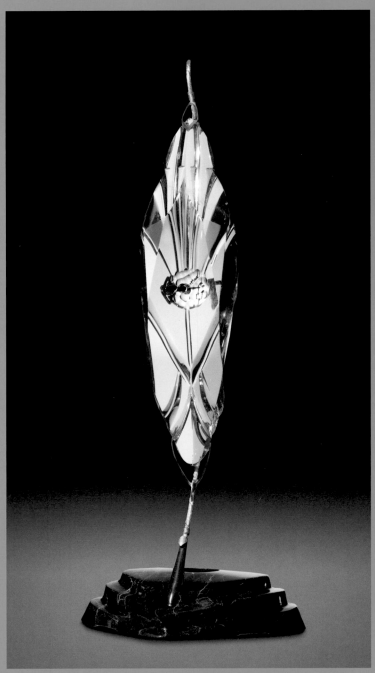 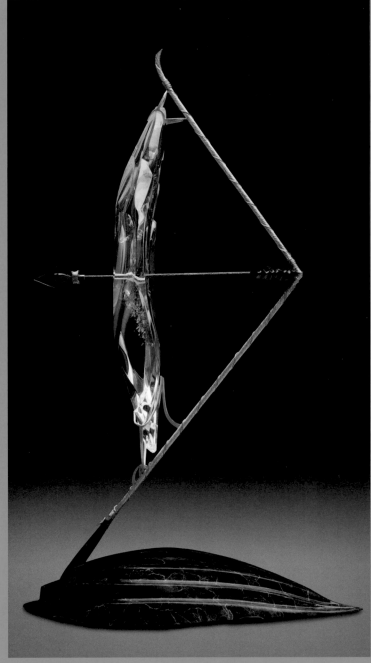

[ABOVE] *Divine Guidance*, carved optical quartz with silver bow, lapis, and ruby arrowhead on bronze base. Silver work by Mary Jo Weiss, 19˝ (h)

"The slow arrow of beauty. The most noble kind of beauty is that which does not carry us away suddenly, whose attacks are not violent or intoxicating, but rather the kind of beauty which infiltrates slowly, which we carry along with us almost unnoticed, and meet up with again in dreams; finally, after it has for a long time lain modestly in our heart, it takes complete possession of us, filling our eyes with tears, our hearts with longing. What do we long for when we see beauty? To be beautiful."
~ FRIEDRICH NIETZSCHE, *Human, All Too Human*

[OPPOSITE] *Inner Fire*, cinnabar crystal in double-terminated quartz, 3˝ (h)

"[The] whole [of] life is a search for beauty. But, when the beauty is found inside, the search ends and a beautiful journey begins."
~ HARSHIT WALIA, Indian writer

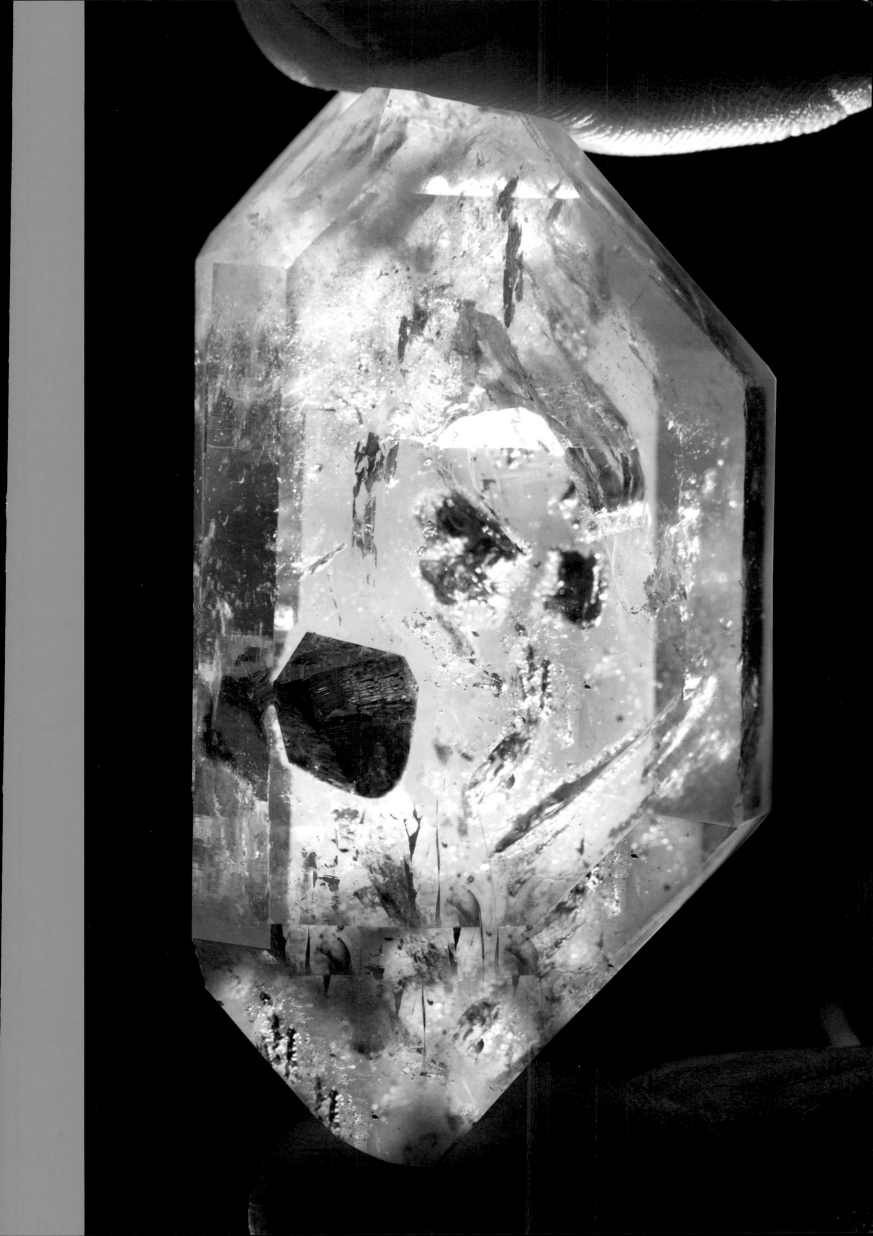

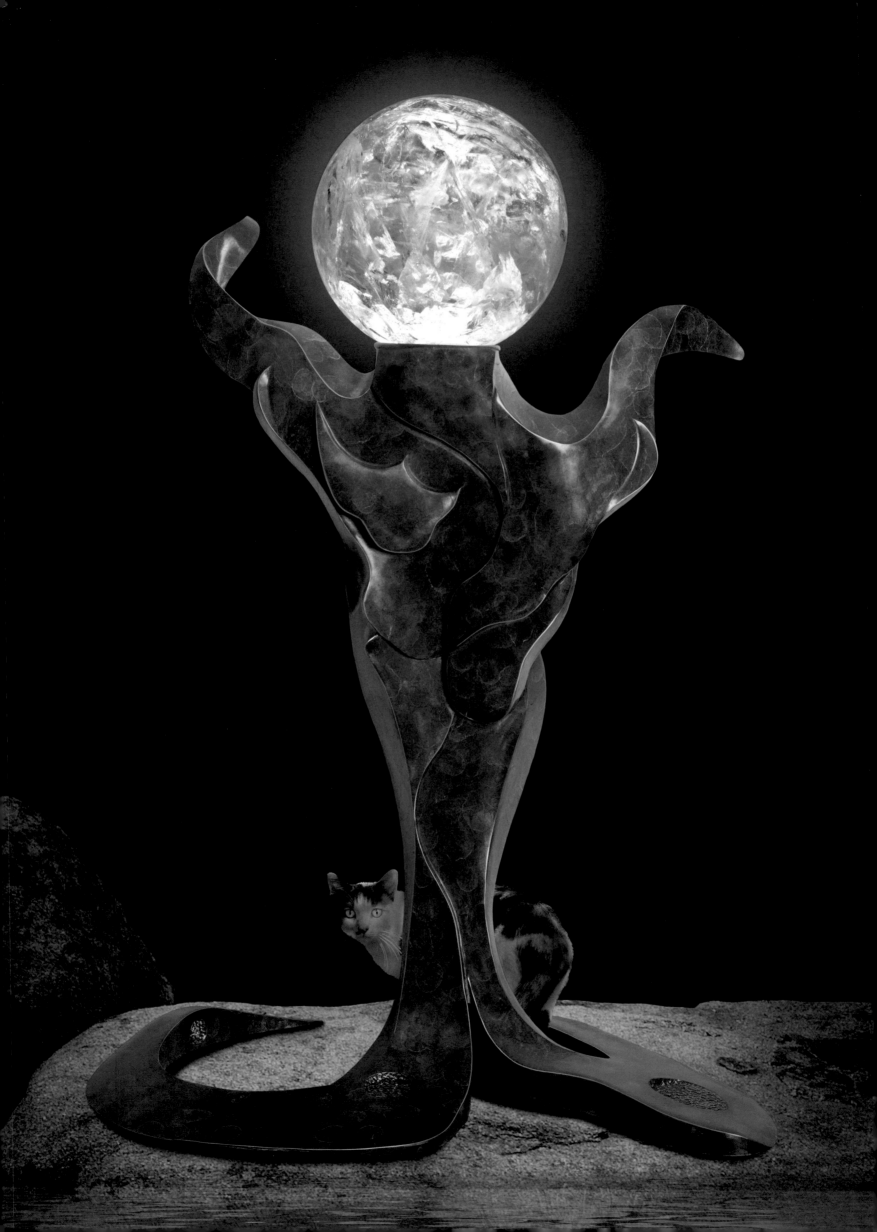

Water Spirit, 14″-diameter quartz sphere on bronze, 48″ (h)

"That pleasure which is at once the most pure, the most elevating and the
most intense, is derived, I maintain, from the contemplation of the Beautiful."

~ Edgar Allan Poe, "The Poetic Principle"

[ABOVE] *Changing Point of View*, carved optical quartz on lighted bronze base, 14″ (h)

"Sculpture occupies real space like we do …
you walk around it and relate to it almost as another person." ~ CHUCK CLOSE, artist

[OPPOSITE] 34-sided double terminated smoky crystal, 11″ (h)

"Stand still like the hummingbird."~ HENRY MILLER

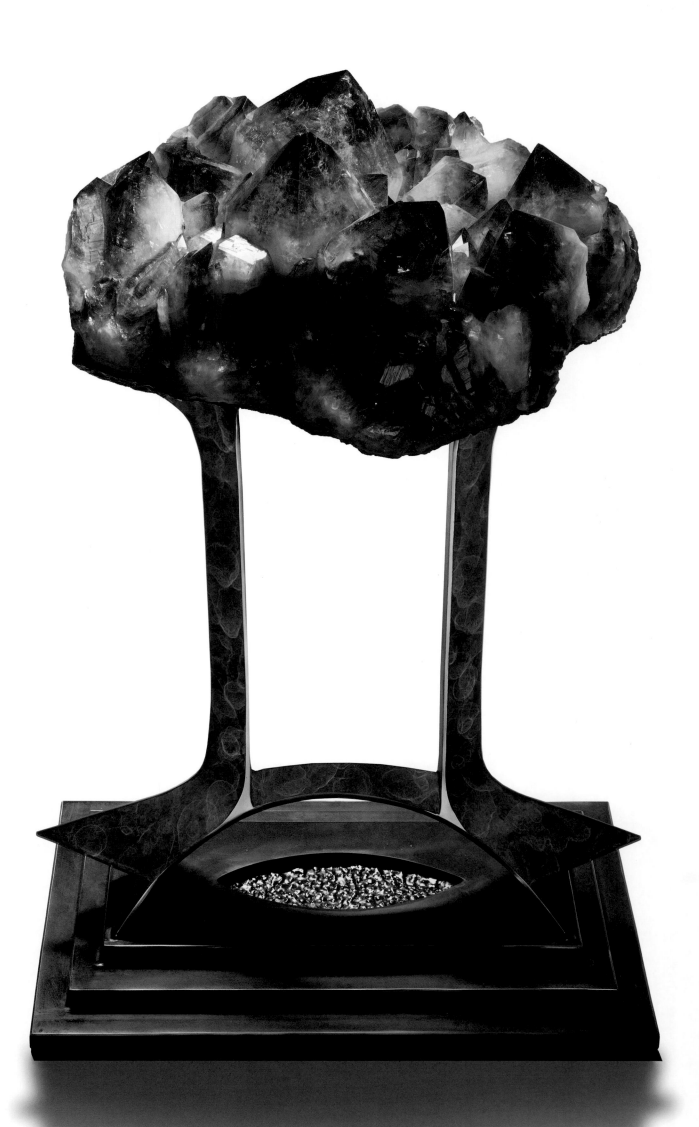

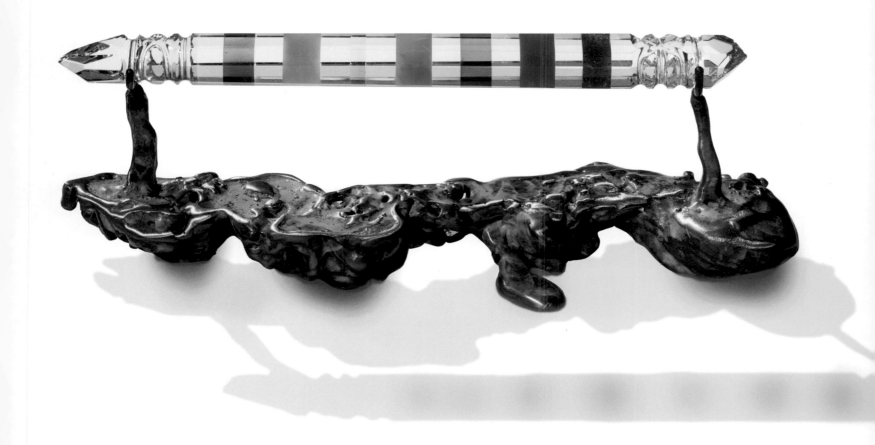

[ABOVE] *Spectrum*, carved quartz chakra totem: rose de France, amethyst, blue chalcedony,
aquamarine, chrysoprase, citrine, opal, tourmaline, 8.5″ (l)

"Vision without action is a daydream; action without a vision is a nightmare."

[OPPOSITE] *Zen Garden*, 64-pound amethyst cluster on bronze, 30″ (h)

"Two roads diverged in a wood and I took the one less traveled by,
and that has made all the difference."
~ ROBERT FROST, "The Road Not Taken"

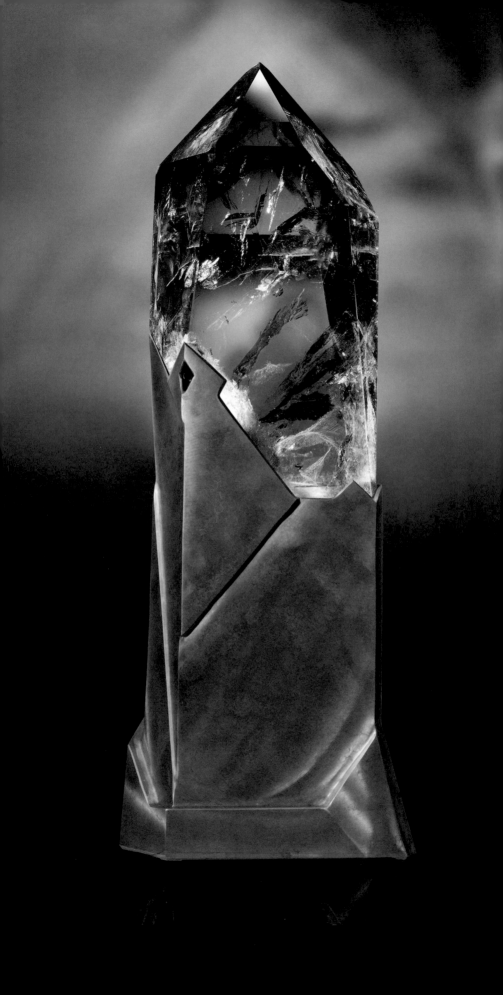

Mystic's Home, Brazilian smoky quartz on lighted bronze base, 30″ (h)

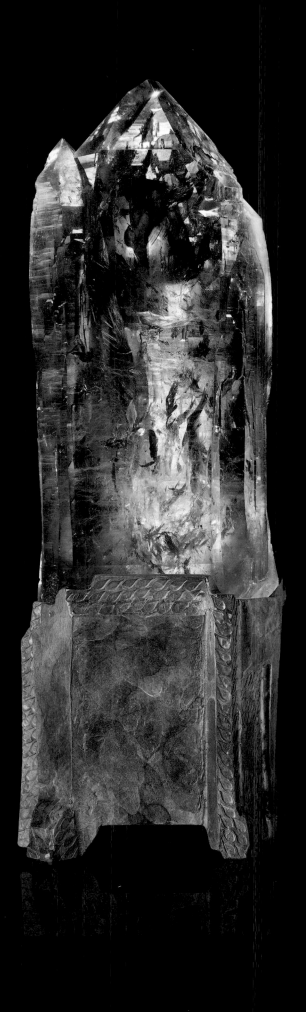

Night's Watch, smoky cathedral quartz on lighted bronze base, 23″ (h)

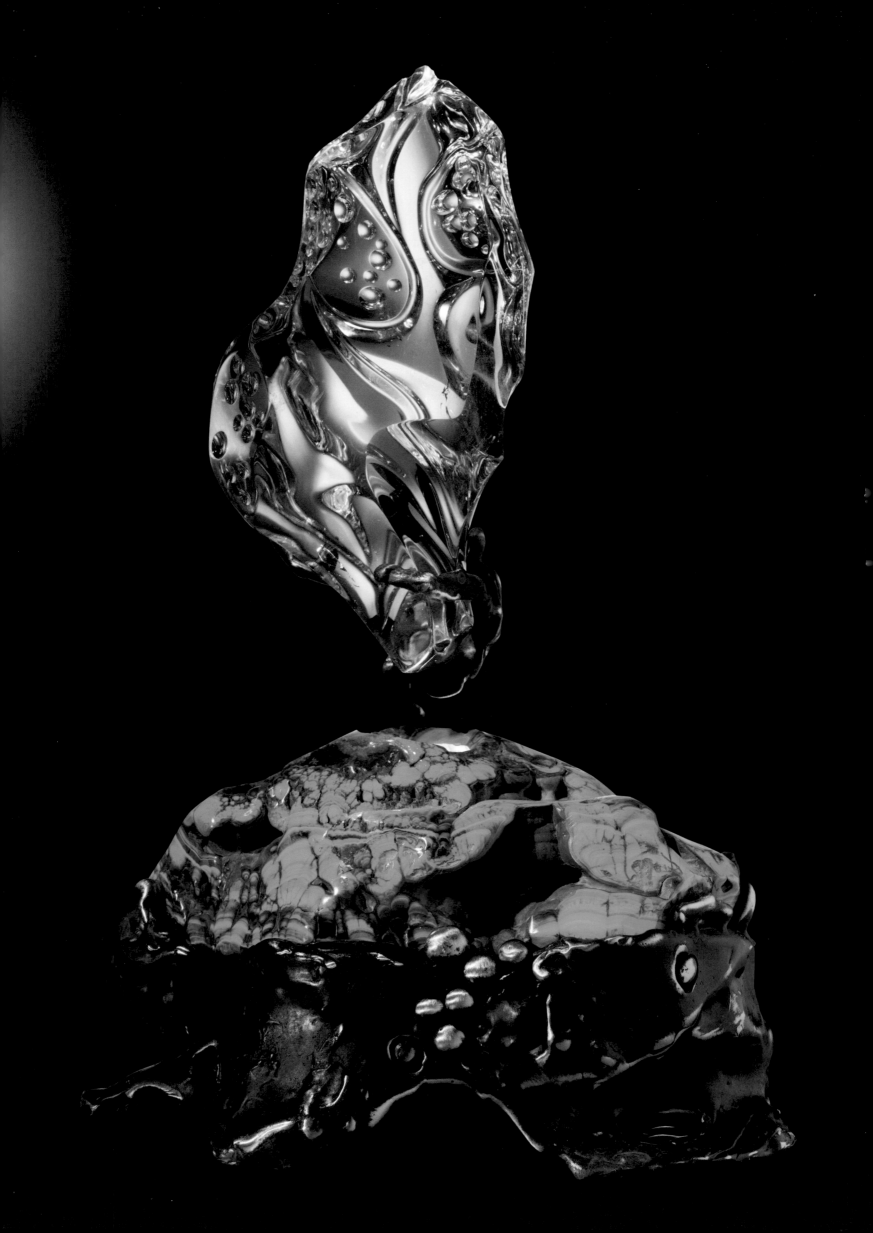

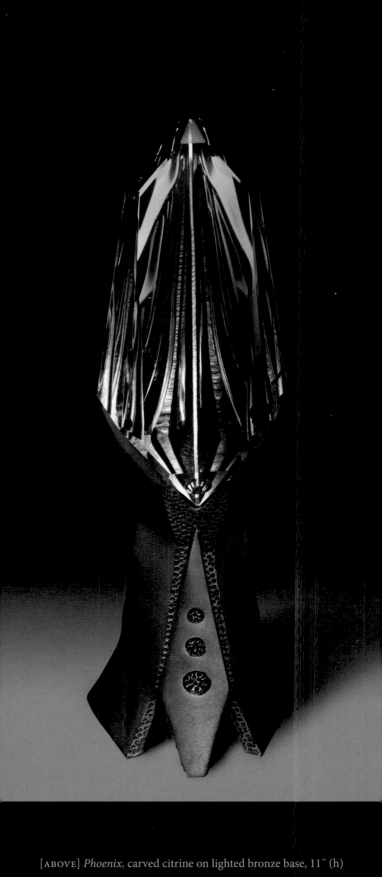

[ABOVE] *Phoenix*, carved citrine on lighted bronze base, 11″ (h)

Life is without meaning. You bring the meaning to it. The meaning of life is whatever you ascribe it to be. Being alive is the meaning.
~ JOSEPH CAMPBELL, *Reflections on the Art of Living*

[OPPOSITE] *Dancing on the Earth*, carved citrine on malachite and bronze, 13″ (h

"Some beautiful paths can't be discovered without getting lost."
~ EROL OZAN, author

WALK OF LIFE

After some research and a year of planning, my dear friend Franc and I decided to take a less traveled route of the famous pilgrimage Camino de Santiago on the north coast of Spain.

Thousands of people have walked the pilgrimage across Spain over the past thousand (or so) years, and there are many different routes and durations of travel on the Camino. We wanted to have the shared pilgrimage experience, but did not want to take the five to six weeks to do the extended journey. Ours was a nine-day trek covering about 150 miles. Long enough to have a meaningful experience, and not so long as to take on many of the extended hardships that accompany such a commitment. Our choice of routes proved to be a perfect match with our desires. We were fully engaged in the challenge, but were not overwhelmed by it, and thus had a meaningful, fun, and fulfilling journey.

For me, the Camino was a chance to separate, and to experience a part of the world I was unfamiliar with, following a traditional pilgrimage that I knew very little about. I considered myself a pilgrim in perpetuity and knew I could plug into the route as a self-proclaimed non-denominational seeker. The road is its own religion, and all gods and goddesses are welcome on the path. The task of a pilgrim is to seek, and also to find.

We walked day after day, looking for and following the sea-shell signposts guiding us through the Spanish countryside of ancient houses, Roman-built stone walls, small villages, and silence. I concluded that there is no better way to have a genuine, day-in-the-life experience of another culture than to use your feet to move across the topographical face of a rolling landscape in a foreign land. To breathe its air and see its geology, rocks, dirt, grasslands, flowers, stone walls, apple trees, cows, fences, coastal waters, streams, forests, stone houses, villages, dogs, cats, and horses, tasting its food, coffee, and the qualities that make it unique to the world. The ancient-faced crones sitting in the shade on the stoop, who seemed as if to have lived in the same stone house for centuries. And the quiet, clean expanses of seemingly endless moist farmland cut by a ribbon of road of which we were a part, if only in passing. We encountered other pilgrims along the way, speaking different languages, taking different routes on different timelines. Some made us wonder if they were from different realities, apparitions perhaps ...

When you are walking for days, thoughts dissipate, your chest rhythmically heaves, your legs striding, "endless and timeless" create a powerful elixir of connected disconnection.

After walking for a few hours one day, we reached the outskirts of a village and the last house on the edge of a forest into which we were about to descend. In the front of the ancient stone casa sat an old man with his barking dog on the other side of the fence. While Franc bent down to engage the small dog, using our limited language skills to interact with the old man, I heard the faint sound of music wafting from within the walls of the house. I strained to hear, and peered beyond the old wooden door into the ancient abode. I recognized a few notes and rhythms, before it hit me: Mark Knopfler (Dire Straits) singing "Walk of Life." And off we went down the trail.

Sandwiched before and after the walk we had the indescribable experience of visiting Antoni Gaudí's *La Sagrada Familia* in Barcelona. Being in this temple masterpiece reshuffled my sense of vision and commitment, of aesthetics, of notions of what is possible in art, sculpture, design, geometry, architecture, and human endeavor. I could have stayed outside the towering temple for hours marveling at the remarkable shapes, details, and storied carvings ascending for hundreds of feet. When I walked inside, I had the experience of being so small and insignificant while simultaneously feeling expansive and immense. A tiny speck of infinity ... Mind-altering doesn't describe the inability to describe it.

Because Gaudí was so committed to original forms in Nature, I figured he must have been aware of crystals with their naturally complex geometries, given the complexity of the geometries he created. I wandered through the museum below the temple and studied the inspiring original plaster models Gaudí created.

In the bottom corner of a small, out-of-the-way room, tucked in the back, was a broken piece of plaster, and pressed into it was a smoky quartz crystal.

The serendipity and mystery made my trip feel absolute ...

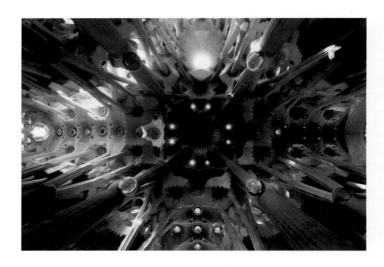

[ABOVE] The ceiling of *La Sagrada Familia* (Gaudí)

[OPPOSITE] *La Sagrada,* carved optical quartz on lighted bronze base, 14.5″ (h)

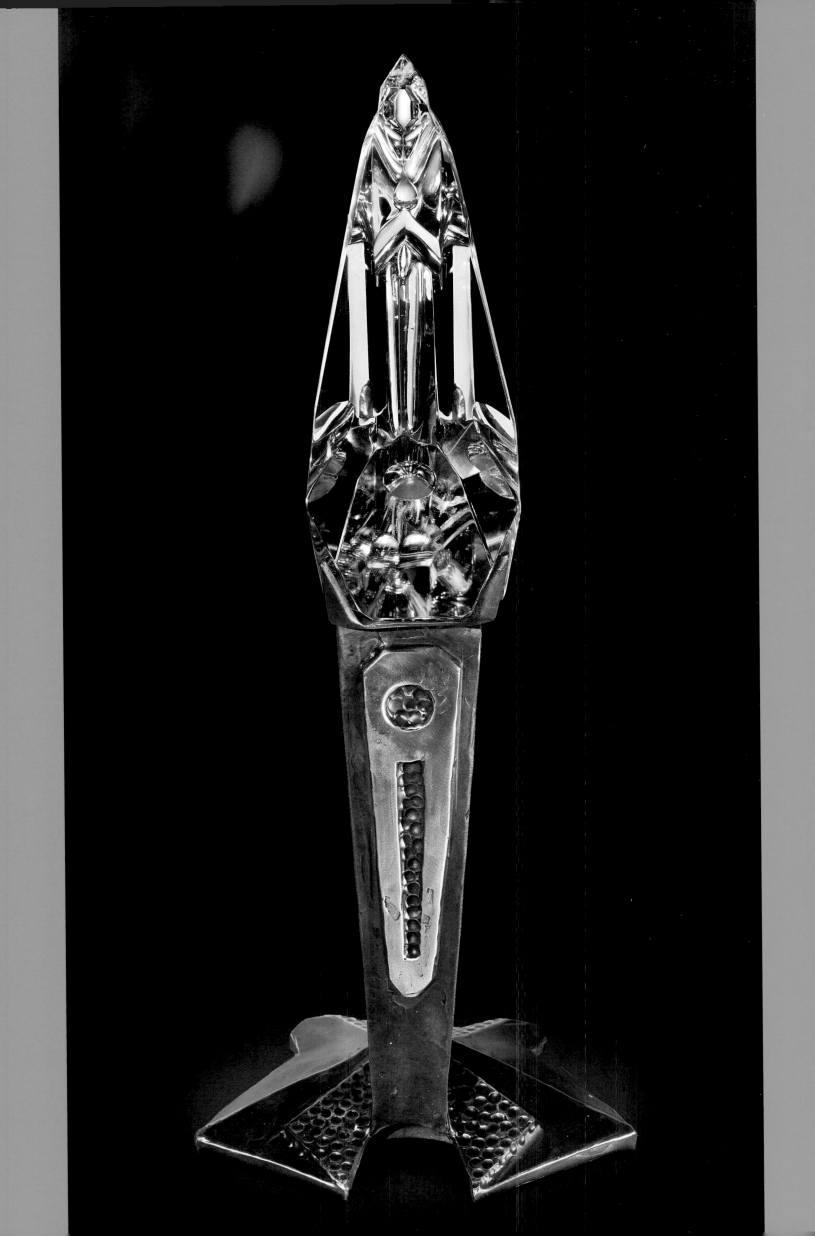

"The future creates the present against the backdrop of the past."

~ LAZARIS, channeled by JACH PURSEL

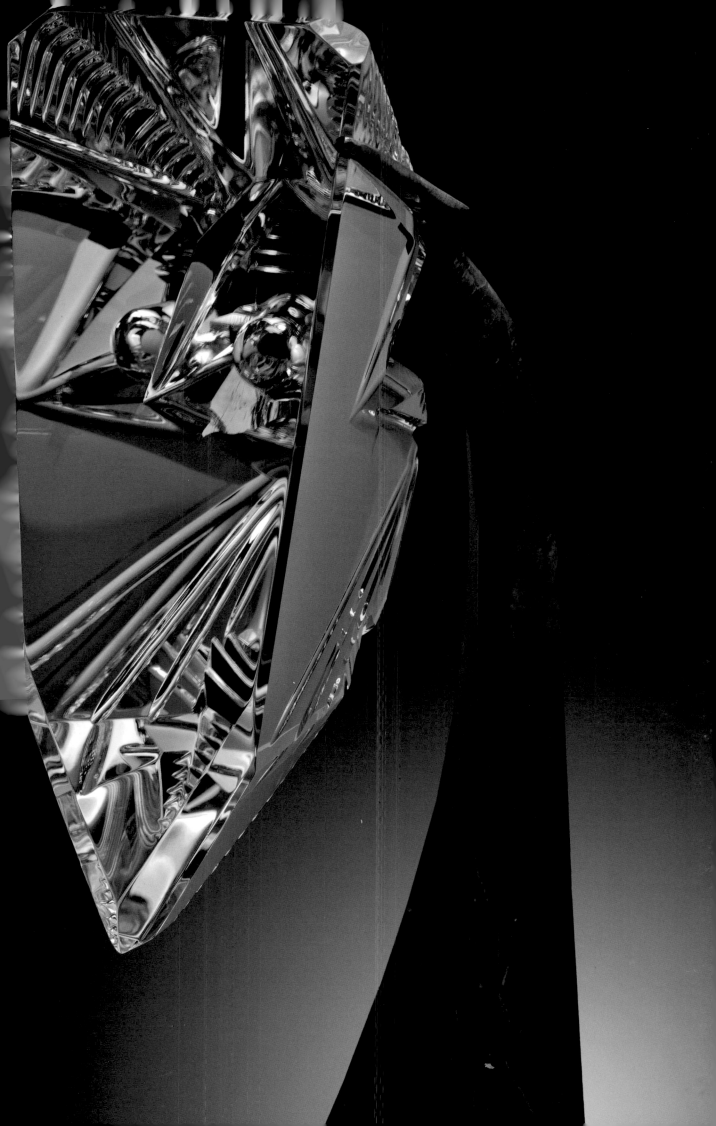

[ABOVE] *Spirit*, Brazilian quartz spar on bronze, 78″ (h)

'We do not want merely to see beauty … we want something else which can hardly be put into words—to b
united with the beauty we see, to pass into it, to receive it into ourselves, to bathe in it, to become part of it
~ C. S. LEWIS, "The Weight of Glory"

[OPPOSITE] *Wisdom Keeper*, carved Madagascar clear quartz wand, 23″ (l)

"Wisdom begins in wonder." ~ SOCRATES, *Theatetus*

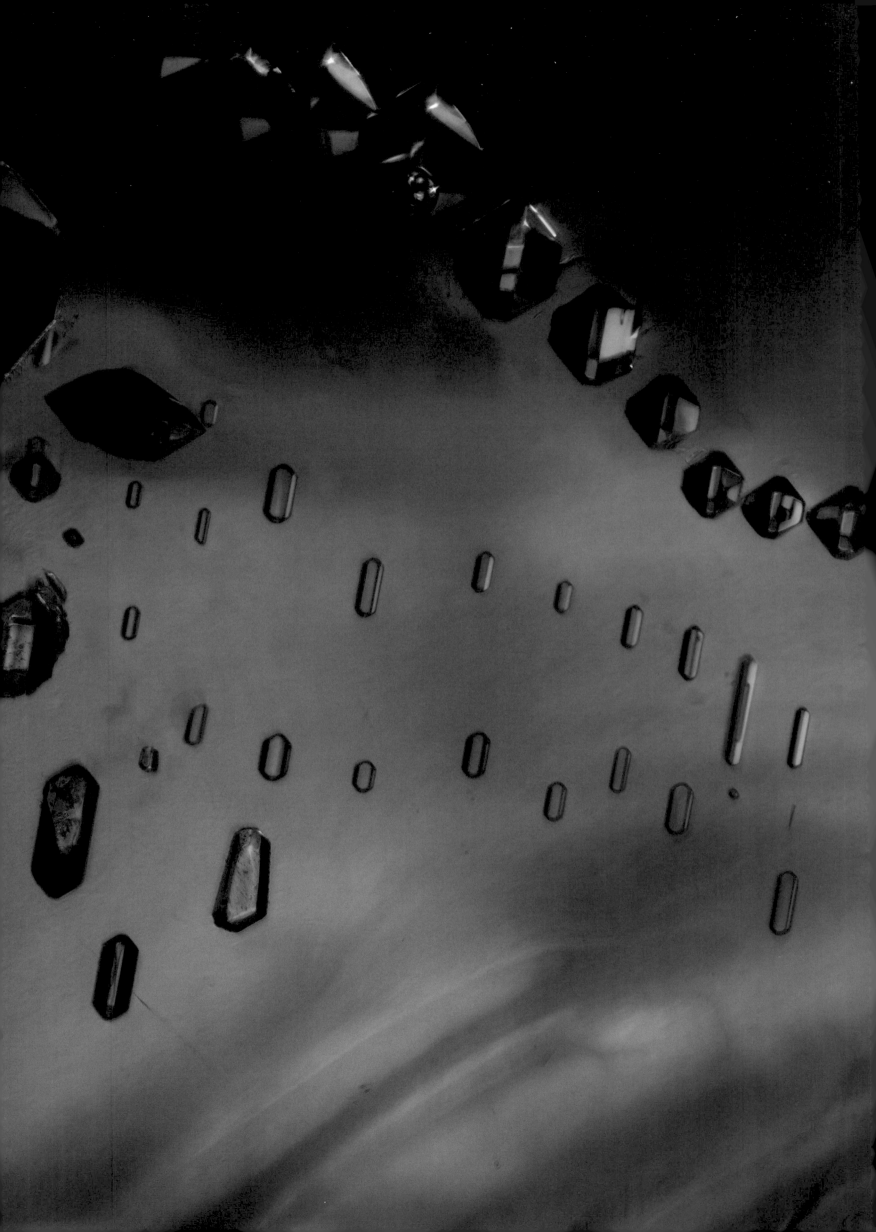

[3]
PHYSICS &
METAPHYSICS

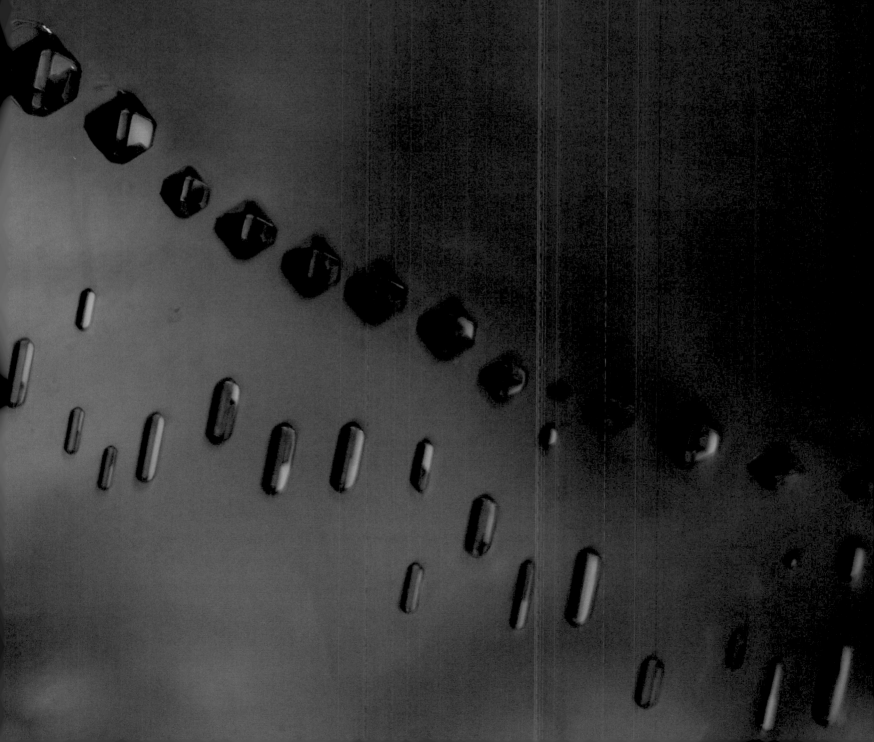

Internal floating micro structures (voids) in Madagascar amethyst quartz

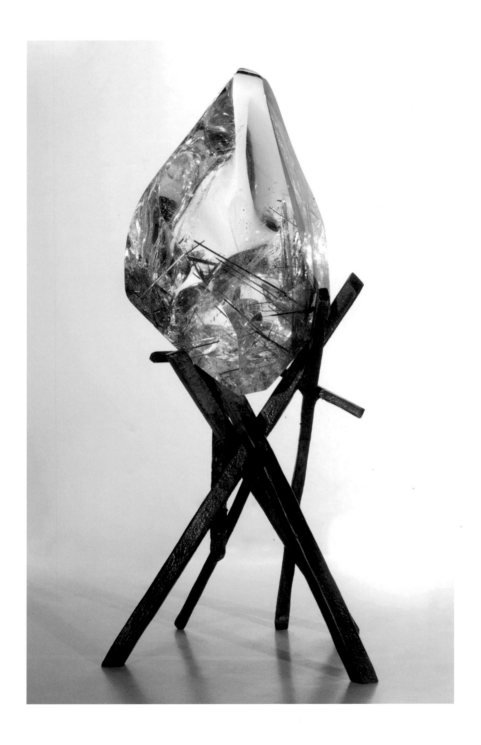

[ABOVE] *Sticks in Stones*, Madagascar red rutile in quartz on bronze, 12″ (h)

[OPPOSITE] *Fusion*, carved clear quartz with red rutile on lighted bronze base, 15″ (h)

"A human being is part of the whole, called by us 'Universe,' a part limited in time and space. He experiences himself, his thoughts and feelings as something separated from the rest—a kind of optical delusion of his consciousness. The striving to free oneself from this delusion is the one issue of true religion. Not to nourish the delusion but to try to overcome it is the way to reach the attainable measure of peace of mind."

~ ALBERT EINSTEIN, letter to ROBERT S. MARCUS (1950)

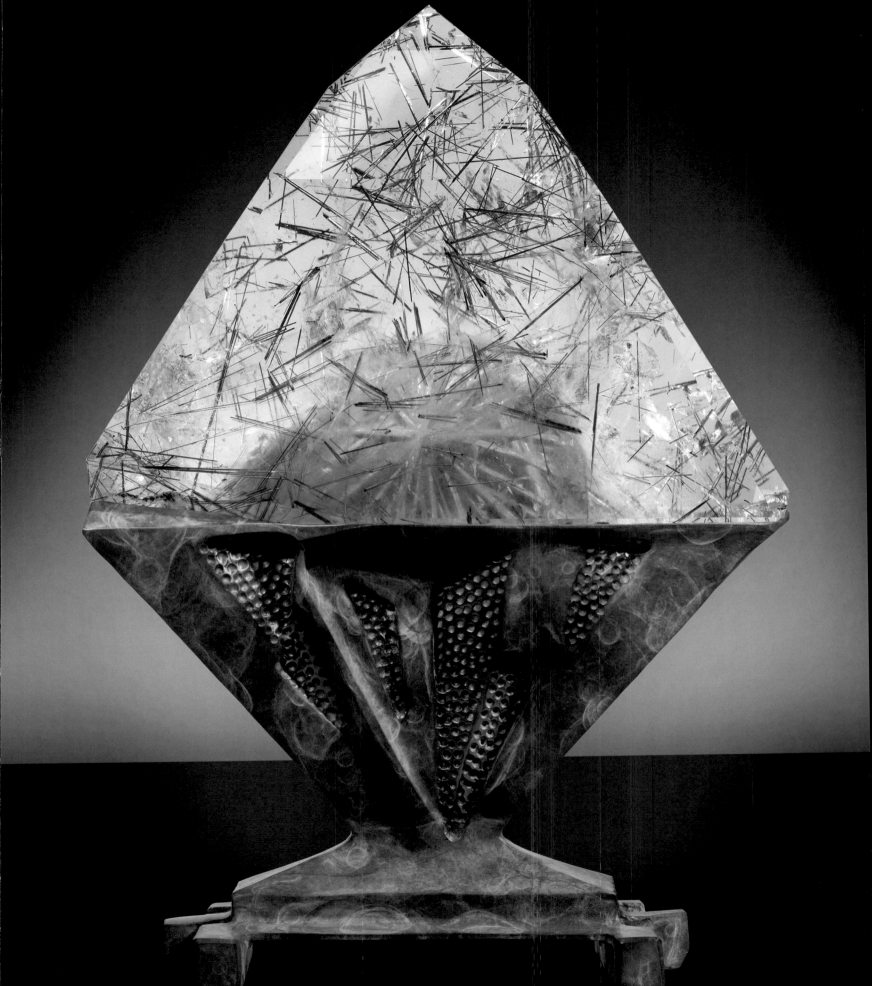

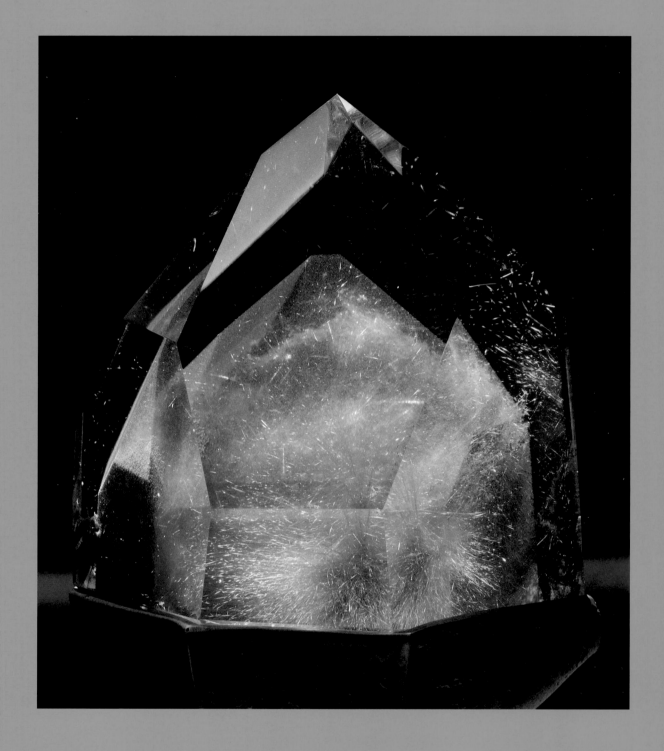

[ABOVE] *Phantom of the Rutile*, Brazilian rutile phantom in quartz on lighted bronze base, 16″ (h)

"Yet, at the quantum level, no part of the body lives apart from the rest. There are no wires holding together the molecules of your arteries, just as there are no visible connections binding together the stars in a galaxy. Yet arteries and galaxies are both securely held together, in a seamless, perfect design. The invisible bonds that you cannot examine under a microscope are quantum in Nature; without this 'hidden physiology,' your visible physiology could not exist. It would never have been more than a random collection of molecules."
~ DEEPAK CHOPRA, *Perfect Health: The Complete Mind/Body Guide*

[OPPOSITE] *Constellation of Red Stars*, Madagascar quartz with red rutile on lighted bronze base, 23″ (h)

"Learn how to see. Realize that everything connects to everything else."
~ Attributed to LEONARDO DA VINCI

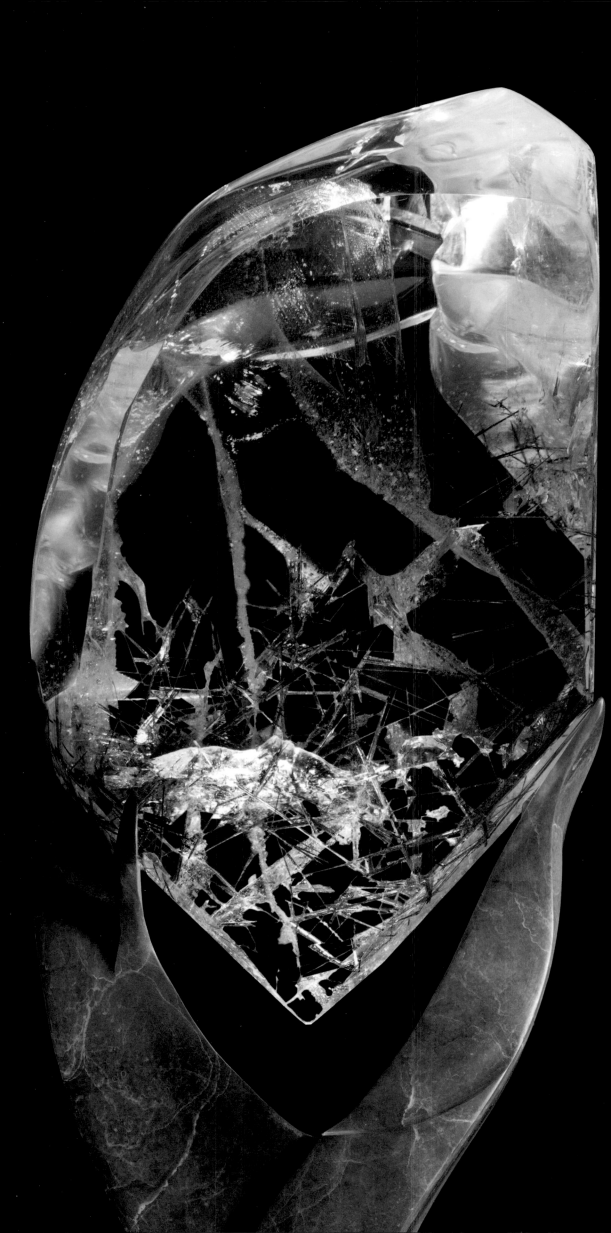

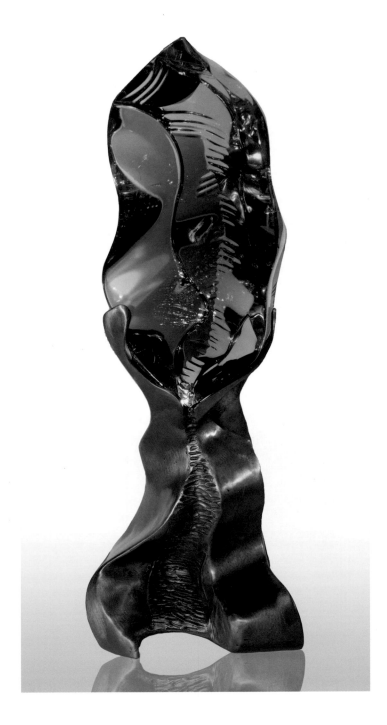 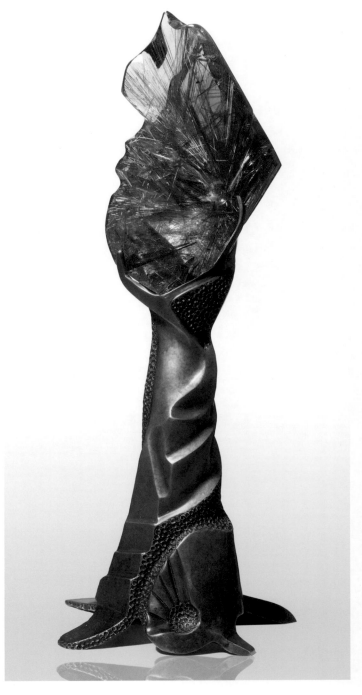

[ABOVE LEFT] *River Run*, smoky citrine quartz on bronze base, 12″ (h)

Forget about time. It is the fastest way to slow down.

[ABOVE RIGHT] *Shooting Star*, Brazilian red and gold rutile in carved quartz on lighted bronze base, 17″ (h)

Does beauty exist if no one is there to appreciate it?

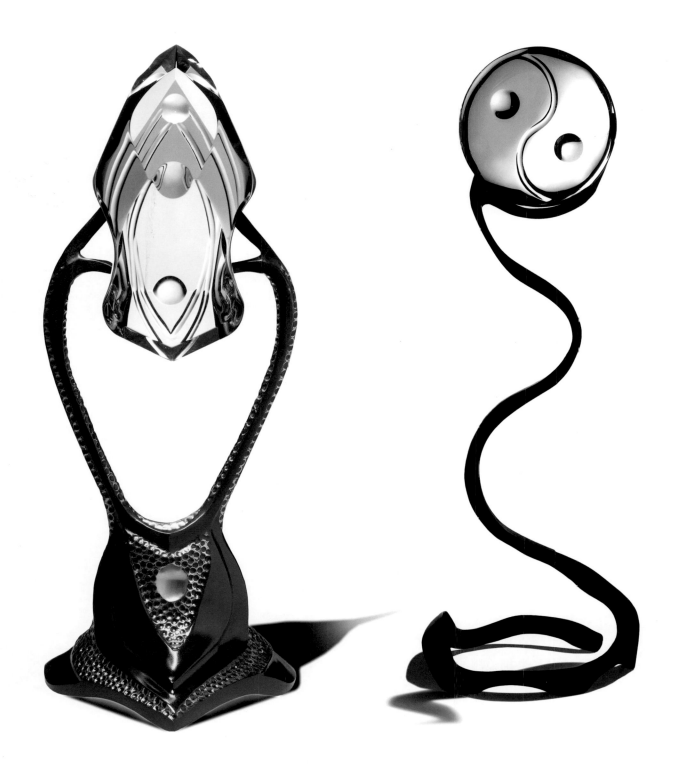

[ABOVE LEFT] *Cosmos*, carved clear quartz on lighted bronze base, 14.5″ (h)

"The beauty of a living thing is not the atoms that go into it, but the way those atoms are put together."
~ CARL SAGAN, *Cosmos*

[ABOVE RIGHT] *Yang Yin*, carved optical quartz on bronze, 12″ (h)

"Some infinities are bigger than other infinities." ~ JOHN GREEN, *The Fault in Our Stars*

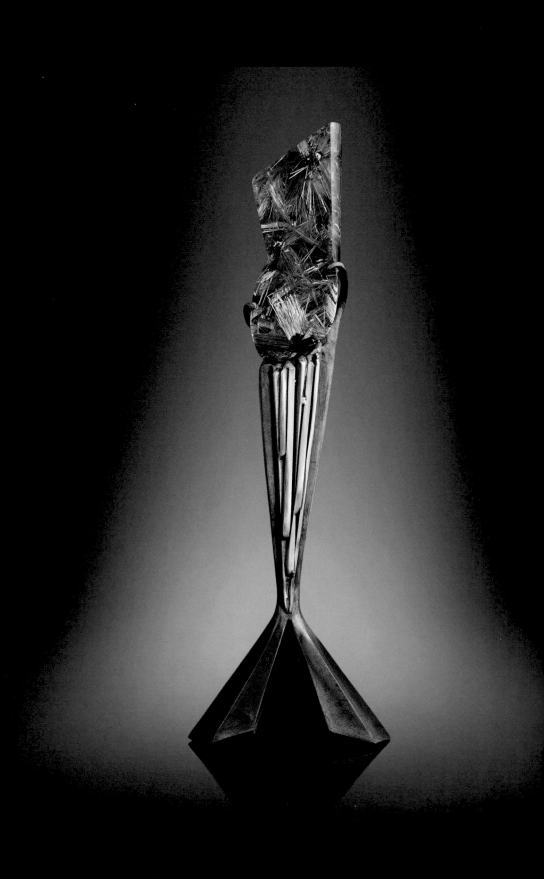

Celestial Compass, Brazilian rutile and hematite stars in quartz on bronze base, 8″ (h)

All life appears inanimate until one recognizes its play of consciousness.

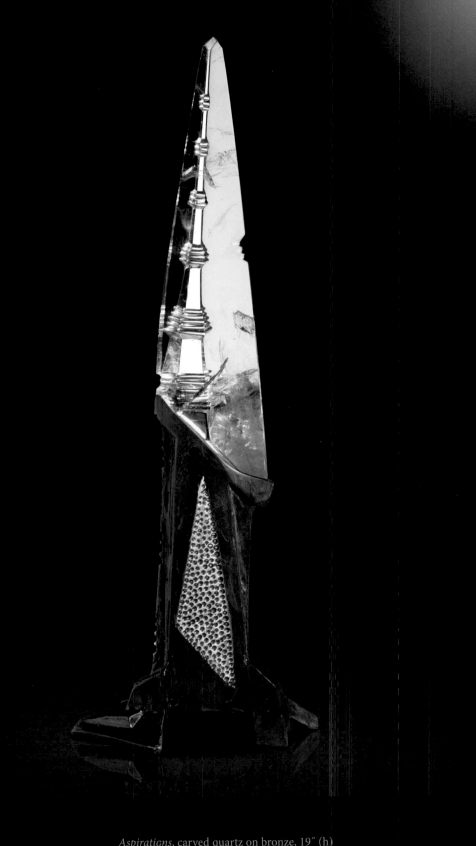

Aspirations, carved quartz on bronze, 19″ (h)

"For at no time are any events predestined. There should be no such word in your vocabulary, for with every moment you change, and every heart-beat is an action, and every action changes every other action."

~ SETH, channeled by JANE ROBERTS

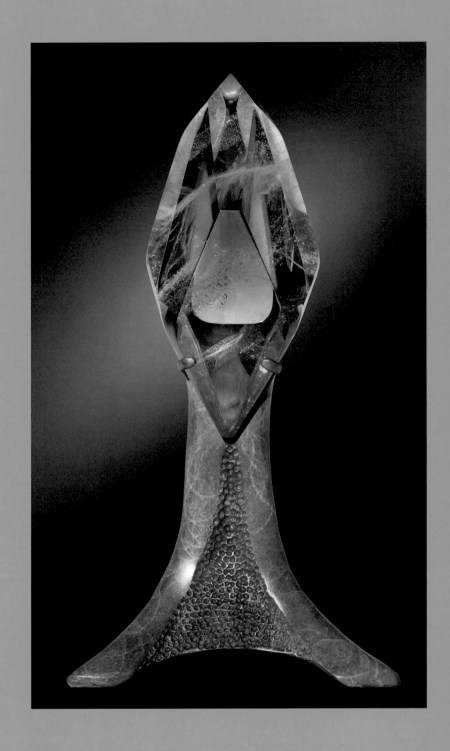

[ABOVE] *Portal*, light smoky quartz with wispy veils on lighted bronze base, 12.5″ (h)

"Be here now." ~ RAM DASS

[OPPOSITE] *Molecular Vortex*, carved citrine on lighted bronze base, 13″ (h)

"It is natural for my body to be well. Even if I don't know what to do in order to get better, my body does. I have trillions of cells with individual consciousness, and they know how to achieve their individual balance." ~ ABRAHAM, channeled by ESTHER HICKS, *Ask and It Is Given*

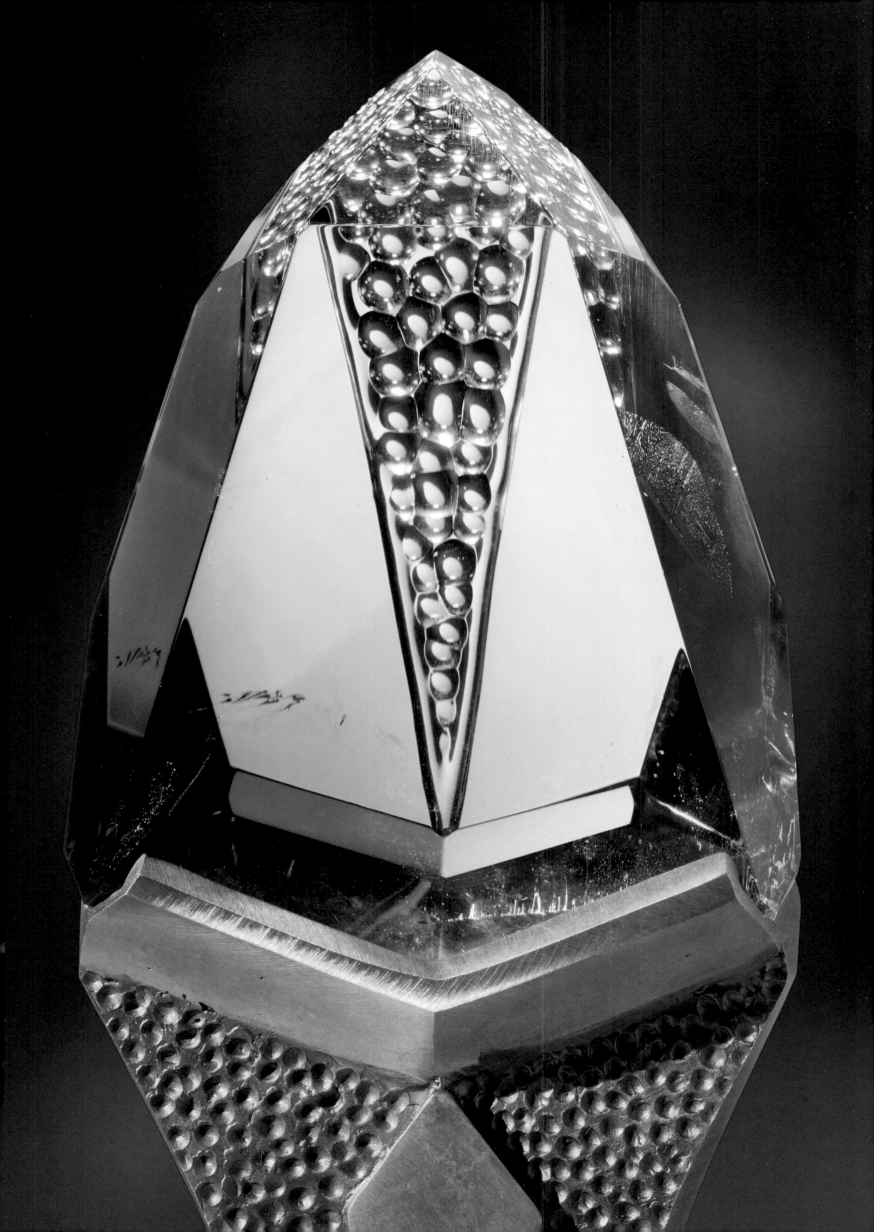

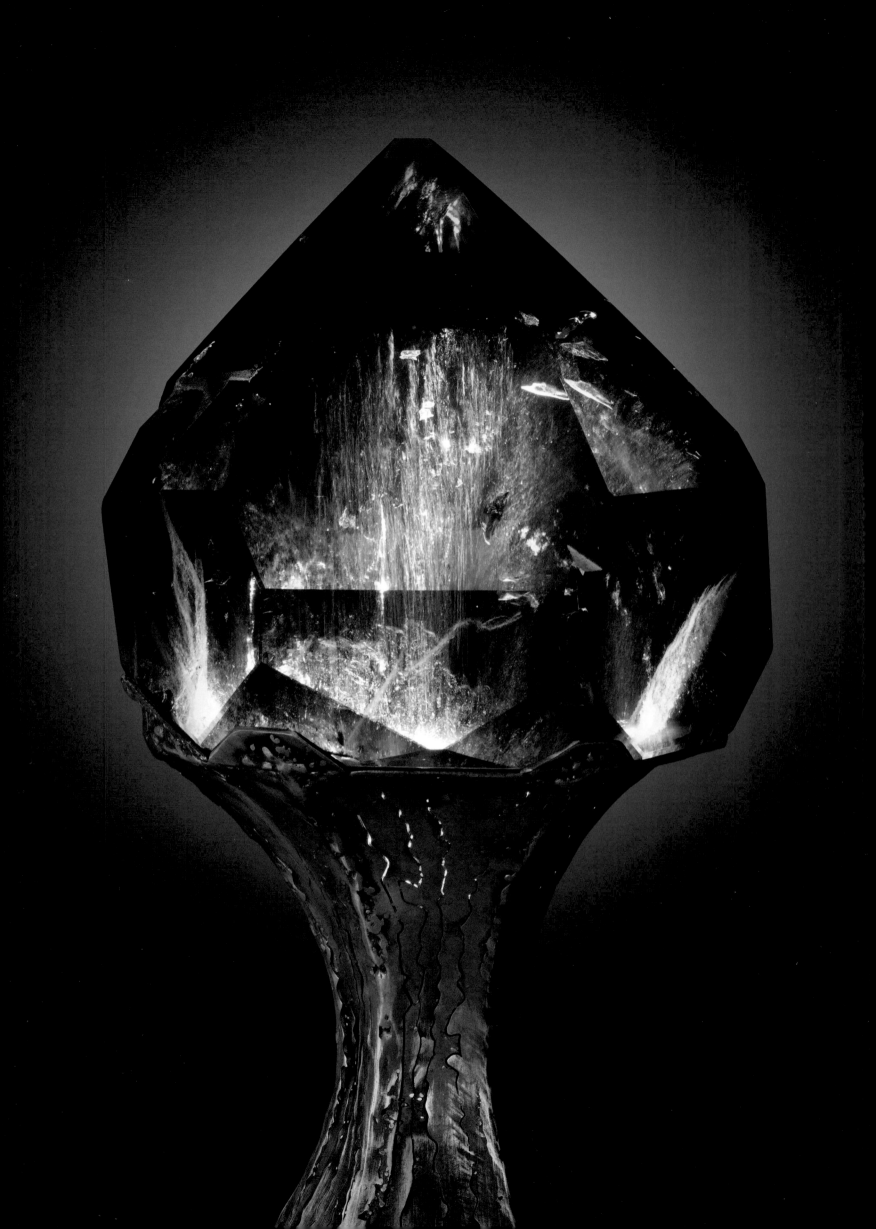

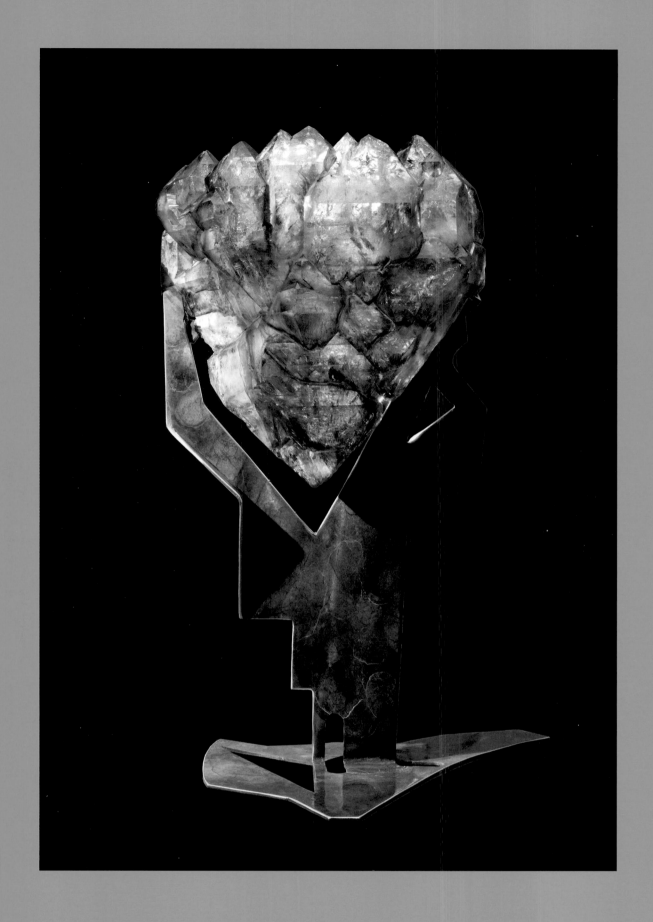

[ABOVE] *Clan of the Cave Bear*, elestial quartz on bronze, 16″ (h)

"Life shrinks or expands in proportion to one's courage." ~ ANAÏS NIN, *Diary*

[OPPOSITE] *Opening Night*, Madagascar smoky generator, 28″ (h)

"Nothing in life is to be feared, it is only to be understood." ~ Attributed to MARIE CURIE

Quartz wand, 13″ (l)

"The past just ended, but I remain." ~ New2TheBrain

This life is a transitory inhabitance between worlds …

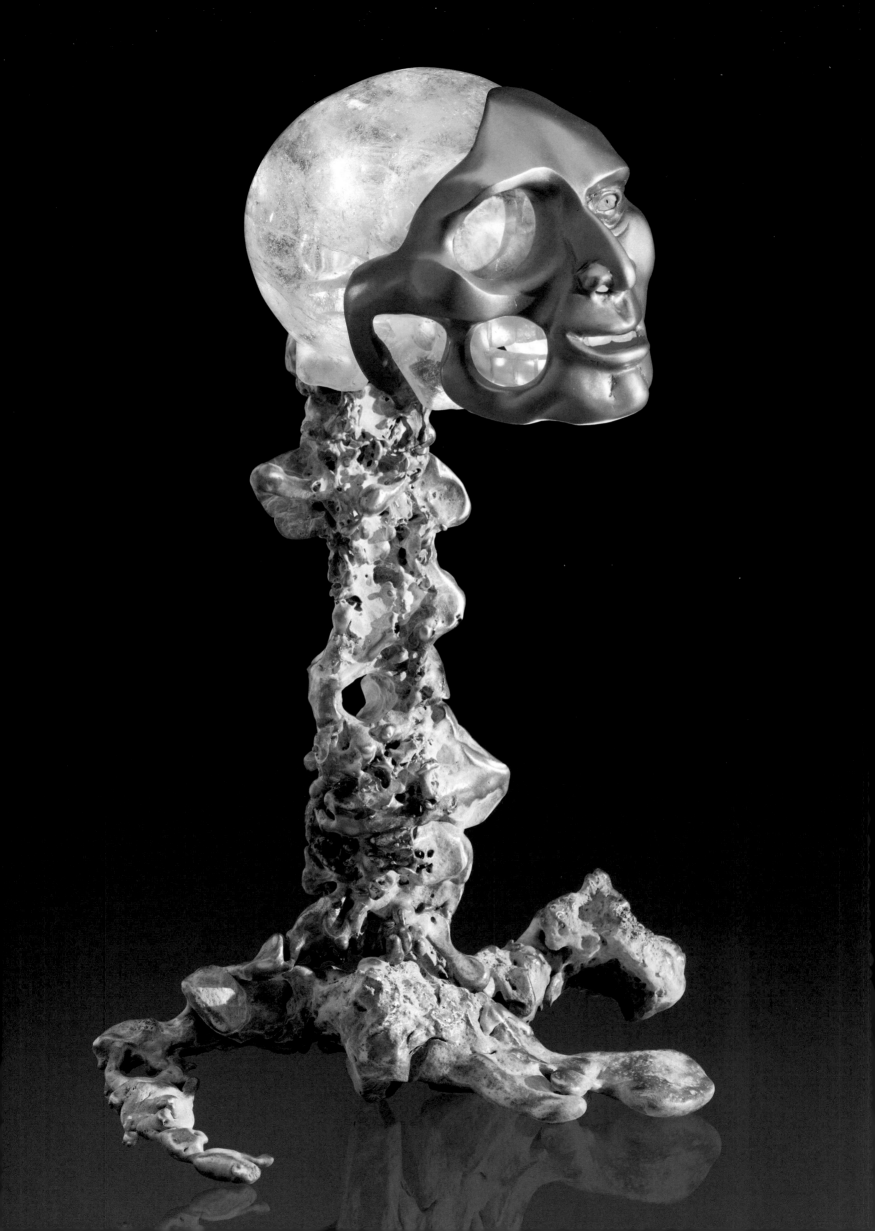

Between Worlds, quartz skull with bronze, 13″ (h)

"There is a face beneath this mask, but it isn't me. I'm no more that
face than I am the muscles beneath it, or the bones beneath that."
~ STEVE MOORE, *V for Vendetta* (novelization)

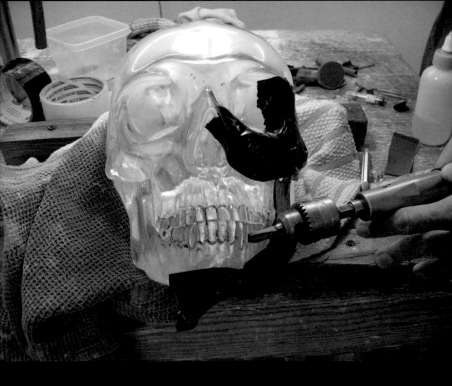

[ABOVE] Quartz skull in the polishing process.
Initial carving done in Bali courtesy Lee Downing – Artifactuals

"Thou know'st 'tis common; all that lives must die,
Passing through nature to eternity."
~ WILLIAM SHAKESPEARE, *Hamlet*

[OPPOSITE] Quartz skull

"The moment you die you will get the biggest surprise of your life."
~ KASKAFAYET, channeled by EDWARD O'HARA

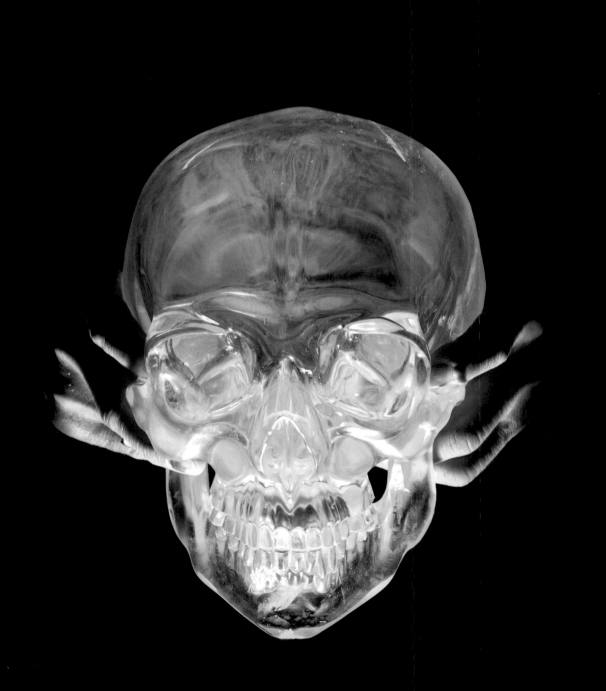

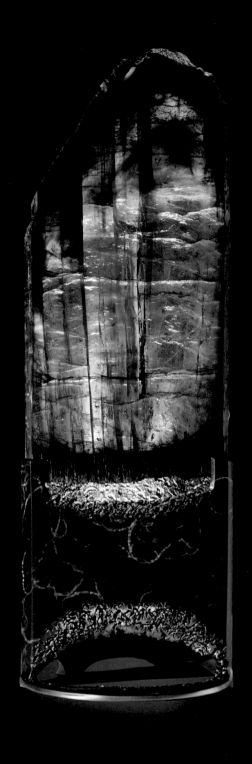

Tricolored Zambian tourmaline on lighted bronze base, 4,860 carats

"The day before [my husband, Lou Reed] died, we were out
swimming in the pool. Looking at the trees. And he was floating and
saying, 'You know, I am just so susceptible to beauty.' I think of that
every day. How to open yourself to the world. And really appreciate it.
~ LAURIE ANDERSON, *The Sunday Times* (UK), 2013

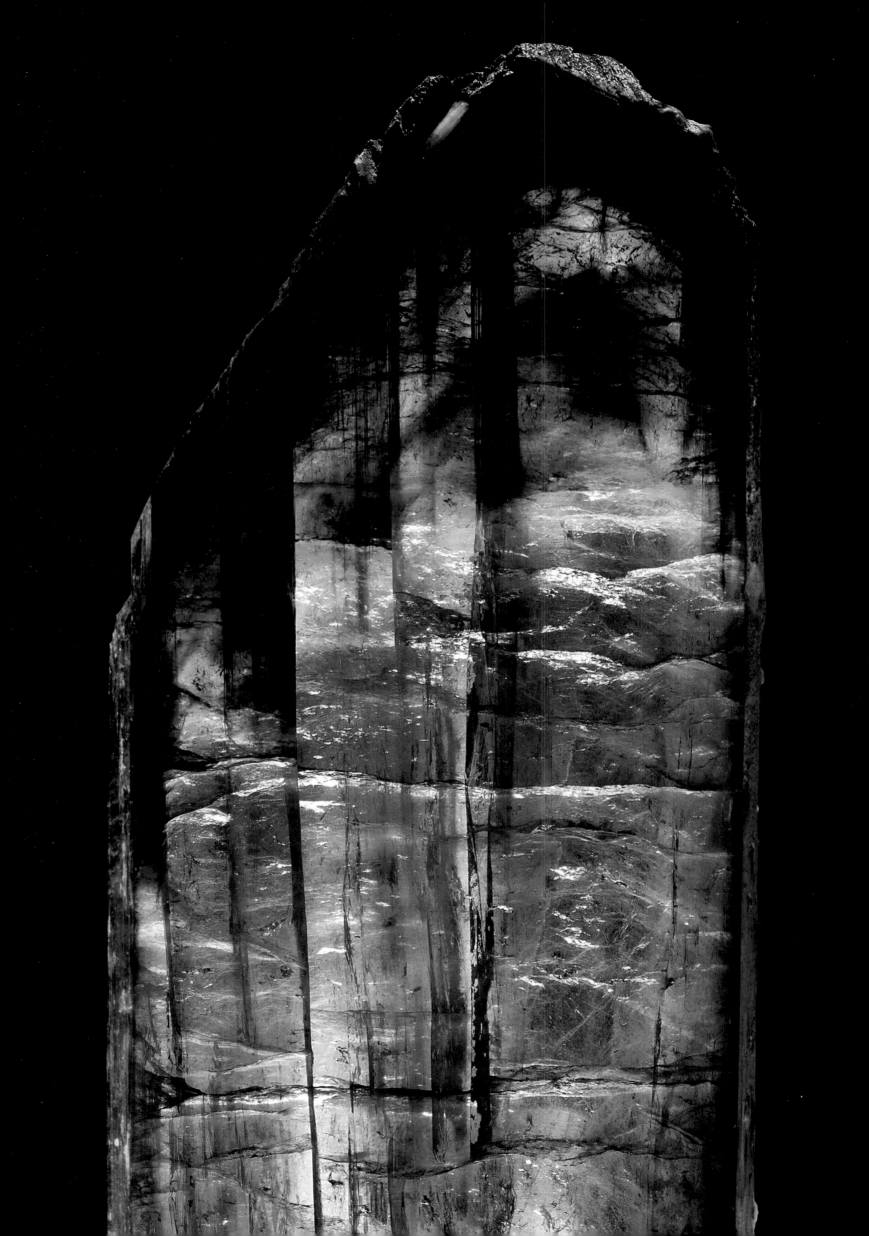

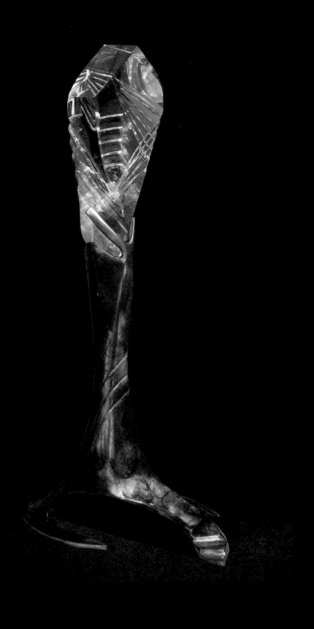

[ABOVE] *Gateway Home*, carved citrine on lighted bronze base, 15″ (h)

Whatever you're thinking about is literally like planning a future event. When you're worrying you are planning. When you are appreciating, you are planning. What are *you* planning?"
~ ABRAHAM, channeled by ESTHER HICKS, workshop

[OPPOSITE] *Summer Solstice*, elestial citrine quartz on lighted bronze base, 25.5″ (h)

"The dying sun will glow on you without burning, as it has done today. The wind will be soft and mellow and your hilltop will tremble. As you reach the end of your dance you will look at the sun, for you will never see it again in waking or in dreaming, and then your death will point to the south. To the vastness."
~ DON JUAN, in CARLOS CASTANEDA's *Journey to Ixtlan*

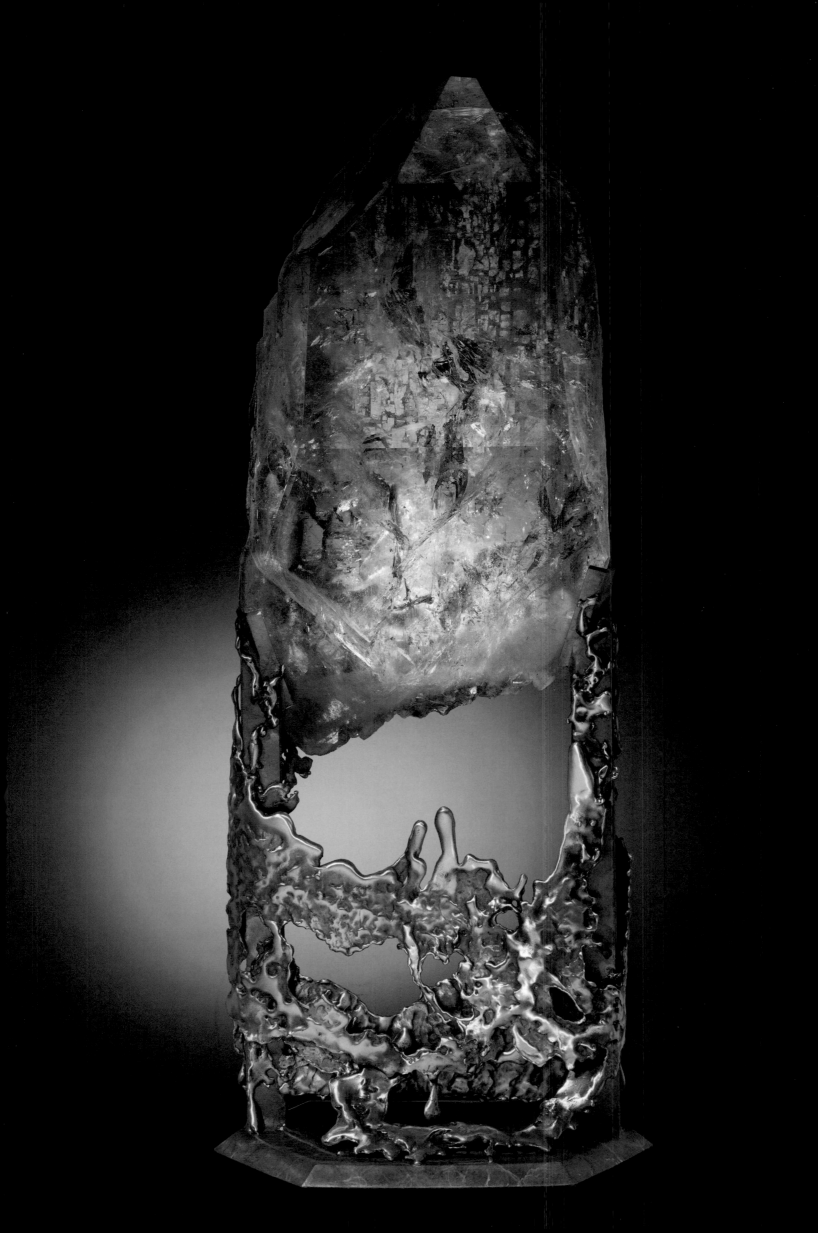

Fire Walk

Franc calls me and says, "There is a guy teaching people how to walk across hot coals, and it only takes one night to learn to do it." It was 1985 and the idea that I could be walking on hot coals seemed impossibly fascinating. Yet fifteen years earlier on the enchanted island, I had witnessed Balinese trance dancers walk on hot coals, a mystifying event so far beyond belief that a new lobe of what's possible formed in me. The nerve to think I could walk over burning coals. But that paled to the audacity of the man outlandish enough to usher a group of unwitting curiosity seekers over a 12-foot bed of burning hot coals and to do so without any of us ending up in an emergency room burn unit.

What I remember is that in preparation our instructor, Tony Robbins, led us through a series of processes, most of which, as I recall, ended in rolling around on the ground in uncontrollable laughter. Then Tony explained that while learning how to walk over hot coals, he burned himself so severely that he spent three months in the hospital with third-degree burns on the bottom of his feet. At this point in the evening, the untethered fun of tempting fate ominously changed. A gasping fear rose in me, as I scoured the horizon of logic for an oasis of rationality. "Are we really going to do this?" "Oh, I get it, we aren't reaalllly going to walk on hot coals; this whole evening is designed to bring us to a place mentally where we will muster enough courage (and stupidity) to be willing to walk over a bed of hot coals." But this theory was extinguished at the end of the evening when anyone who wanted to proceed went outside where a 4-foot-high bonfire now turned to red coals was spread in a 12-foot-long pit of glowing red-hot burning embers, 8 inches deep.

I put myself in the trance state I had just learned and fire walked.

~

FEAR comes up all the time: that little man behind the curtain of doubt and foreboding, telling me go back, be safe, or be consumed by any number of Wizard-of-Oz-ly dooms. Attack of the flying monkeys of chaos, the raw spike of nerve, and adrenaline-induced threats hurled by the wicked witch of my own self-doubt, squeezing the life force out, forbidding me to proceed.

It seems that whenever I endeavor to take on a new-fangled challenge, I am confronted by fear. Fear is the gatekeeper, the troll guarding the boundary between the known and the unknown, the doable and the perception of impossibility; a lighthouse forewarning peril, while searching for safe passage. Fear is the burning coals between me and what I want to accomplish. Do I turn back, or do I fire walk over my trepidation?

With all the real and imagined fears in the world, it sounds a bit melodramatic; after all, I was simply holding a huge, otherworldly piece of raw fire orange opal, entertaining a barrage of doubts questioning whether I was up to the task of carving the raw opal into an expression of beauty. Sweat was pouring off my head at the thought of owning it and the challenges it would commit me to.

It was 2007, and Carlos, a Brazilian miner, had placed the 7,600-carat chunk of orange Brazilian fire opal in my hands. A reaction of emotional chemistry, half excitement, half anxiety, coursed through my hands as I held this "burning coal," a challenge that would artistically call me out. I would have to reinvent my skills to do a reverse intaglio carving (carving from the back of the opal). What if I failed?

To fire walk I had put myself in an altered state of mind: beyond doubt, so convincing to my physicality that the burning coals I was stepping on did not char my flesh. The fire walk took three hours of mental preparation and about fifteen seconds of walking.

It took me eight years to find my way with this opal.

In the timeless hours of carving there were long lapses where I couldn't find myself in the art. I would work on it, make the obvious cuts with my diamond grinding tools, carving out fractures and incongruous shapes, and then put it back on the shelf. Months later, I would force myself to pick it up, look at it under the bright lights of expectation, only to experience the motivation-killing depression of my indecision, and either put it back on the shelf or force myself to carve further into it in hopes that a vision would emerge. Would I whittle the valuable orange gem down from limitless possibility to a heap of dust or find my way to a finished magnificent sculpture? Eventually, I transcended my mind, surrendered, and submerged into primal creativity, and rode the steed of spirit into the orange light until an apparition appeared.

In a dance of determination and resolve, the Fire Dancer emerged and was set free.

Fire Dance, Brazilian fire opal, 4,255 carats on lighted bronze base, 19″ (h)

I am willing to be someone other than who I think I am.

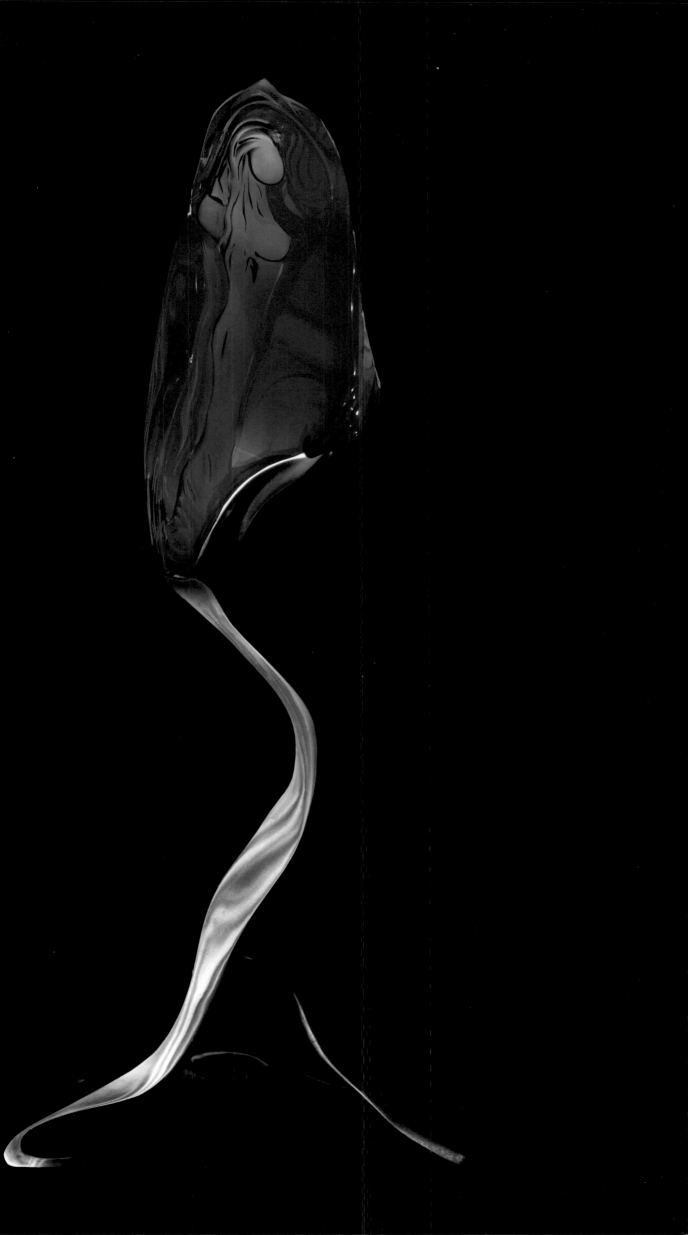

Blue Moon, 35,000-carat carved natural blue topaz on bronze. Stone carved with Glenn Lehrer, 23″ (h)

"The scientific man does not aim at an immediate result. He does not expect that his
advanced ideas will be readily taken up. His work is like that of the planter—for the future.
His duty is to lay the foundation for those who are to come, and point the way.
He lives and labors and hopes."
~ Nikola Tesla, "The Problem of Increasing Human Energy,"
The Century Magazine (1900)

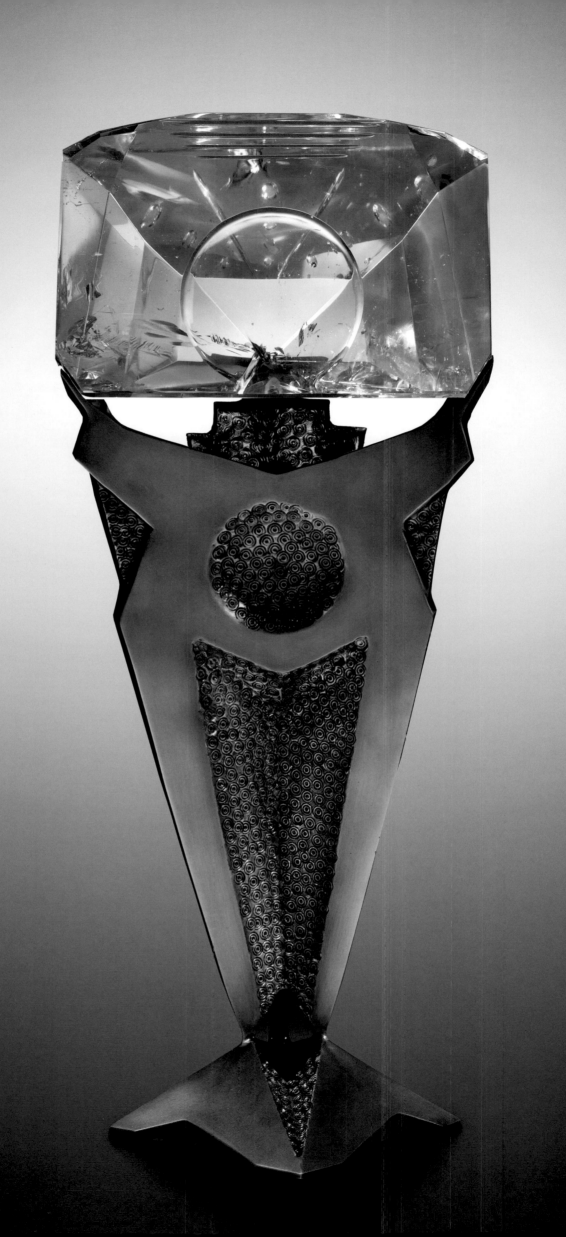

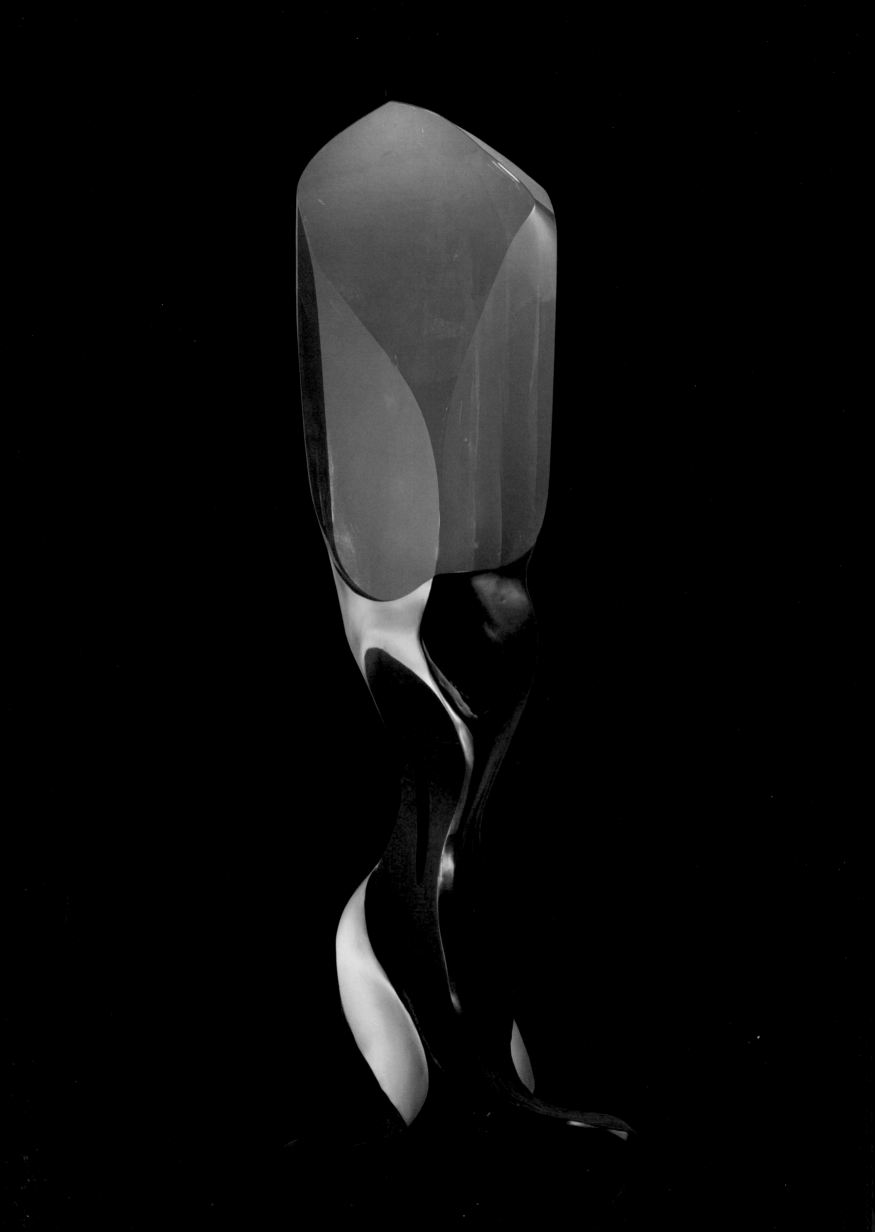

[ABOVE] Madagascar rose quartz rough, 21½ pounds

"The practice of forgiveness is our most important
contribution to the healing of the world."
~ MARIANNE WILLIAMSON, author

SITE] *Full Bloom*, 63,560-carat carved gem-quality rose quartz on lighted bronze base, 20

"'Hope' is the thing with feathers –
That perches in the soul –
And sings the tune without the words –
And never stops at all."
~ EMILY DICKINSON

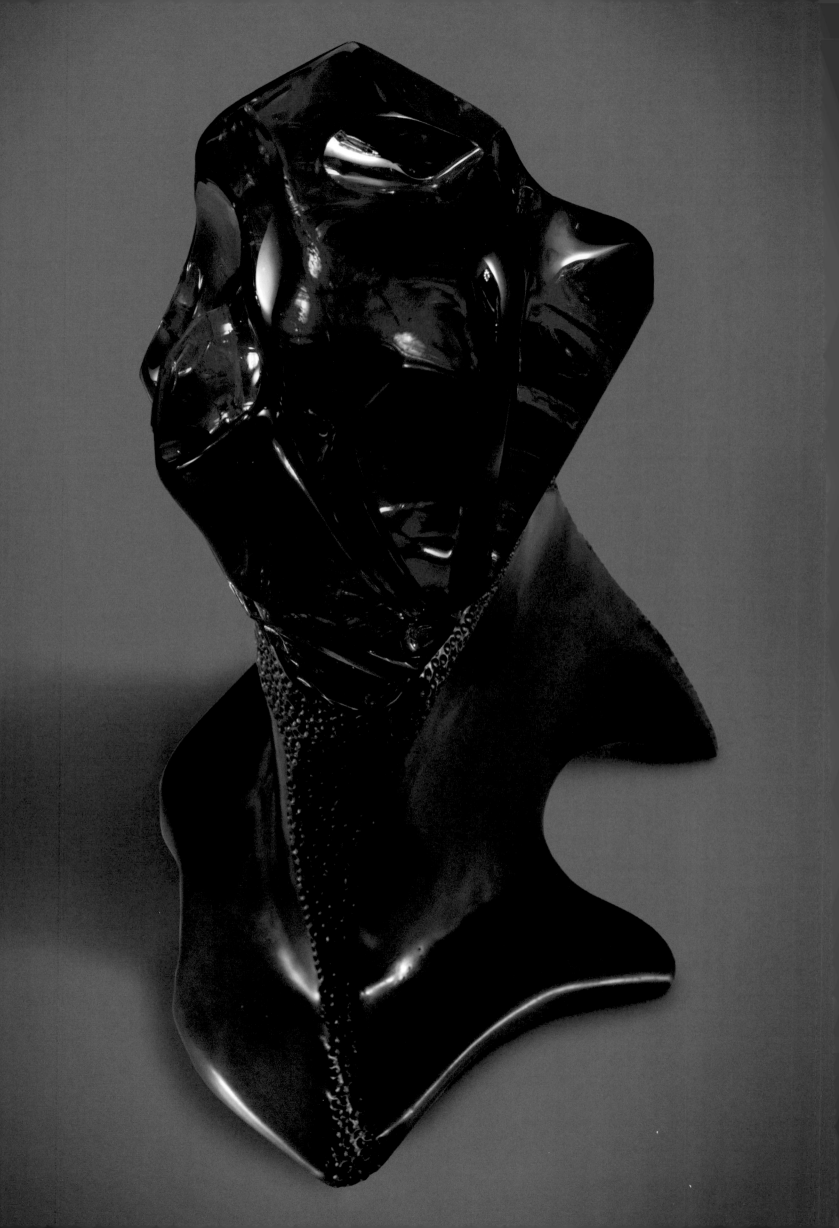

WELL RED

I was treasuring, hunting my way around the vast pavilions of the Tucson (Arizona) Gem and Mineral show, absorbed in the endless search for tantalizing minerals. As I wandered through halls and tents, the years blended, as did the faces of crystal importers and merchants from remote locations around the globe like Brazil, Madagascar, Russia, Afghanistan, and China. Many exotic minerals and gems that pocket the upper crust of our Earth are transported here to barter and trade for.

I entered the tent of a Brazilian man whom I have known for years. We exchange greetings, fumble over small talk, until finally he said in a lowered voice, "Lawrence, I have something for you." Encoded in that phrase is a signal that transcends centuries of clandestine dealings: "game on."

The churning of a Pavlovian response begins, my pupils widen, and the moment gets bigger. I mentally salivate with the anticipation of spying naked treasure. But at the same time, I assume a defense posture, protecting the boundaries of my good sense and pocketbook. There are diametrically opposed feelings that mix in my mind: the possibility of acquiring something spectacular, blended with the dread that I may like it so much I "must" buy it.

He takes me in the back room and pulls out a nearly black, opaque chunk of quartz. I am immediately relieved and disappointed at the same time. It doesn't look like my kind of rough, lightless and lifeless, unattractive. The meter on my interest level flatlines. He walks me and the chunk over to a bright white halogen light and holds it over the beam. It glows red. My head spins, realizing I have never seen that color of vibrant ruby red in a large quartz crystal.

The words "How much?" wiggle out between my clenched jaw. His price knocks my head back like a counter-punch. Certainly it can't be that expensive; he can't really expect to get that much for a black crystal … But he is not budging on the price. Now I am in trouble. A choir of disparate voices joins a raucous debate in my head: "Don't even think about it; it is too expensive," followed by "That is unbelievable, the color can't be real, but it is," "You have to find a way to buy this," "You can't be serious," "Offer him much less," "It will be a completely unique sculpture when finished," "You will never make your money back," "I've got to have it" … All the while my passive face masks just how serious I am about paying his price.

~

When I got the black smoky chunk back to my studio, I began sizing it up. I had paid for the promise of red. But I knew that to fulfill the promise of this sculpture it was going to demand a far greater price. And the medium of exchange demanded that I invest myself in a way I never had before.

An exploratory face-cut creates a window in the craggy broken surface, allowing my eye to glimpse the heart of the dark crystal. After several saw cuts I begin to navigate the visual interior of the crystal, holding the chunk over a bright light, turning it to every angle and in all directions. The dazzling red color appears and quickly disappears; elusive, as if trying to hide from me. A red apparition, momentarily darting across the interior walls before vanishing. I turned the crystal over the light, but couldn't capture and control the color.

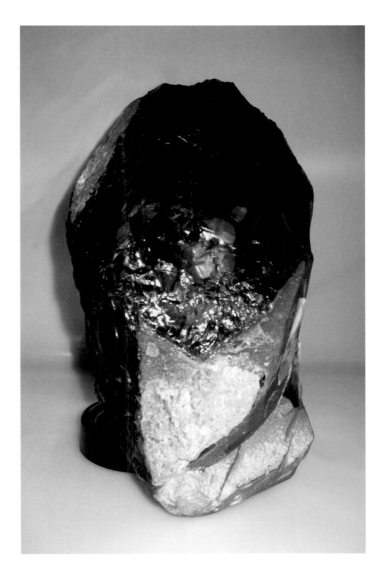

[ABOVE] Rough Brazilian red citrine

[OPPOSITE] *Well Red*, carved Brazilian red citrine quartz on lighted bronze base, 11″ (h)

"Beauty awakens the soul to act." ~ Attributed to DANTE ALIGHIERI

The challenge was to facet and align the angles of the quartz to ignite the smoldering red ember inside. I needed to create a house of mirrors to pinpoint, activate, and reflect a vector of light through the smoky crystalline lattice that would slow the light resonance to the spectrum of red. And then to bounce that red beam off precisely angled faces so as to fill the sculptural vessel with this burgundy radiance.

So the process went, cutting, grinding, and carving into the dark night of the crystal, trying to release a sliver of trapped light in this black hole of matter. I was frustrated because I am used to the process of "revealing a crystal" being immediately gratifying: make a cut, see the light, make another cut, marvel for a bit, cut and polish, and it is only a matter of time before the wonder of the crystal is in full bloom. With this one, however, it seemed that no matter what I did, it was not going to surrender the light of dawn I knew was in its core.

Unfortunately, there were no new lapidary tools I could employ to help me create the desired result. I used saws, lap wheels, carving and polishing tools of various shapes and sizes. I used nearly every tool in my arsenal to take away material in hopes that the absence of the crystalline matter would allow more light to penetrate and escape the crystal. This only proved that the result I was seeking would not occur as a function of tools alone.

Each time I took the carving in my hands, I descended into the emotional vortex of the Unknown. The Unknown has its own rules, which by definition are mysterious. So when you are in the Unknown but haven't surrendered to the fact that you are in the Unknown, there are no telltale indicators of how to proceed. I was lost. And every time I worked on the piece, I reinforced my apprehension that the Promised Land was nowhere to be found.

The famous opening passage from Dante's Inferno (in Longfellow's translation)—"Midway upon the journey of our life / I found myself within a forest dark / For the straightforward pathway had been lost"—came alive for me. When one enters the "forest dark," everything one perceives to be right and true no longer is. Once trapped there it can be quite frightening.

This crystal became a microcosm of "the forest dark," a place I would reluctantly visit over the next five years, trying to find my way, but to no avail. There is an anxiety that goes with being lost that propels you forward. My metaphysical mission was to go through the narrows of doubt, fear, and frustration, to find the "red light" of certainty. Moments of salvation came only when I would surrender to the freedom that exists in "not knowing."

If I hadn't paid such a dear price for the raw crystal, I would have put it back on the inventory shelf, leaving it for some ambiguous future to deal with. But this red ghost haunted me, initially because I felt a responsibility to get my investment back out of it. Beyond that it seemed that every remedy I carved into this piece only helped shape it into an effigy of doubt. But the crystal had its own volition and destiny, patiently waiting for me to align with it, rather than the other way around.

Every few months I would pick it back up, hold it to the light, trying to plot my longitude and latitude, only to conclude once again I was adrift. I would force myself to cut a new groove or face in hopes of creating some reflection of truth.

Finally my breakthrough came. I had convinced myself for five years that the crystal had a prescribed orientation, i.e., a front, a back, a top, and a bottom. I was operating under the assumption that the red color would appear as a function of my carving and shaping of the crystal. It wasn't till I turned the almost completed sculpture upside down and backwards that I found the angle of light refraction focused so as to reverberate the smoky zone at the precise spectrum resonance to fill the crystal.

Finally, blood was pumping through a beating red heart.

I once was lost, until I found
that right side up is upside down.

[OPPOSITE] *Dazzling Blue*, carved blue topaz, 202 carats

"Love is eternal sacred light."

~ PAUL SIMON

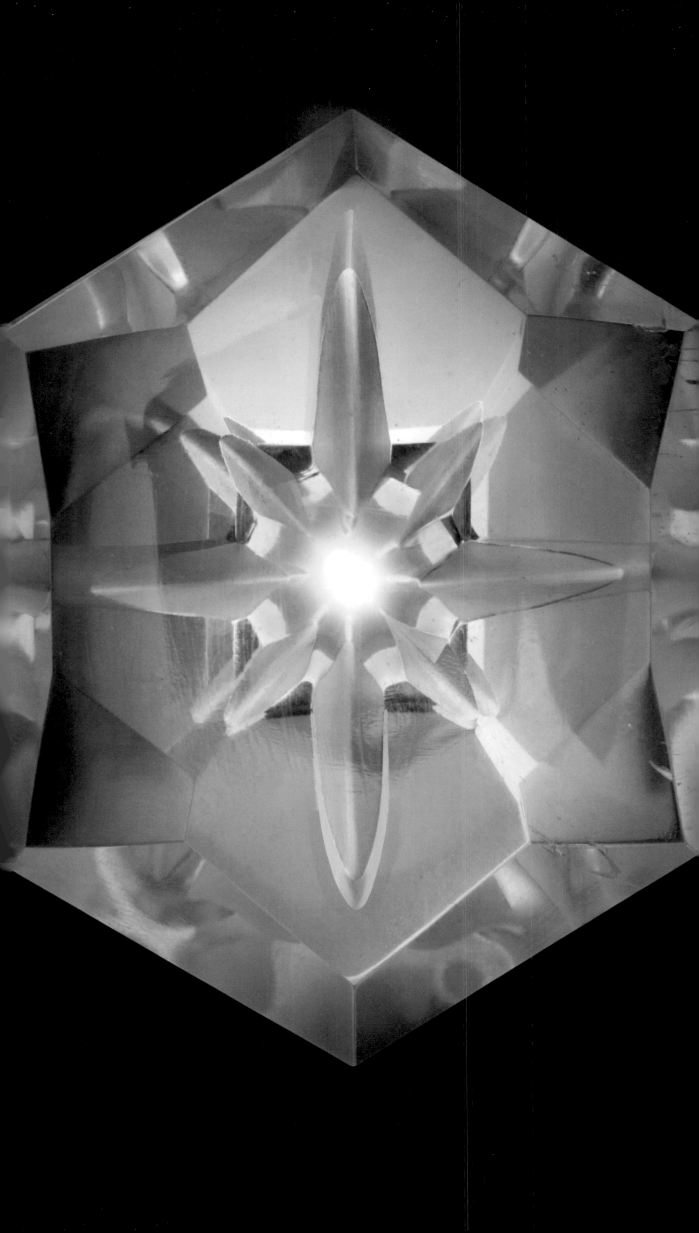

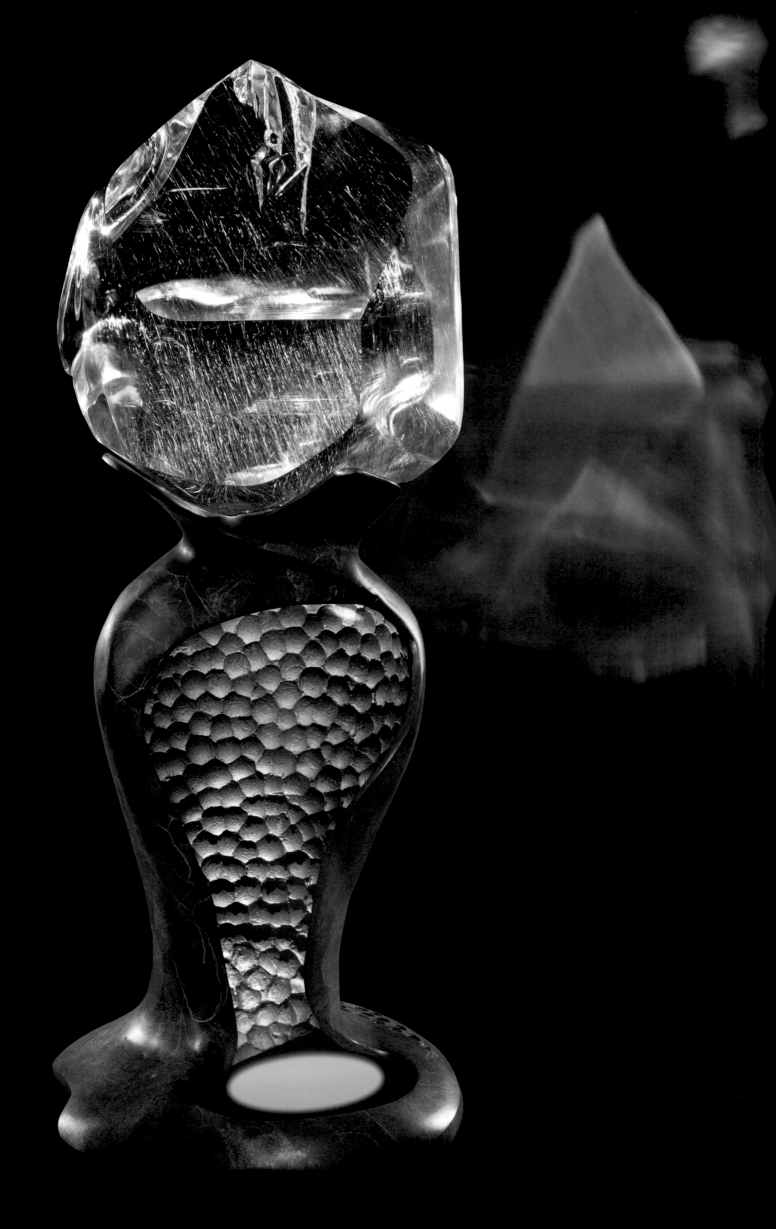

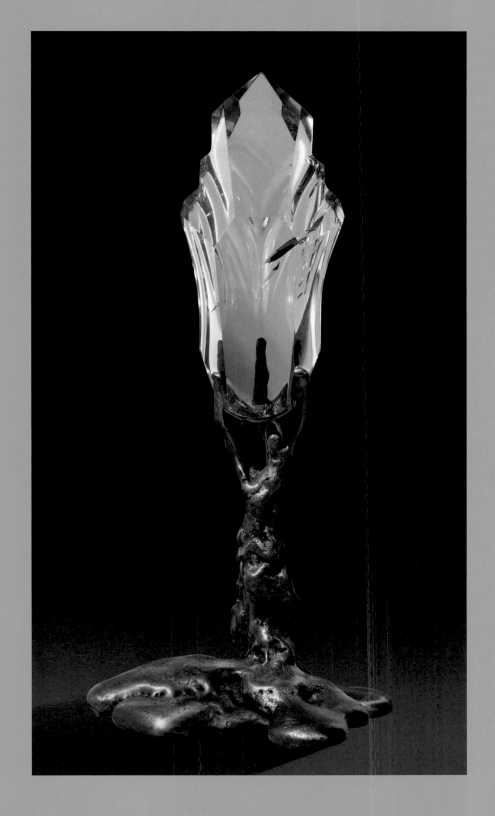

[ABOVE] *Light Seeker*, carved citrine on lighted bronze base, 12″ (h)

"There is a crack in everything. That's how the light gets in."
~ LEONARD COHEN

[OPPOSITE] *Initiation*, hair rutile in carved Madagascar quartz, 24″ (h)

"When you light a candle, you also cast a shadow."
~ URSULA K. LE GUIN, *A Wizard of Earthsea*

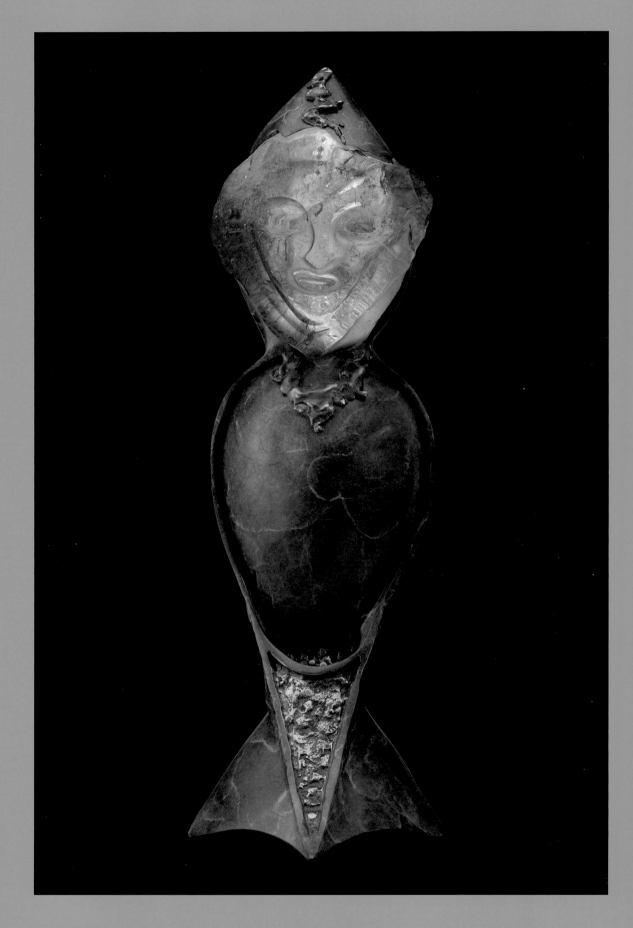

[ABOVE] *Wizard*, carved river-tumbled Madagascar quartz with natural iron coloring, 22″ (h)

"To know that we know what we know, and to know that we do
not know what we do not know, that is true knowledge."
~ Attributed to NICOLAUS COPERNICUS

[OPPOSITE] *Wizard* (detail)

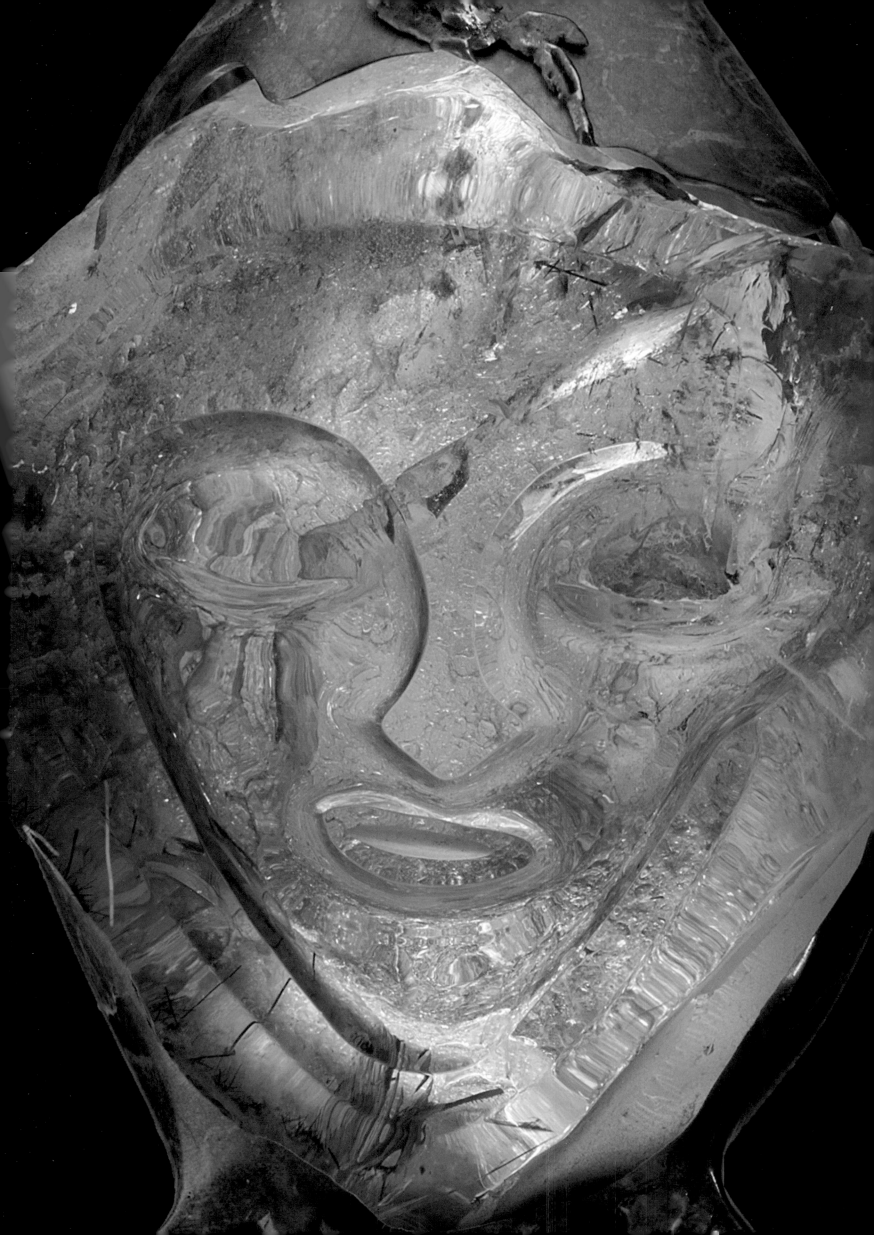

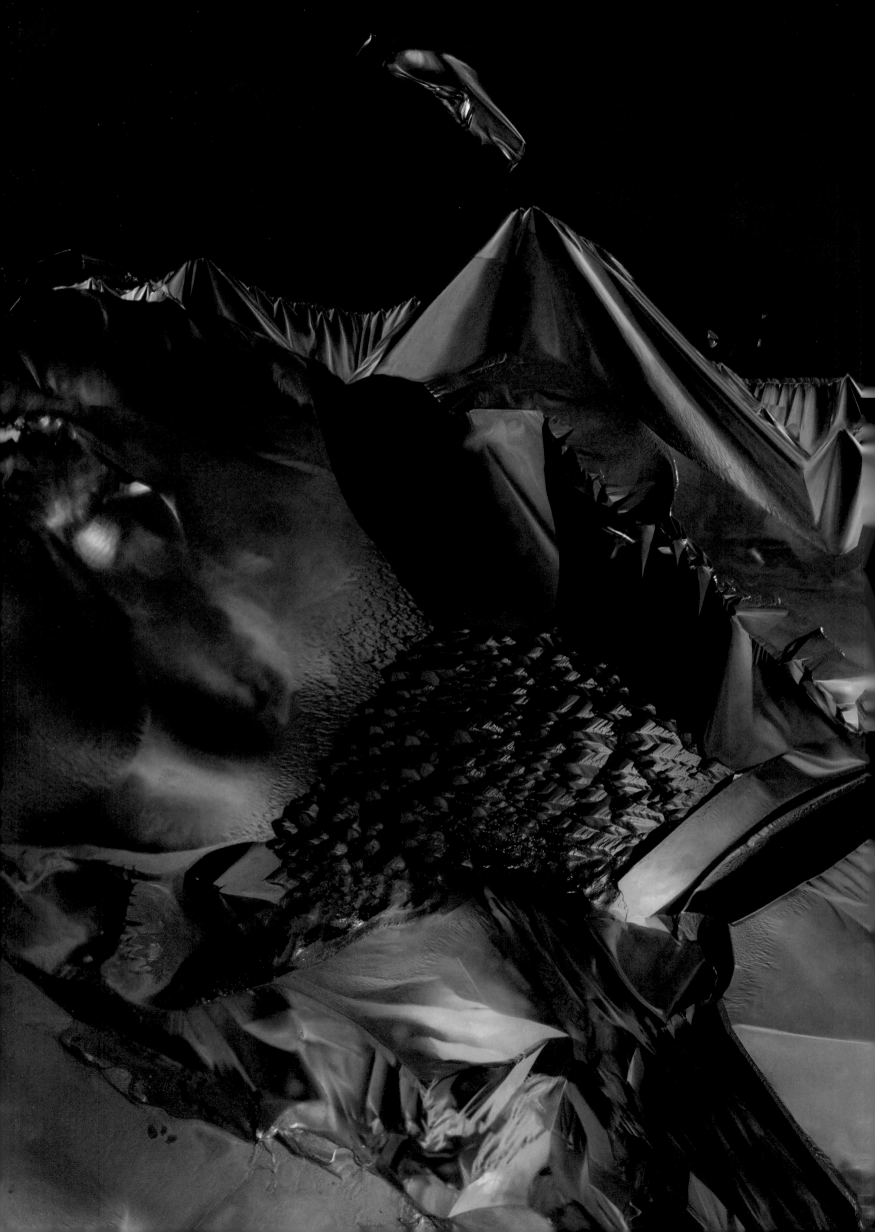

Internal natural gemscape of quartz crystal

"The atoms or elementary particles themselves are not real; they form a
world of potentialities or possibilities rather than one of things or facts."
~ Attributed to WERNER HEISENBERG

[4]
AESTHETICS

THE PLAY OF LIGHT
AND THE ART OF
THREE DIMENSIONAL TRANSPARENCY

When does solid dense matter become invisible?
In the geological process of Earth creation,
a transparent mineral forms from a combination of elements.
Starting from a supersaturated solution,
congealed by heat and pressure over eons of time,
they coalesce as a solid crystalline structure
imbued with transparent splendor.
How do we see the invisible
in the heart of solid, transparent matter?
Our eyes use variations of light
to identify the outer faces of the crystal.
But instead of stopping,
our vision passes through the outer surface.
The mind's eye distinguishes the interior form,
defined by refractions, reflections, and shadows of light.
The brain perceives the interior as hollow,
appearing to contain (mostly) light,
when, in fact, we are looking through the solid dense body of the crystal.
This paradox is stimulating to the brain.
The invisible solid interior is molecularly aligned
with such precision that light passes through it uninhibited,
allowing the eye (an appendage of the brain) to roam freely
to all angles of the internal architecture.
For a moment the brain believes it is inside the crystal.
And the mind as an extension of the brain is left to wonder.
And wonder leads the soul to the gateway of beauty,
where beauty changes you.

Bonfire, carved smoky quartz on lighted bronze base, 19″ (h)

"The aim of art is to represent not the outward appearance of things,
but their inward significance."
~ Attributed to ARISTOTLE by SENECA in *On Tranquility of Mind*

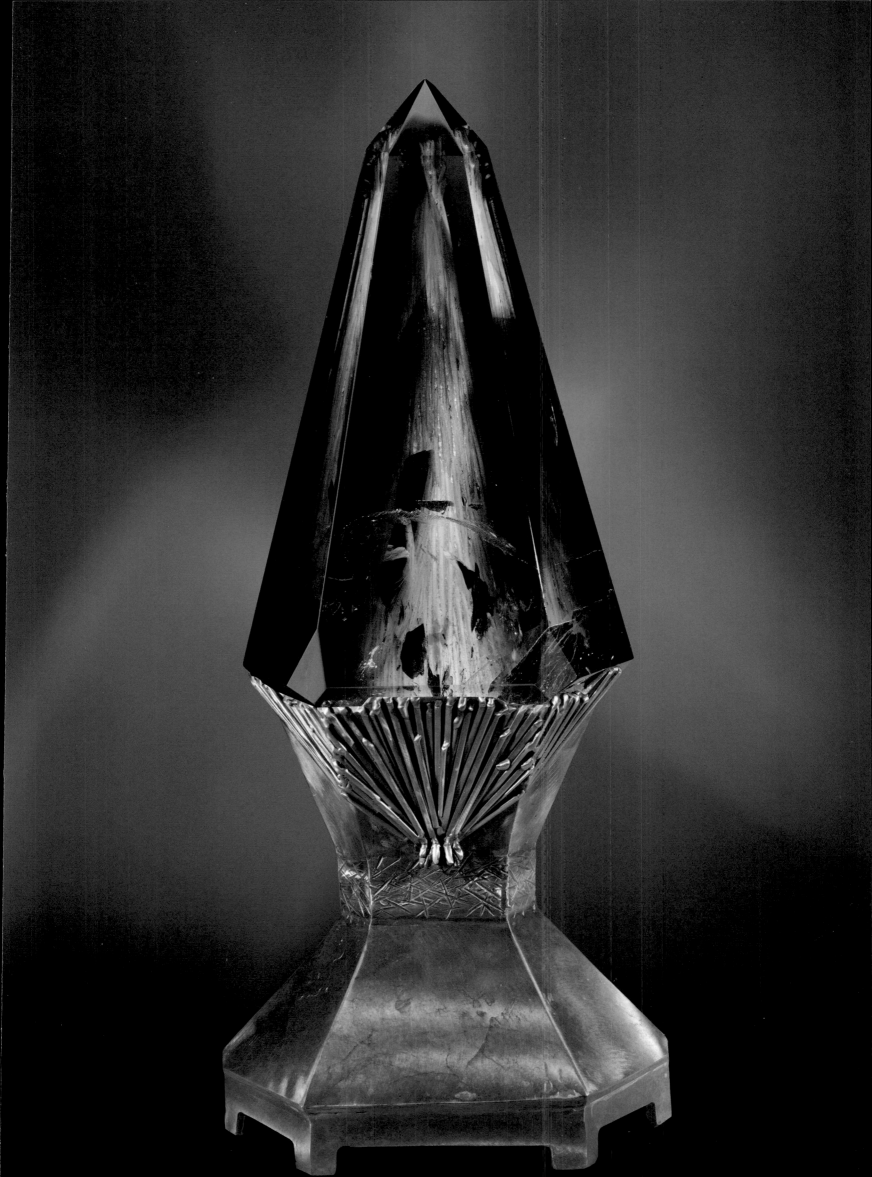

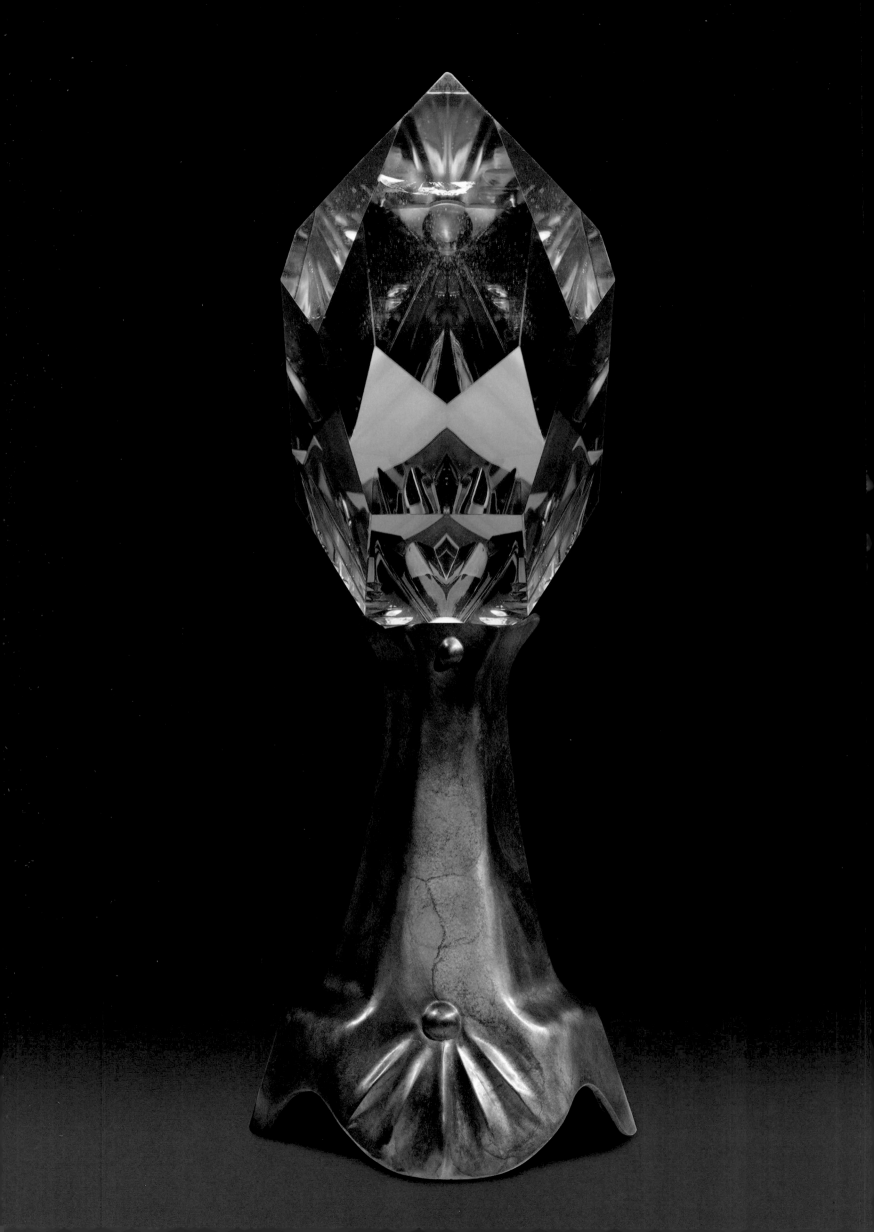

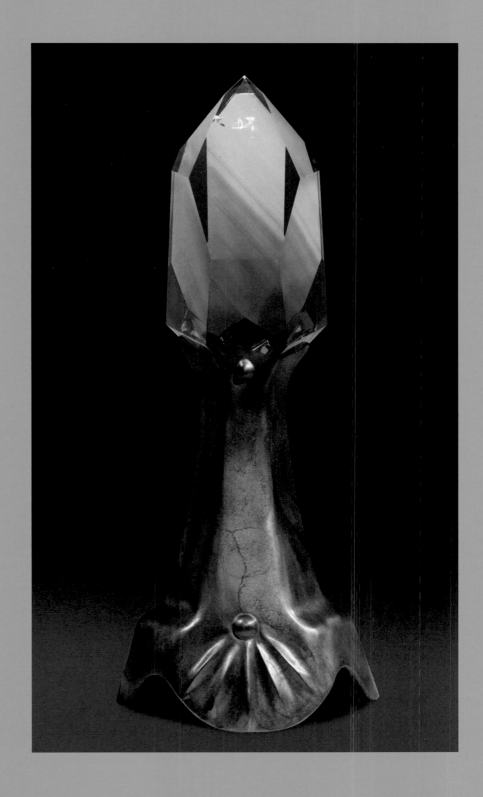

[OPPOSITE & ABOVE] *Sunrise on Silk Road*, citrine on lighted bronze base, 13″ (h)

These are two photographs taken of the same crystal. The difference is the angle at which the photos were taken. The above image is a straight-on shot of the crystal and base. The image opposite is taken at a slightly higher angle, capturing carving at the bottom and light refractions bouncing off side faces.

"The appearance of things changes according to the emotions; and thus we see magic and beauty in them, while the magic and beauty are really in ourselves."
~ KAHLIL GIBRAN, *The Broken Wings*

Wild, carved quartz, quartz cluster, bronze on walnut. Created with Justin Kelchak, 30″ (h)

"Where the spirit does not work with the hand, there is no art."
~ Attributed to Leonardo da Vinci

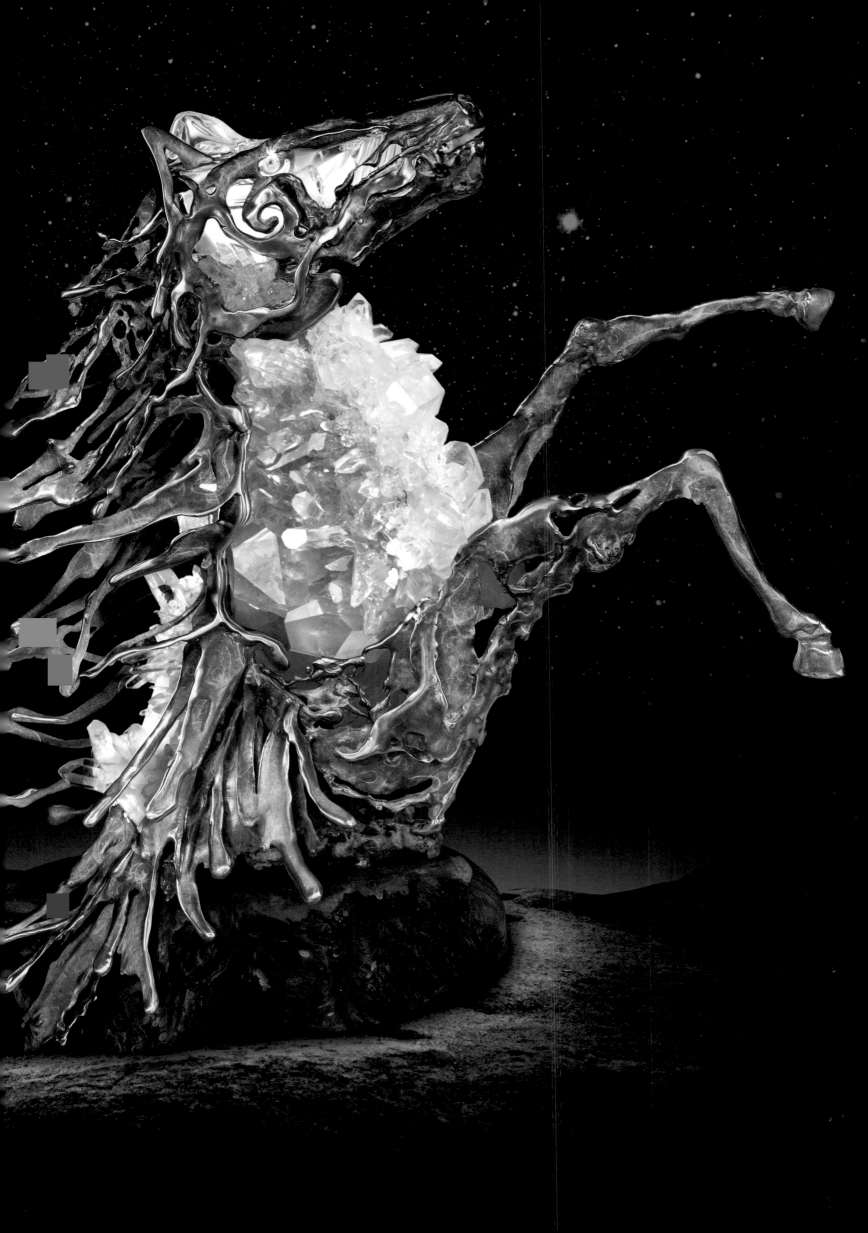

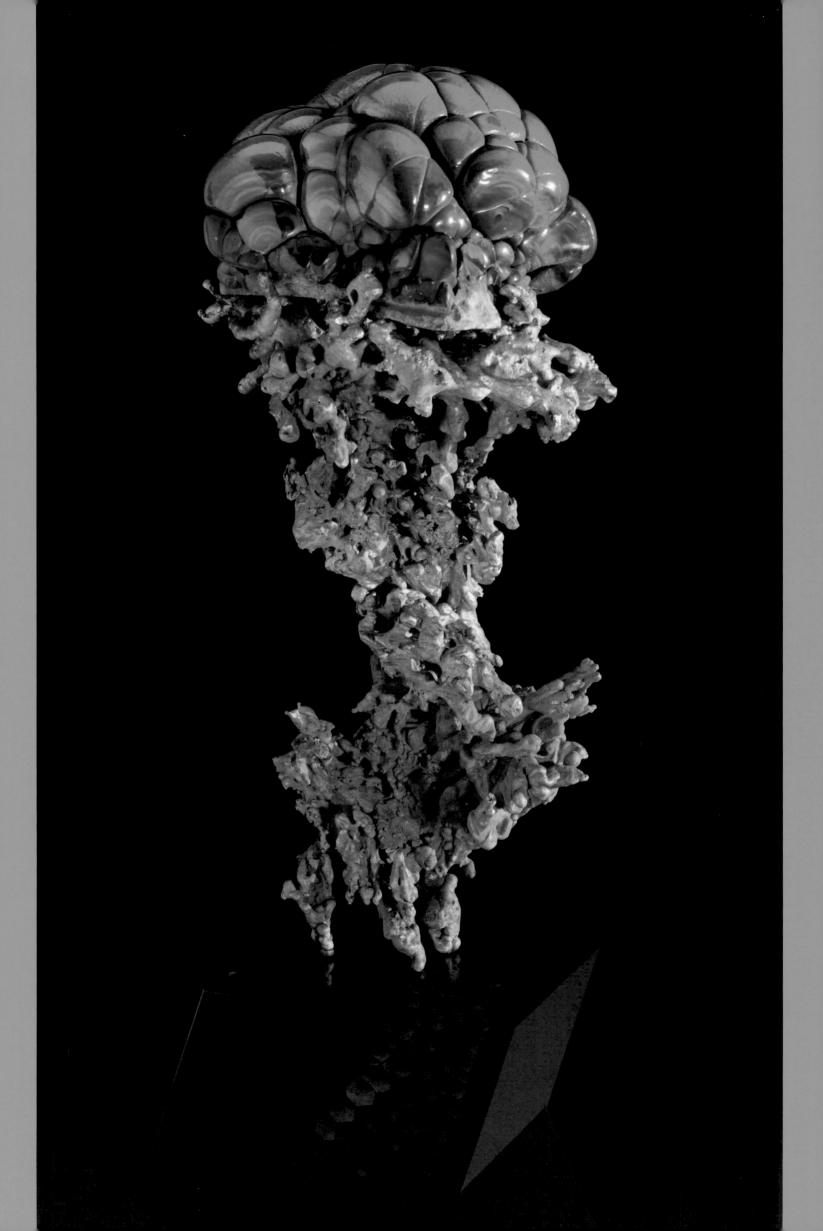

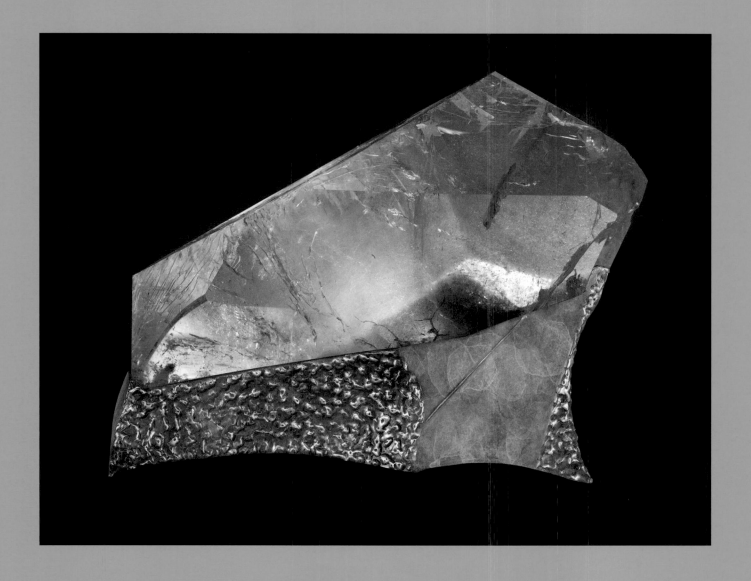

[ABOVE] *Emerald City*, 68,667-carat pink morganite with emerald-colored phantom on lighted bronze base

"You cannot recognize in another a quality you do not have yourself."
~ Attributed to LIU SHAO, 3rd-century AD Chinese philosopher

[OPPOSITE] *Dancing Brain*, Congolese malachite on copper and basalt base, 15″ (h)

"I do not have much patience with a thing of beauty that must be explained
to be understood. If it does need additional interpretation by someone other
than the creator, then I question whether it has fulfilled its purpose."
~ Attributed to CHARLIE CHAPLIN

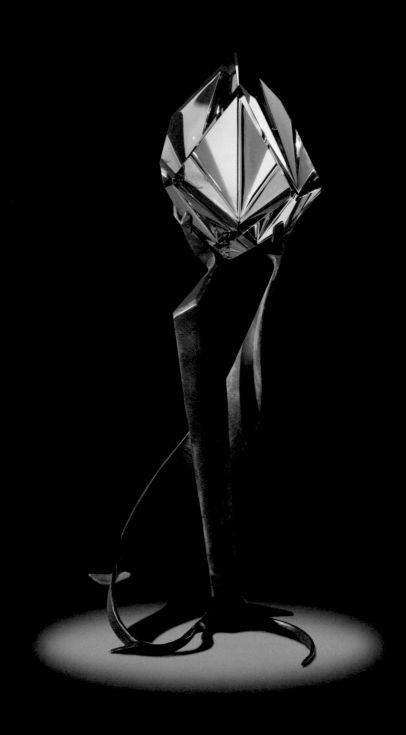

[ABOVE] *Art of Dance*, carved optical citrine on bronze base , 13″ (h)

"Beauty is not caused. It is." ~ EMILY DICKINSON

[OPPOSITE] *In Rhythm*, carved electronic-grade citrine quartz on lighted bronze base, 12″ (h)

"You can't depend on your eyes when your imagination is out of focus."
~ MARK TWAIN, *A Connecticut Yankee in King Arthur's Court*

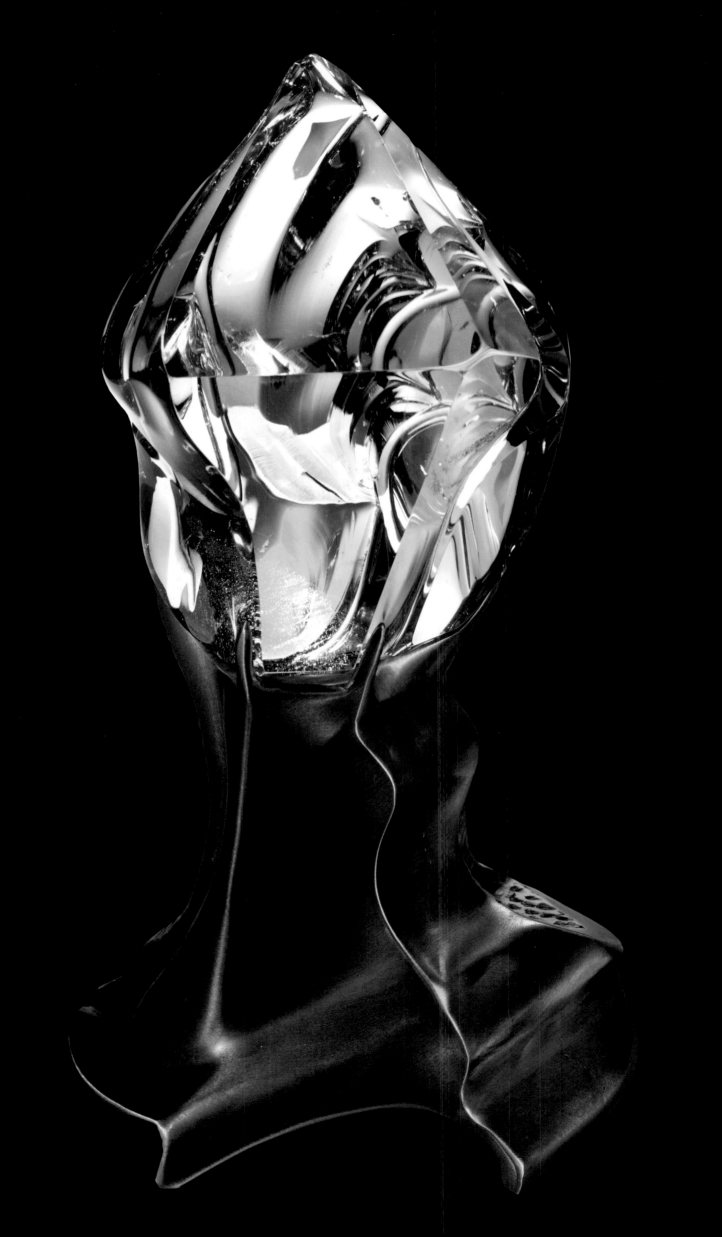

WHEN STARS ALIGN

When I was ten years old, I encountered an object on my mother's desk. It was made out of multicolored stones that were seamed together and cut geometrically. Natural blue, red, brown, white, green, and yellow stones precisely spliced together into an unusually perfect shape. At ten I didn't know what a dodecahedron was. My ten-year-old self was awed by this perfectly angular composite of stone, wonder personified, and I liked picking it up, turning it around in my palm, marveling, all the while wondering how was this made. My future was calling me in a whisper.

Twenty years later, I was fortunate to have many close encounters with Buckminster Fuller, a family friend and mega-brained futurist and poet of geometry. His work represents the optimism of someone who could think on a global scale into the future, and who believed in "doing more with less" to serve humankind's basic needs. From Bucky I learned that geometry and mathematics help explain the vexing and intricately complex beauty that we interpret as our universe.

Listening to Bucky talk about the marvels of how the universe is constructed was dizzying and exhausting. When I could understand two consecutive sentences he was espousing, I felt like I had really comprehended something important, even if I didn't know what it was. I just didn't have the mental muscle to understand Bucky, but I understood him at a fundamentally human level.

As my comprehensive brain developed, I began in-corporating the rudimentary threads of some of Bucky's multidimensional concepts. And as I evolved my cutting skills working more complex forms—double tetrahedrons, pentadodecahedrons, hendecagons, triacontakaitetragons, etc., maintaining vector equilibrium—I began to witness firsthand why Bucky was so excited about the geometry of the basic building blocks of Nature, which, of course, includes the geometric structures found in crystallography.

About forty-five years after my ten-year-old self's first encounter with the multicolored stone dodecahedron, I saw this fascinating shape cut in quartz. But this piece had multiple star patterns intricately notched into it. I marveled at the vexing design problem of mind-vectoring angles and the precision that inhabited this form. When I saw a photo image of the same form a few years later, the exuberance of my inner child partnered with the experienced artisan of my present self to proclaim, "Okay, I have to try and cut one of these myself."

And thus began one of the most fascinating lessons in hard linear symmetry that my soft-orbital brain has had the pleasure of figuring out.

A pentadodecahedron is a twelve-sided shape (dodecahedron) with five-sided faces (pentagons) forming the twelve faces. In order to achieve this, 120 notched faces have to be cut along the edges of the dodecahedron. When every one of the 132 individual faces come together with exact precision, the stars align …

[OPPOSITE] *Star Prism*, pentadodecahedron in quartz, 3.75″ (d)

"The creative mind plays with the objects it loves."
~ CARL JUNG, *Psychological Types*

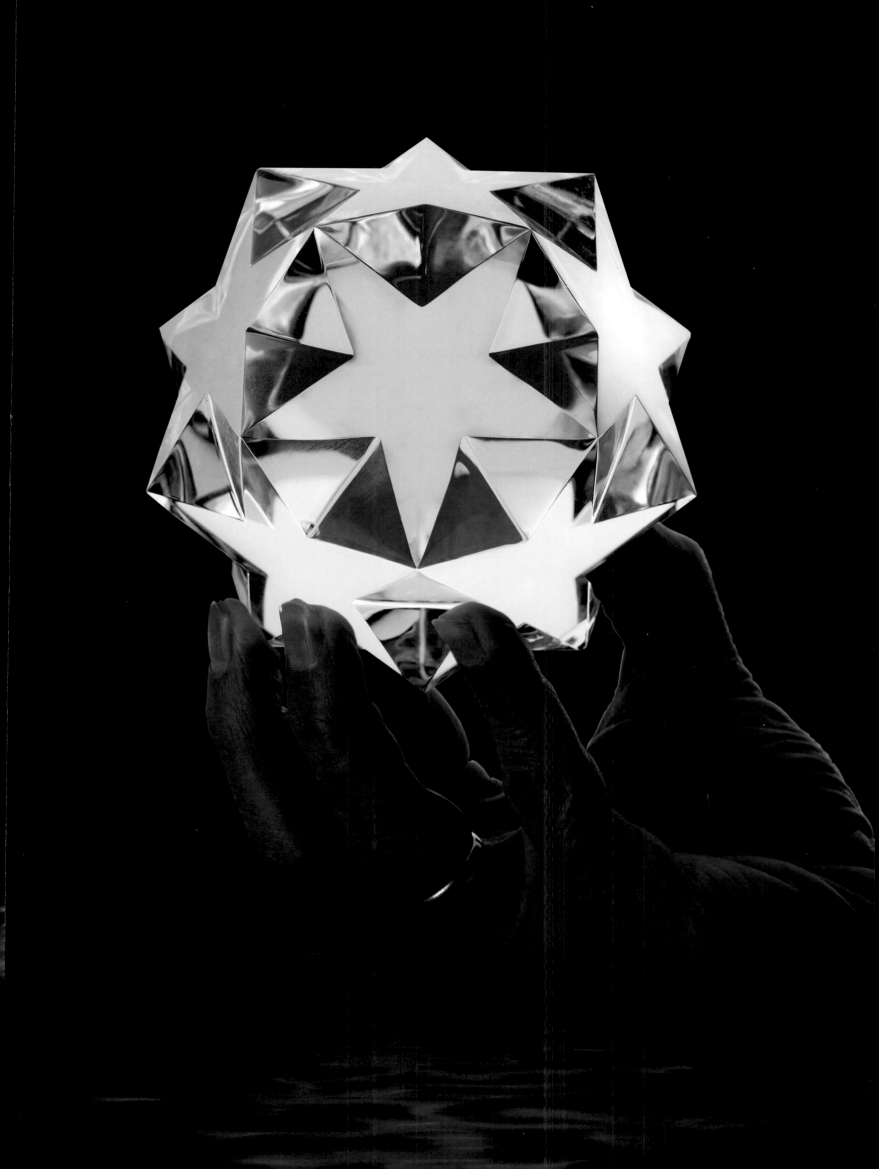

[OPPOSITE] Carved phenacite on bronze, 5″ (h)

"Beauty exists, even in unlikely places.
The key isn't to open your eyes but to open your heart."
~ RICHELLE E. GOODRICH, author

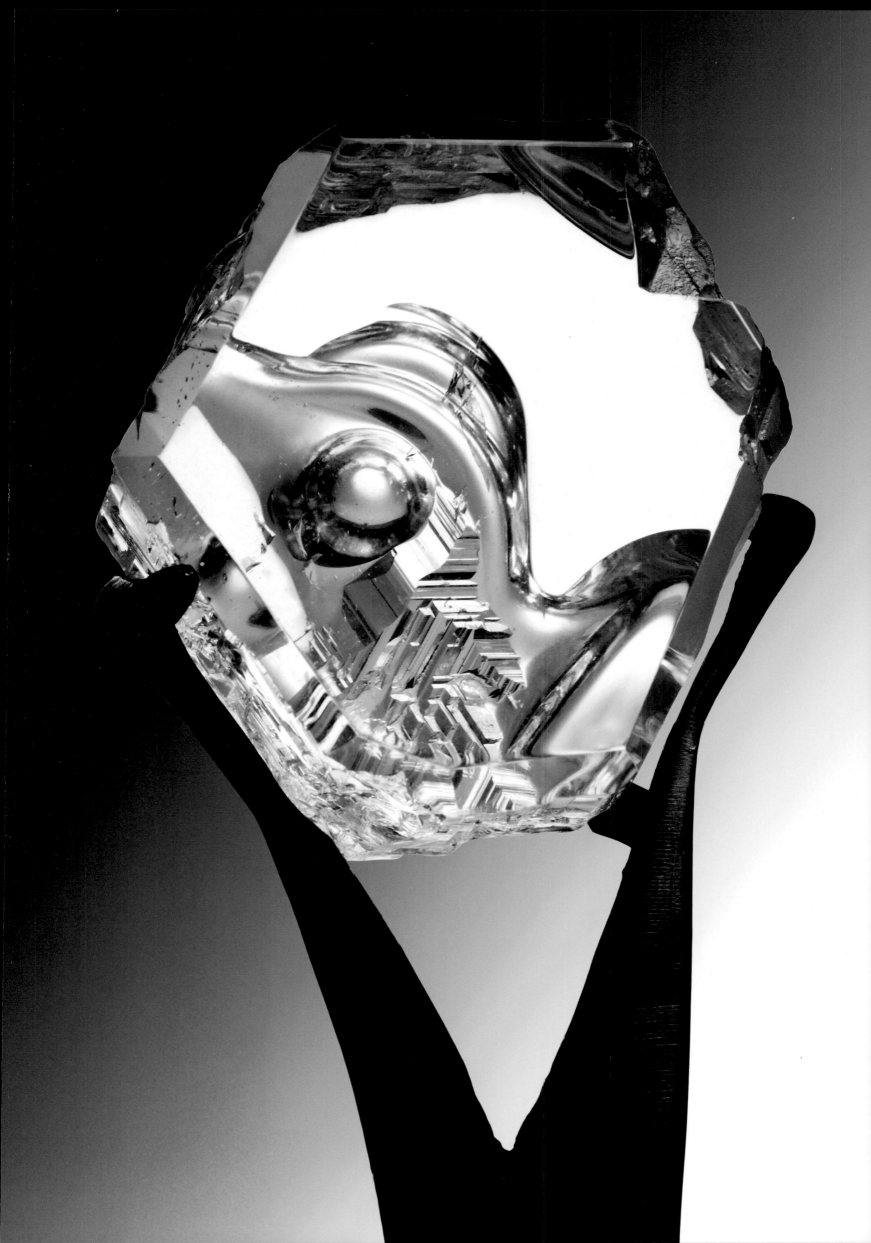

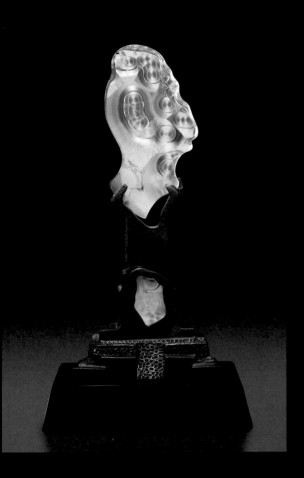

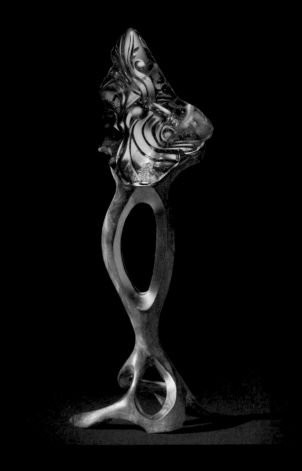

Mayan Dreamer, carved agate on lighted bronze base, 13″ (h)

Incan Sorcerer, carved citrine on lighted bronze base, 13.5″ (h)

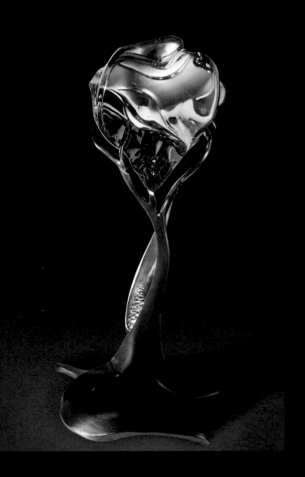

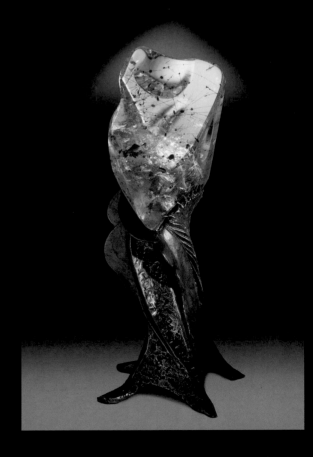

Nature Spirit, carved citrine on lighted bronze base, 14″ (h)

Worlds Within, carved Madagascar quartz with black tourmaline and mica inclusions on lighted bronze base, 15″ (h)

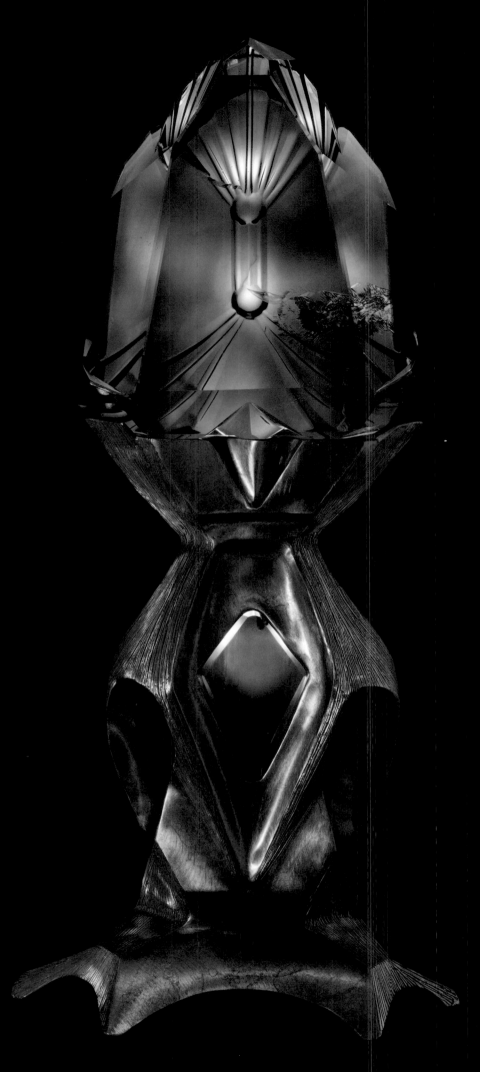

Beyond the Threshold, carved smoky citrine on lighted bronze base, 23″ (h)

"I am enough of an artist to draw freely upon my imagination. Imagination is more important than knowledge. Knowledge is limited. Imagination encircles the world."
~ ALBERT EINSTEIN, interview in *The Saturday Evening Post* (1929)

~ Janette Rallison, *How to Take the Ex Out of Ex-boyfriend*

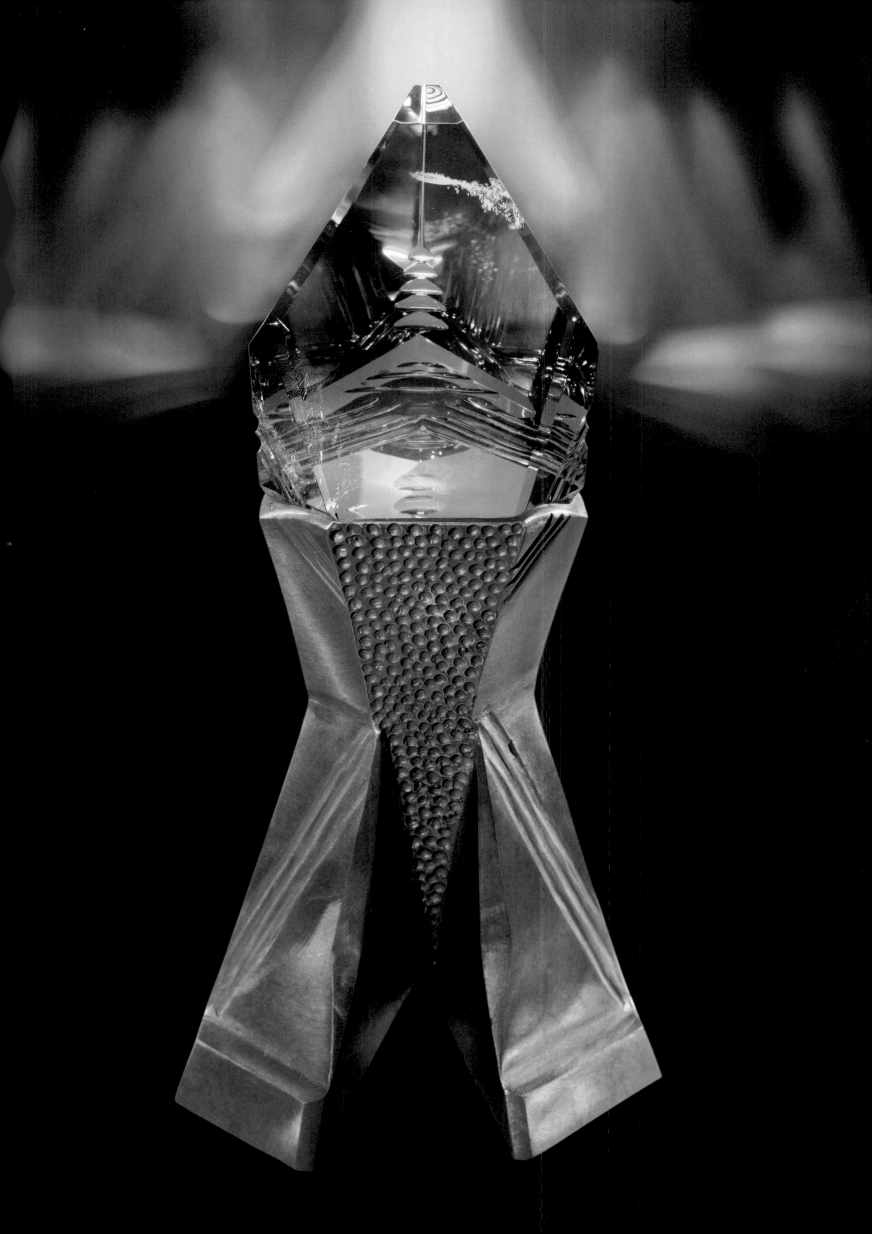

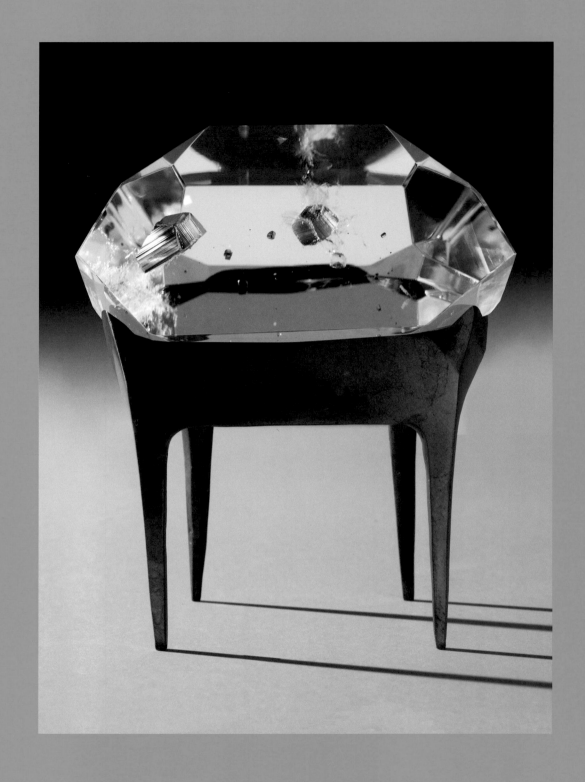

[ABOVE] *Concerto in Pyrite*, pyrite in quartz on bronze base, 4″ (h)

"The music is not in the notes, but in the silence between."

[OPPOSITE] *Transcendance*, 68-pound double-terminated quartz generator on lighted bronze base, 26″ (h)

"Music expresses that which cannot be put into words and that which cannot remain silent."
~ Attributed to VICTOR HUGO

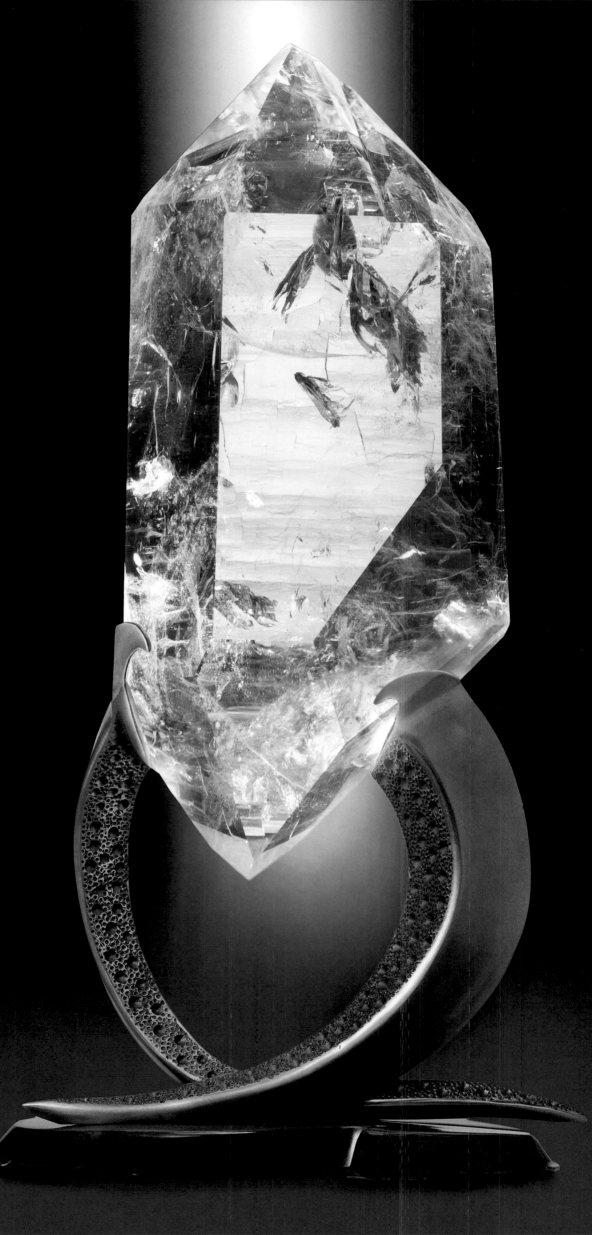

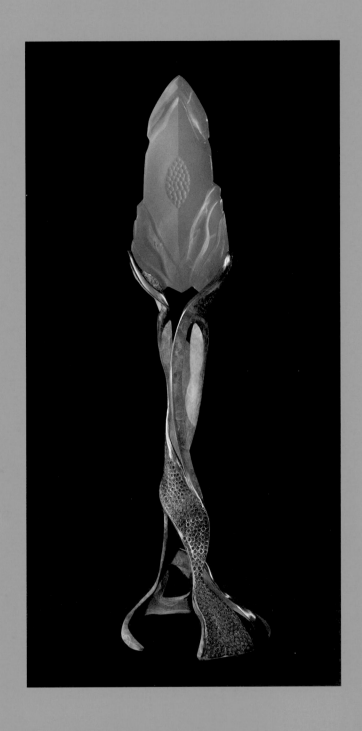

Conception, sculpted rose quartz on bronze, 22″ (h)

Creation happens at the moment of conception.

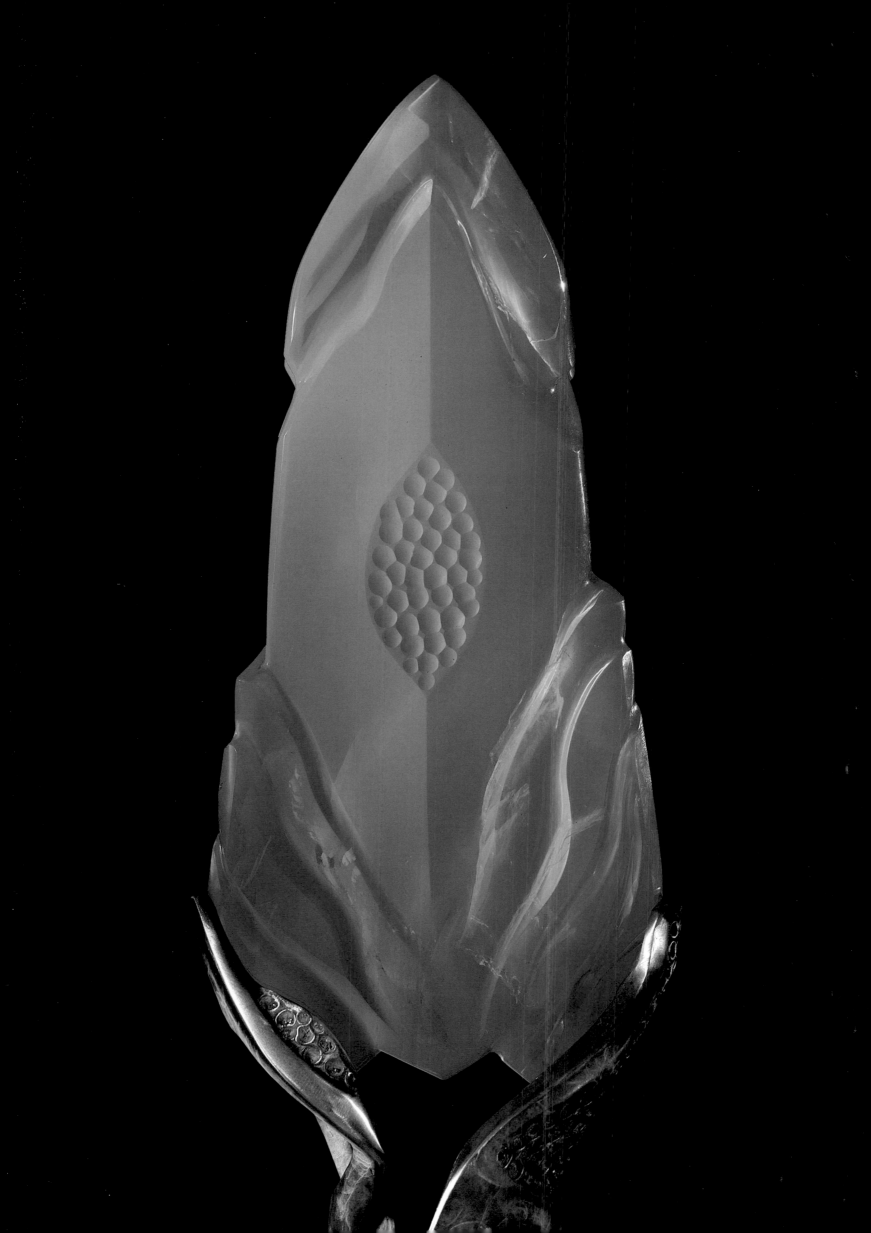

[ABOVE] Canadian fossilized ammonite sea shell (detail)

[OPPOSITE] Canadian fossilized Ammonite sea shell on bronze, 18″ (h)

"Beauty of whatever kind, in its supreme development,
invariably excites the sensitive soul to tears."
~ EDGAR ALLAN POE, "The Philosophy of Composition"

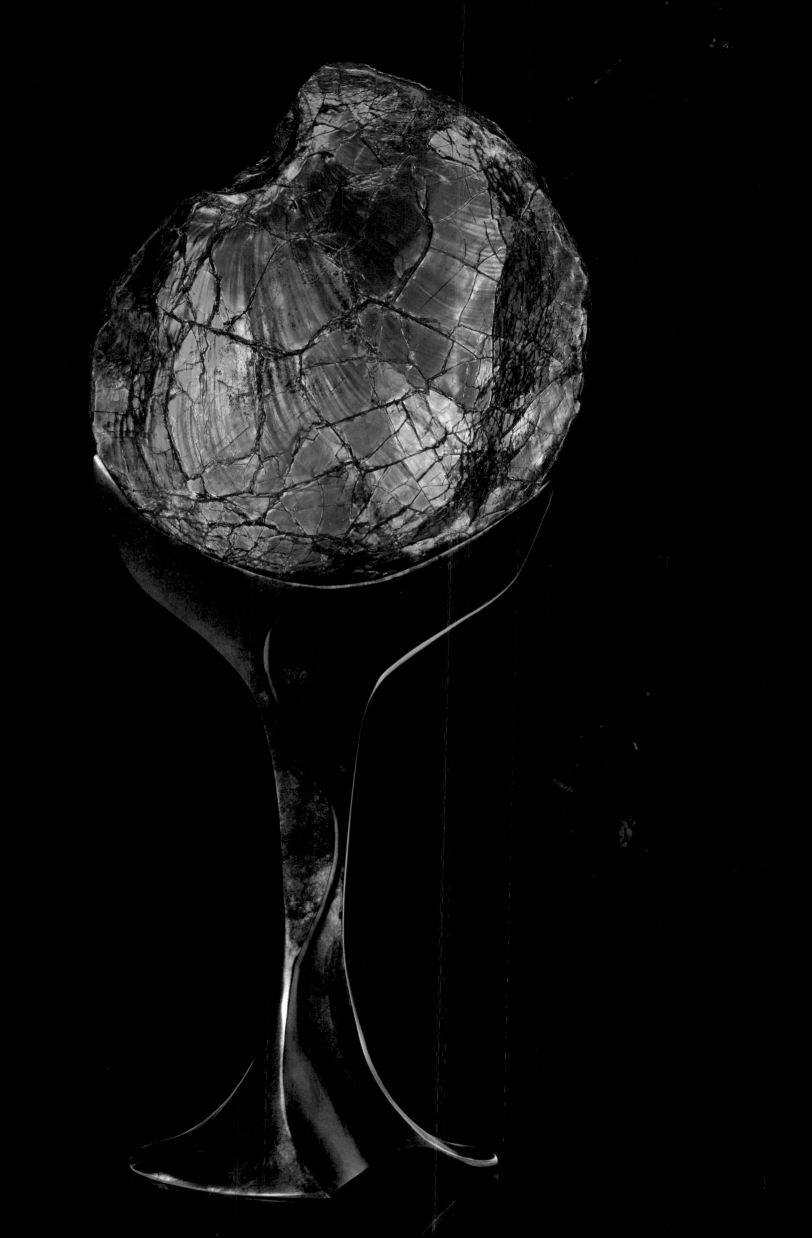

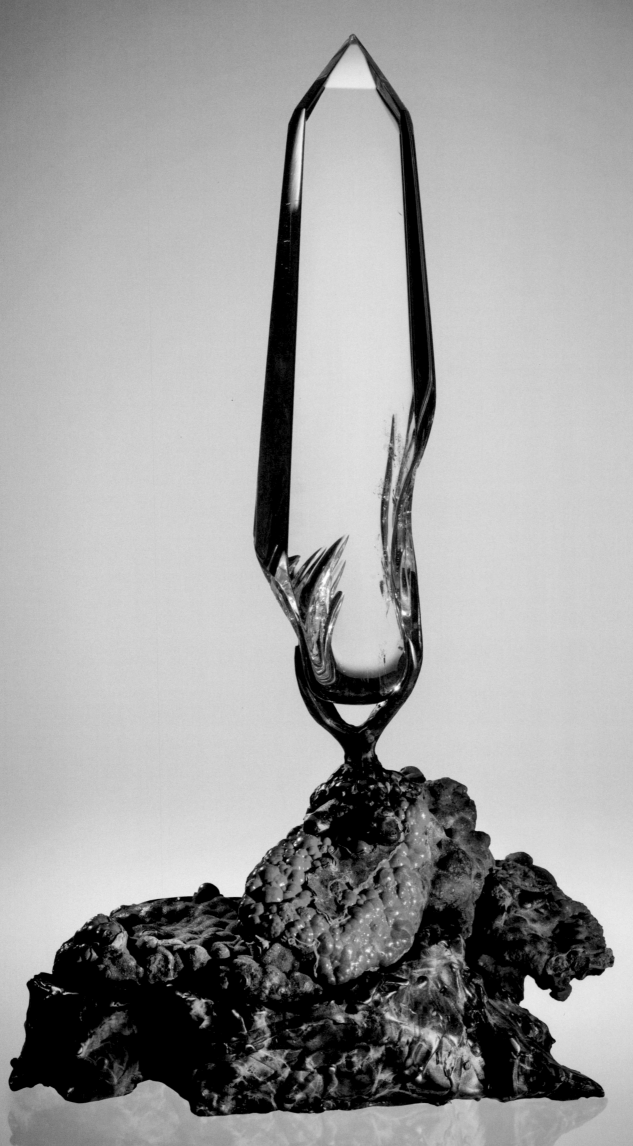

Taming the Dragon, carved quartz crystal on chrysocolla and bronze, 13″ (h)

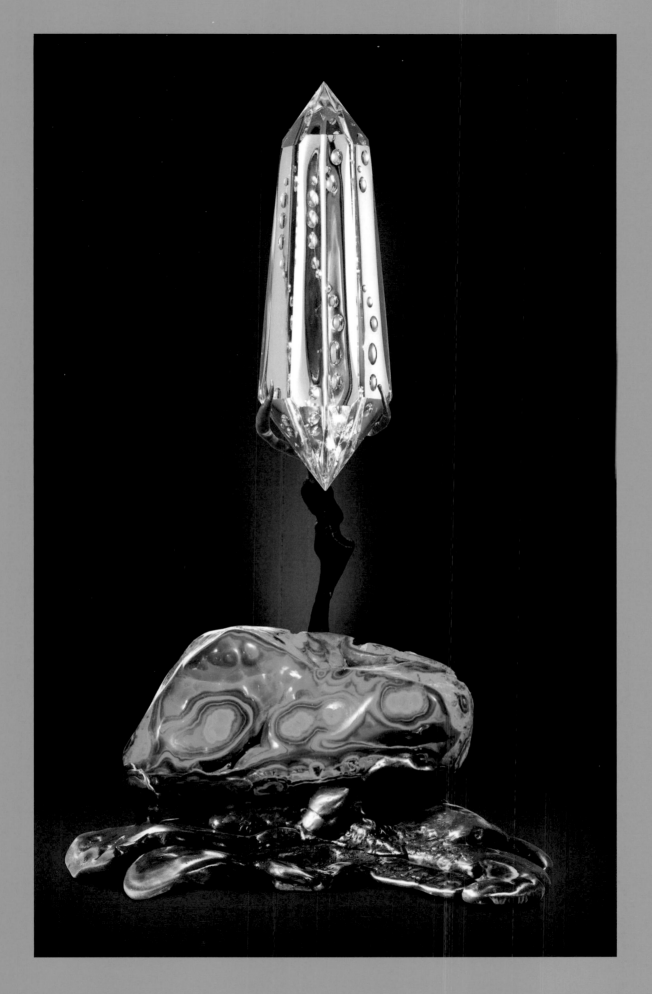

Effervescence, carved optical double terminated quartz on chrysocolla and bronze, 15″ (h)

"To be creative means to be in love with life. You can be creative only if you love life enough that you want to enhance its beauty, you want to bring a little more music to it, a little more poetry to it, a little more dance to it."
~ OSHO (BHAGWAN SHREE RAJNEESH)

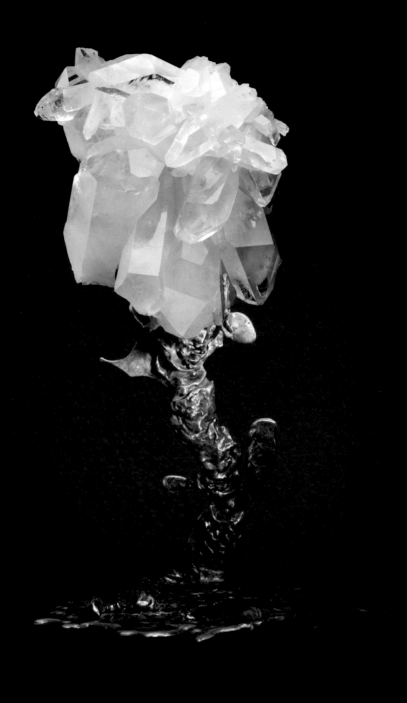

[ABOVE] *Zoe's Garden*, quartz cluster on bronze, 14″ (h)

"Things are pretty, graceful, rich, elegant, handsome, but,
until they speak to the imagination, not yet beautiful."
~ RALPH WALDO EMERSON, *The Conduct of Life*

[OPPOSITE] *Multiplicity*, Arkansas quartz cluster on lighted bronze base, 28″ (h)

...have fallen in love with the imagination. And if you fall in love with the imagination
...you understand that it is a free spirit. It will go anywhere, and it can do anything."
~ ALICE WALKER, interview with AMY GOODMAN (2006)

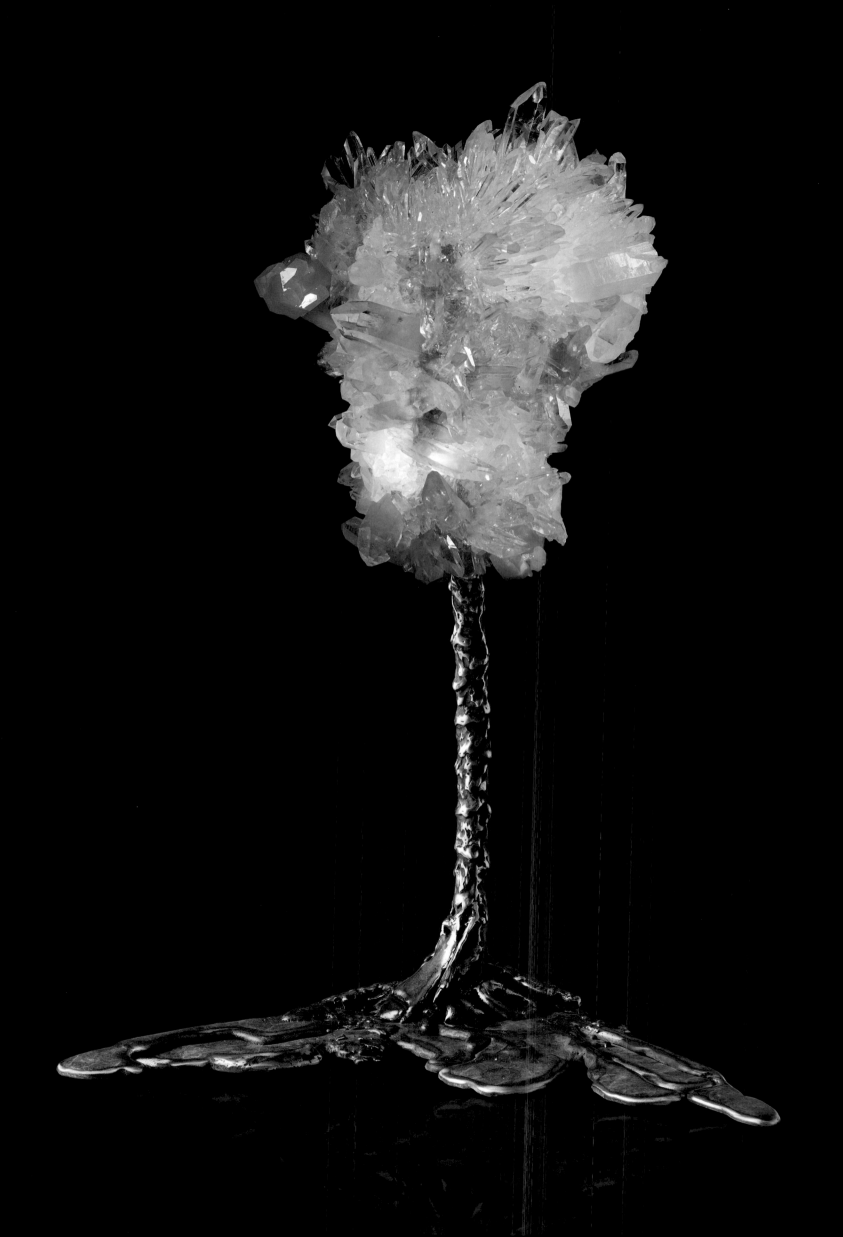

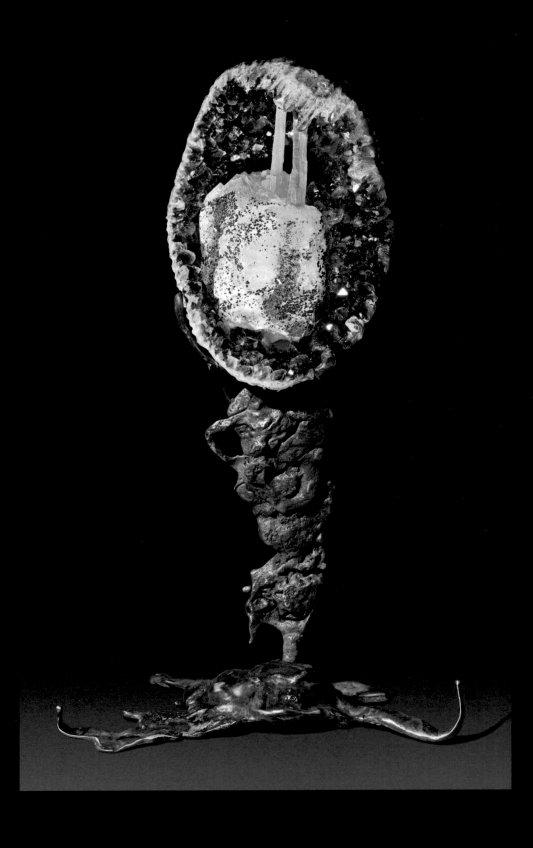

[ABOVE] *In-Spire*, Uruguayan amethyst with calcite on bronze, 17.5″ (h)

I may not know where I am, but I am not lost.

[OPPOSITE] *Narnia*, Uruguayan amethyst with calcite on bronze, 12″ (h)

Nature is my manifestation of God. I go to nature every day for inspiration in the day's work
~ FRANK LLOYD WRIGHT

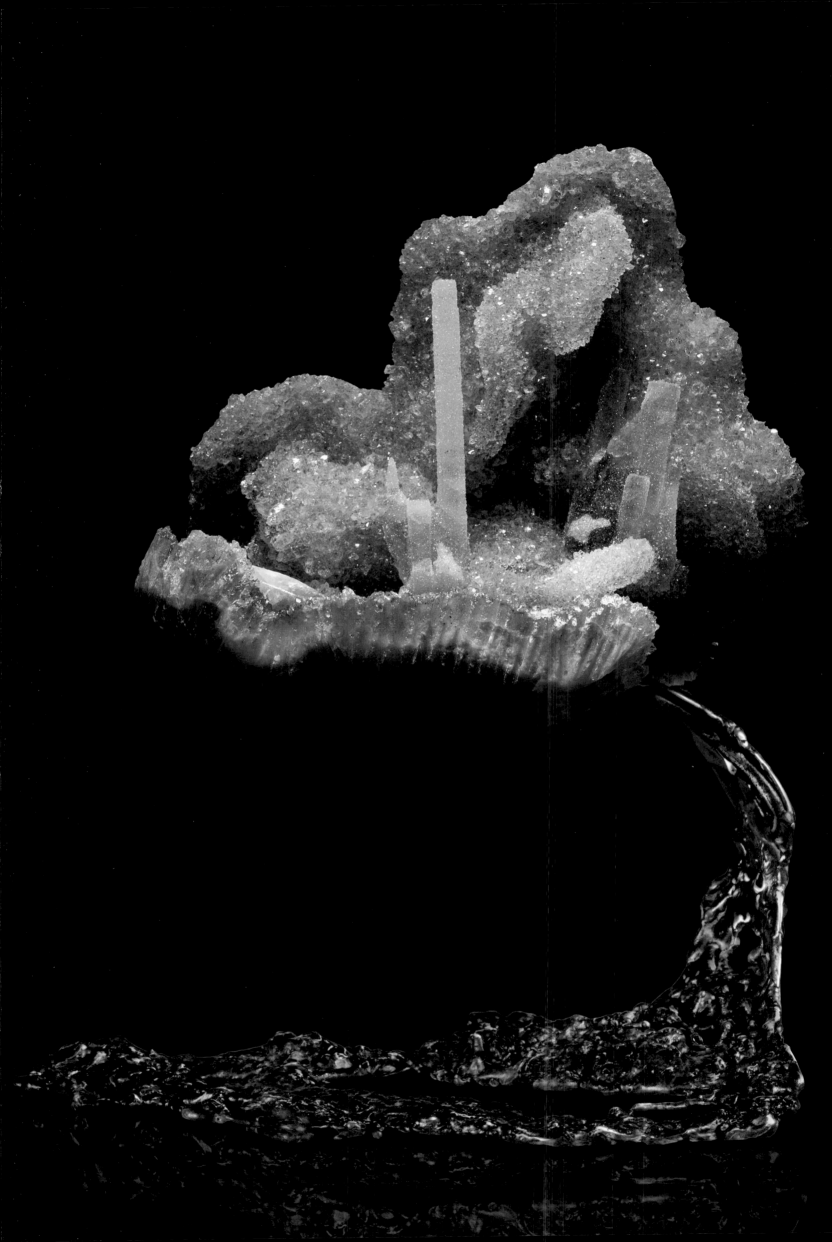

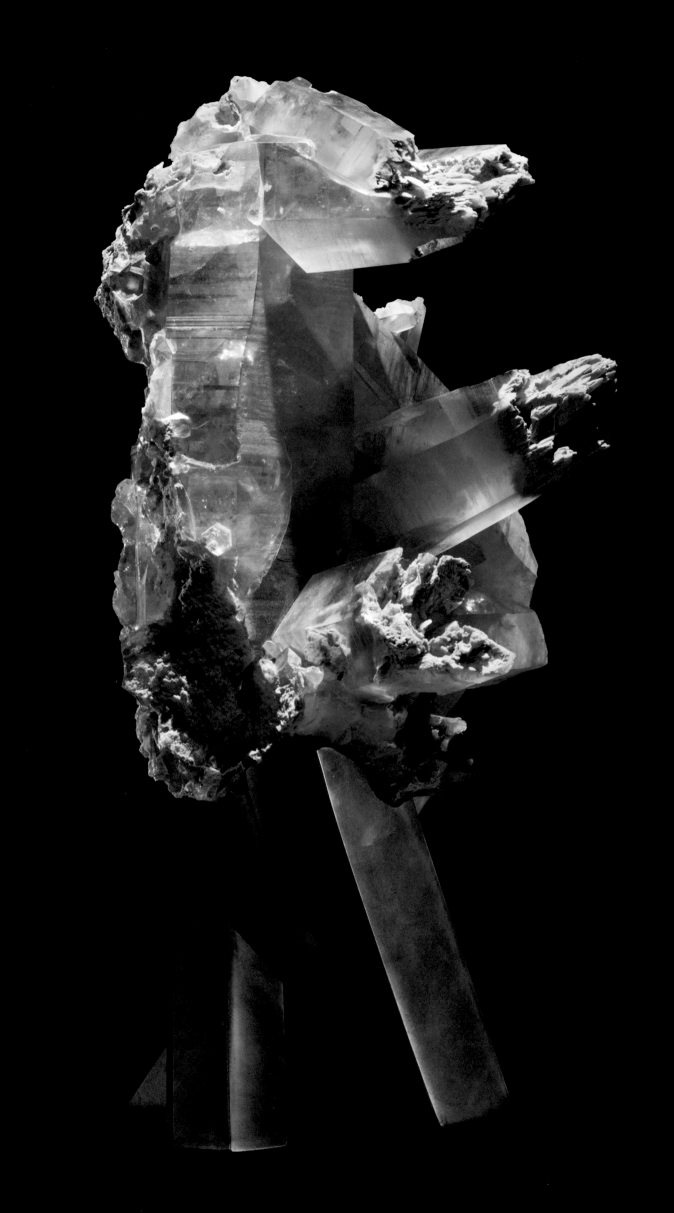

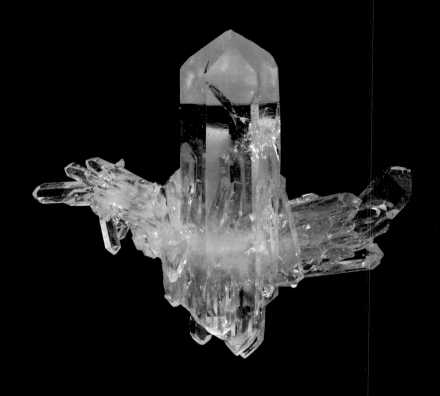

"But it is one thing to read about dragons and another to meet them."
~ Ursula K. Le Guin, *A Wizard of Earthsea*

[ABOVE] quartz crystal

[OPPOSITE *Dragon Knowledge*, quartz specimen on bronze, 12.5″ (h)

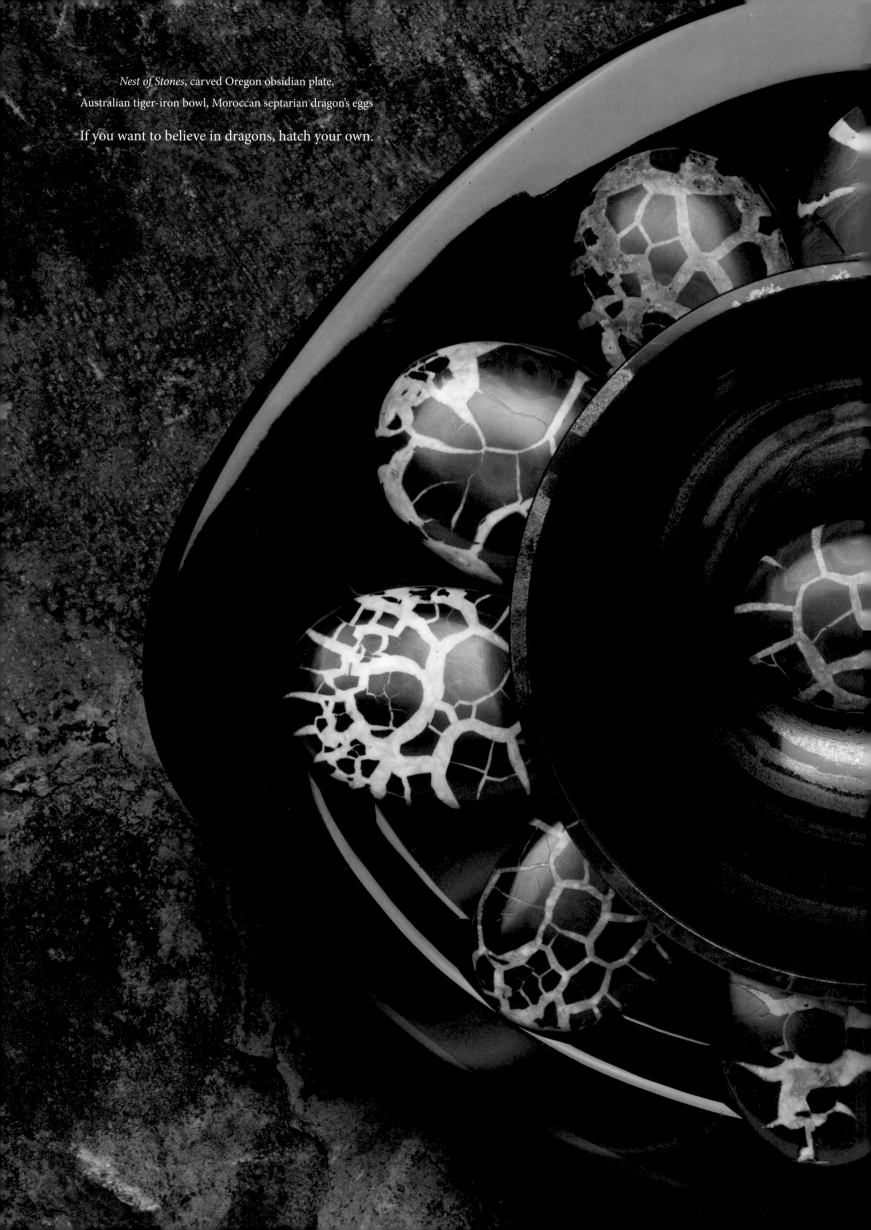

Nest of Stones, carved Oregon obsidian plate,
Australian tiger-iron bowl, Moroccan septarian dragon's eggs

If you want to believe in dragons, hatch your own.

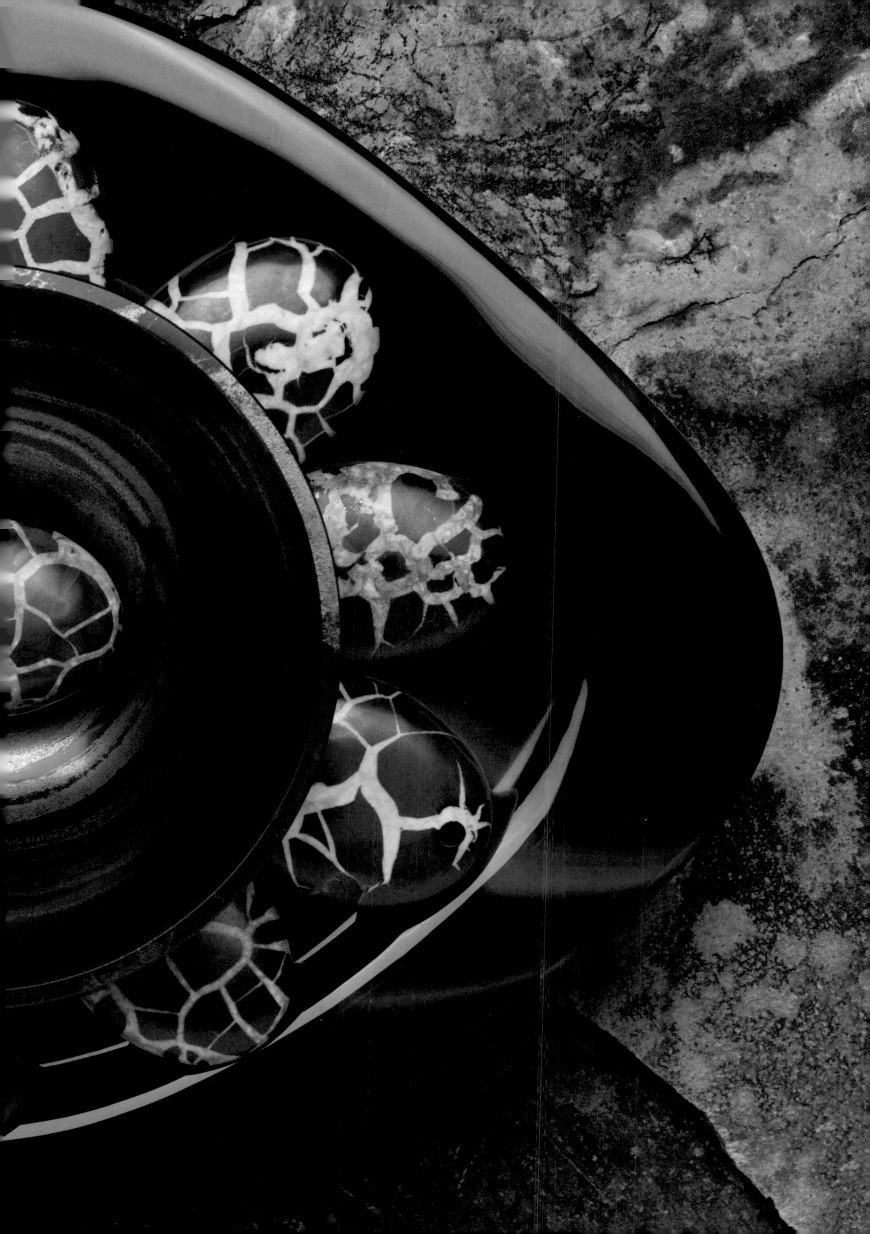

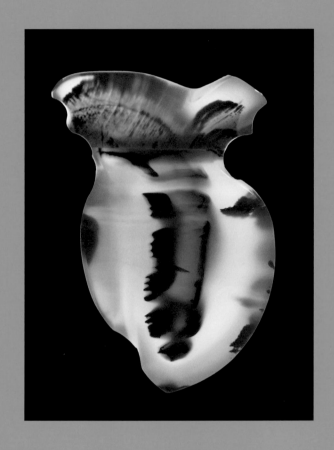

[ABOVE] carved Montana agate, 1.5″ (h)

[OPPOSITE] *First Flight*, carved Montana agate on bronze base, 15″ (h)

"Everything you can imagine is real."
~ Attributed to PABLO PICASSO

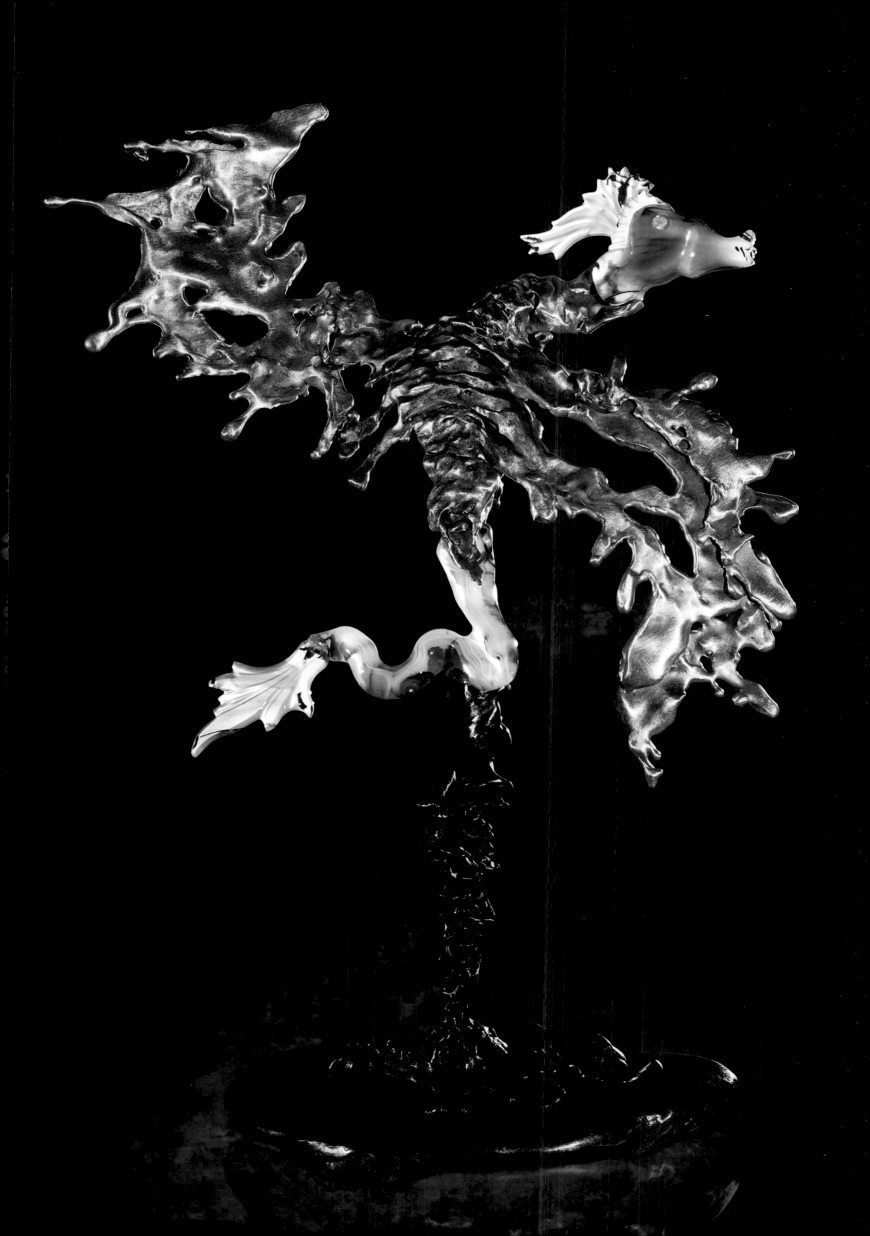

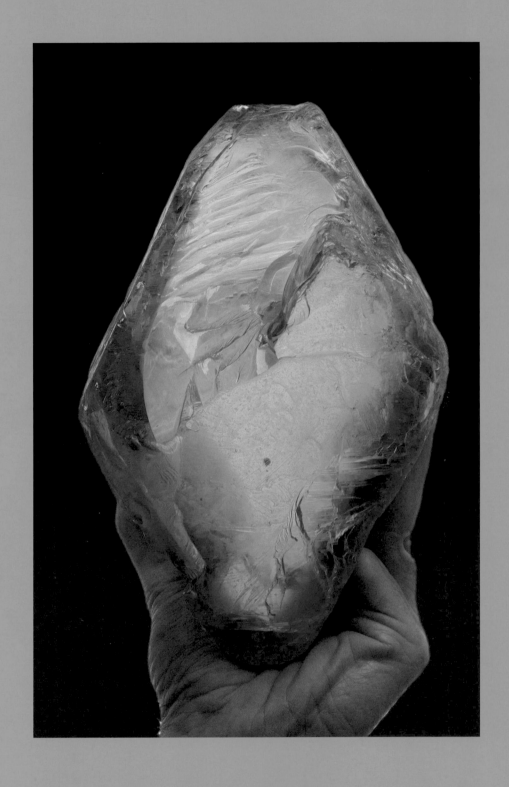

[ABOVE] *Balance Vector*, rough topaz crystal

"The power of imagination makes us infinite." ~ JOHN MUIR, *John of the Mountains*

[OPPOSITE] *Balance Vector*, 13,620-carat carved blue topaz with floating red garnet on bronze

"When I am working on a problem I never think about beauty. I only think about how to solve the problem. But when I have finished, if the solution is not beautiful, I know something is wrong." ~ Attributed to R. BUCKMINSTER FULLER

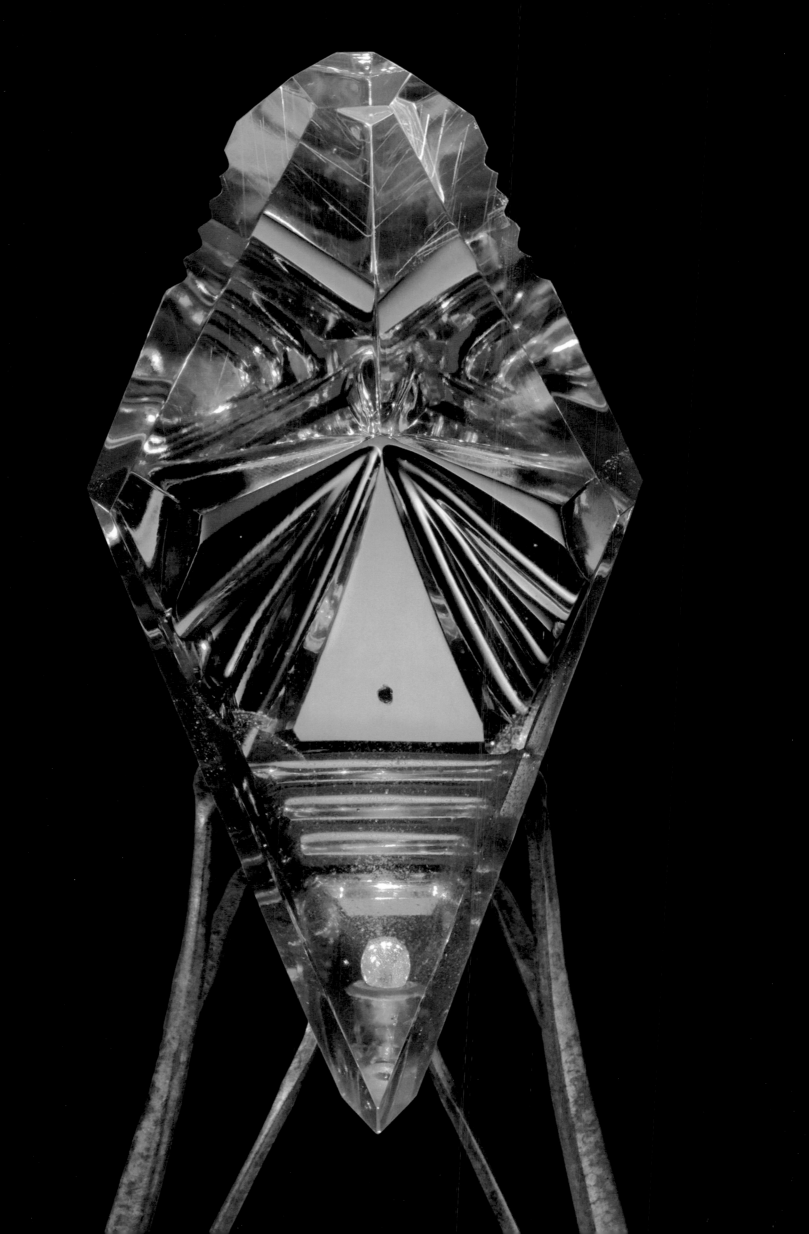

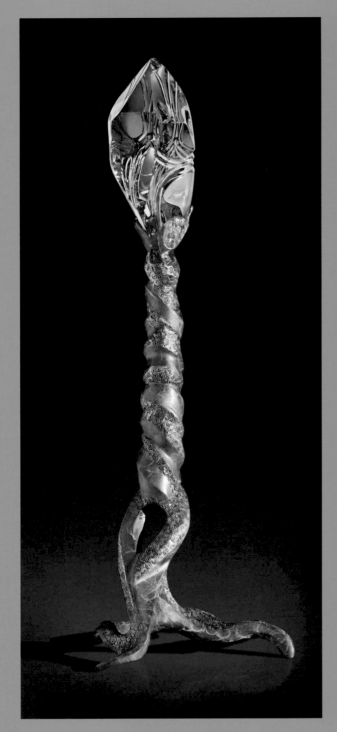

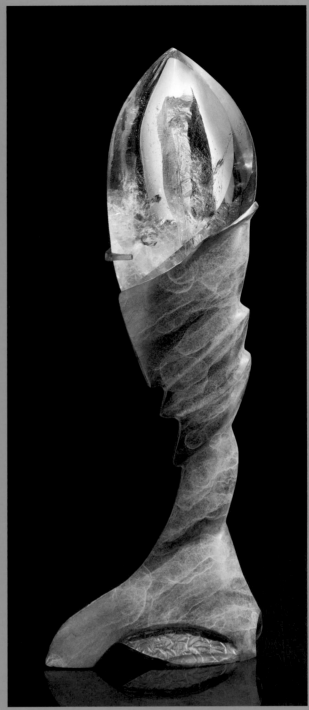

[ABOVE LEFT] *Light as a Feather*, carved citrine on lighted bronze base, 24″ (h)

"Among the many answers I have found, I believe love is the most
beautiful and simple art that reflects the beauty of life." ~ MABEL IAM, author

[ABOVE RIGHT] *Petroglyph*, carved citrine on lighted bronze base, 15″ (h)

[OPPOSITE] *Light Being*, carved optical quartz with chlorite inclusion on bronze , 18.5″ (h)

"Beauty does not linger, it only visits. Yet beauty's visitation affects us and invites us into its rhythm,
it calls us to feel, think, and act beautifully in the world: to create and live a life that awakens the Beautiful."
~ JOHN O'DONOHUE, *Beauty: The Invisible Embrace*

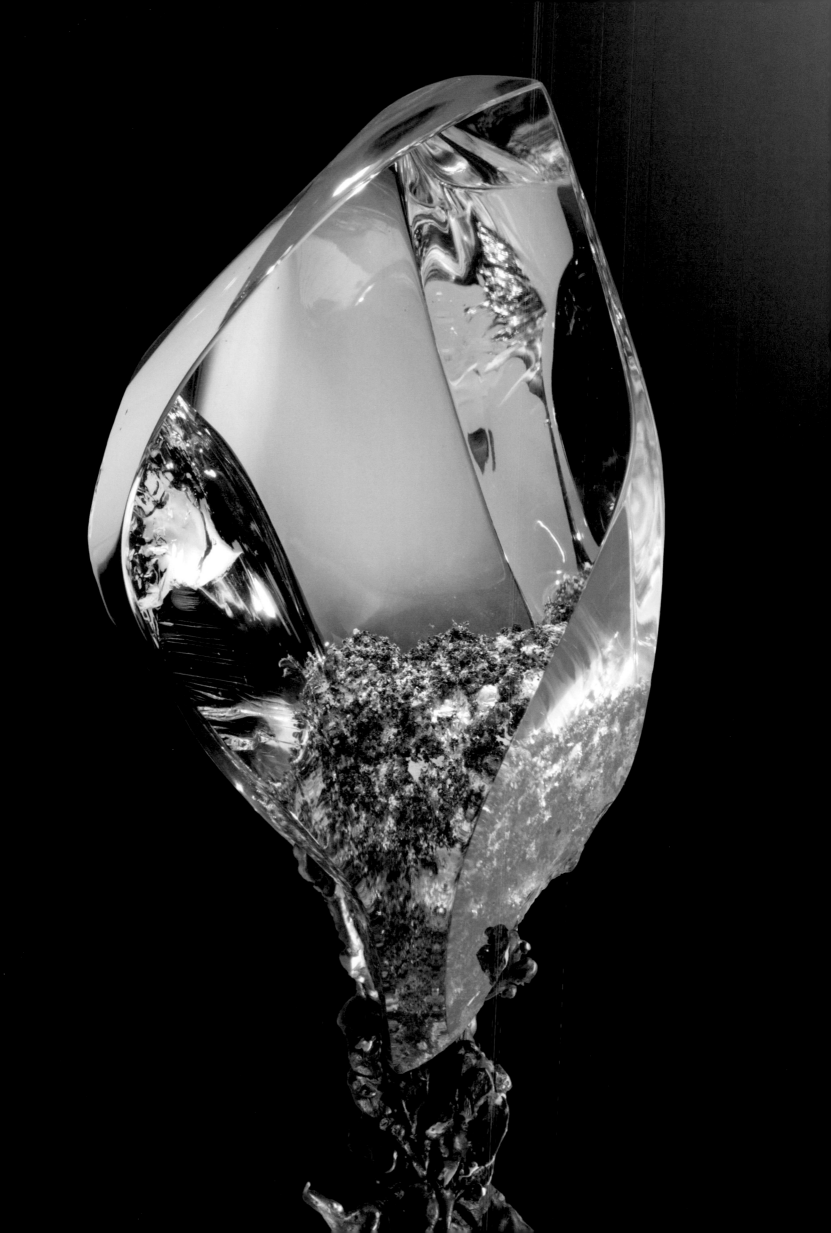

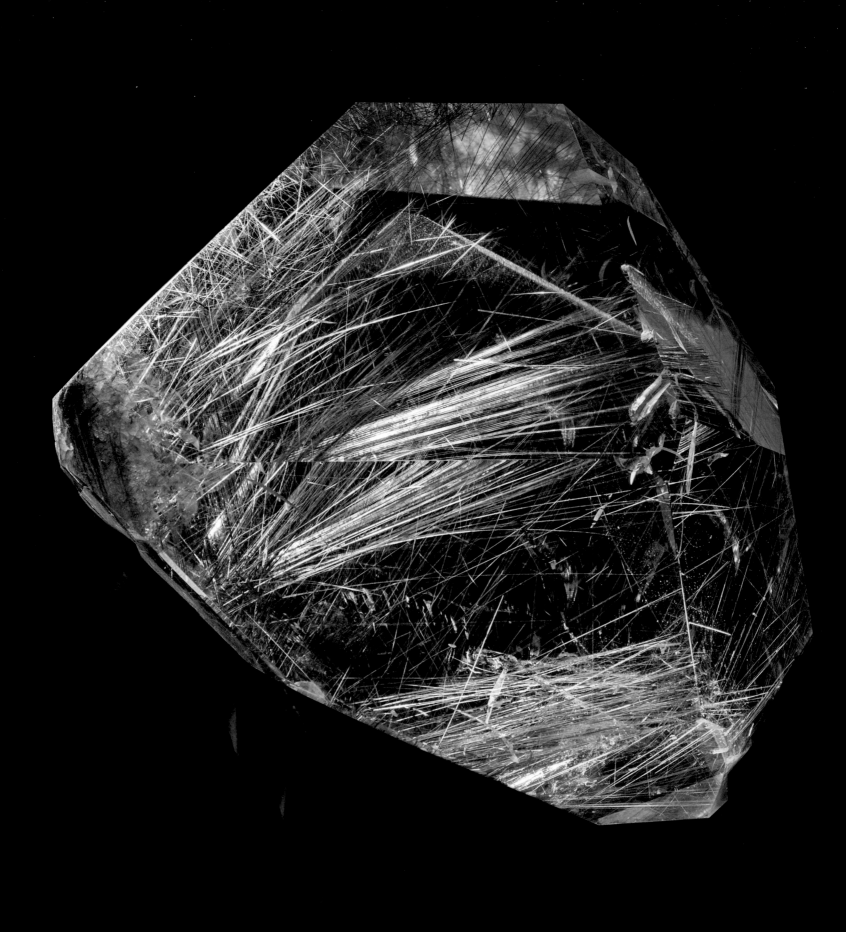

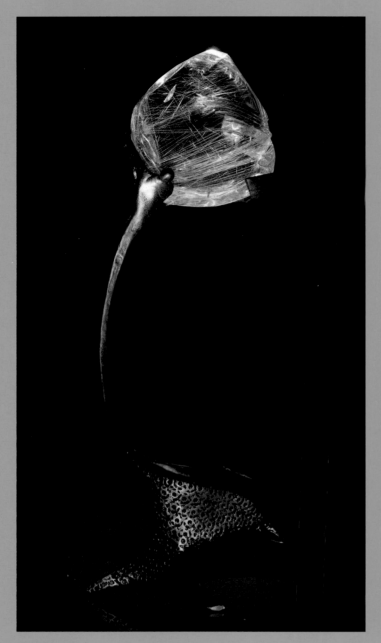

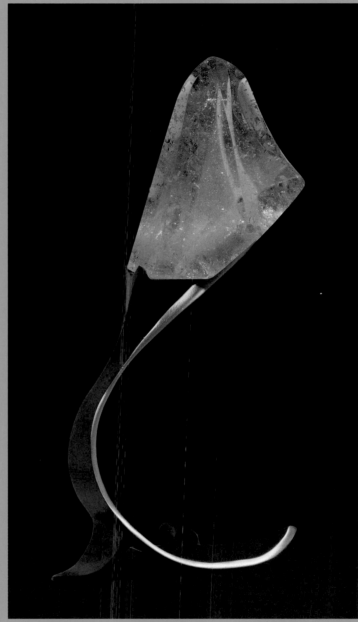

[ABOVE LEFT] *Balance in Motion*, carved rutilated quartz on lighted bronze base, 14″ (h)

Harmony and equilibrium of opposing forces

[ABOVE RIGHT] *Prima! Creativity*, carved morganite on bronze, 12″ (h)

To flow in the stream of creativity is to live an inspired life.

[OPPOSITE] *On Fire*, Brazilian red, orange rutile in quartz with white phantom, on lighted bronze base, 18″ (h)

Passion is the spark, inspiration flames,
and after they die
the art remains

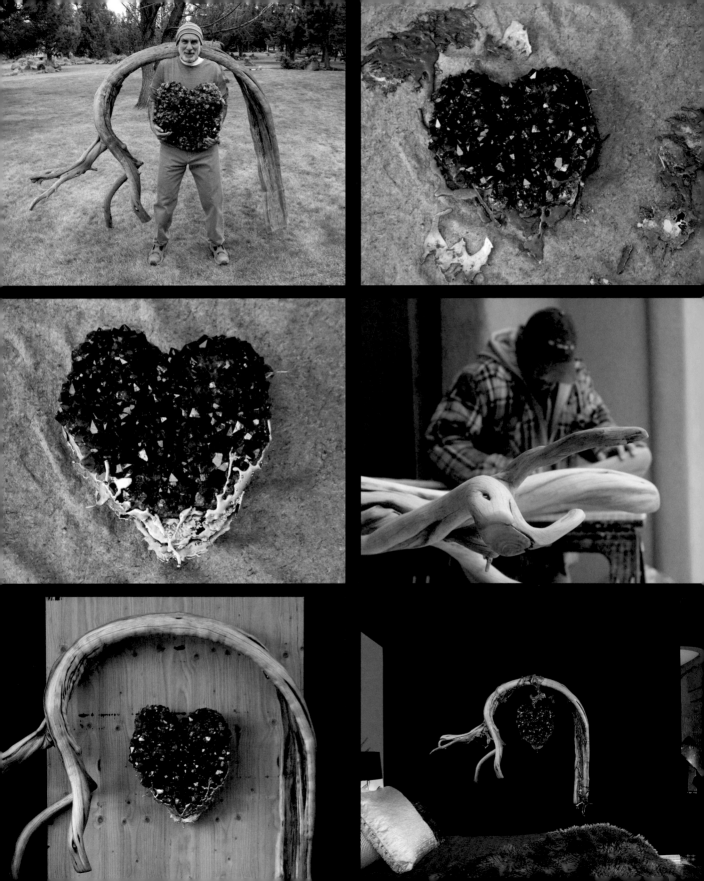

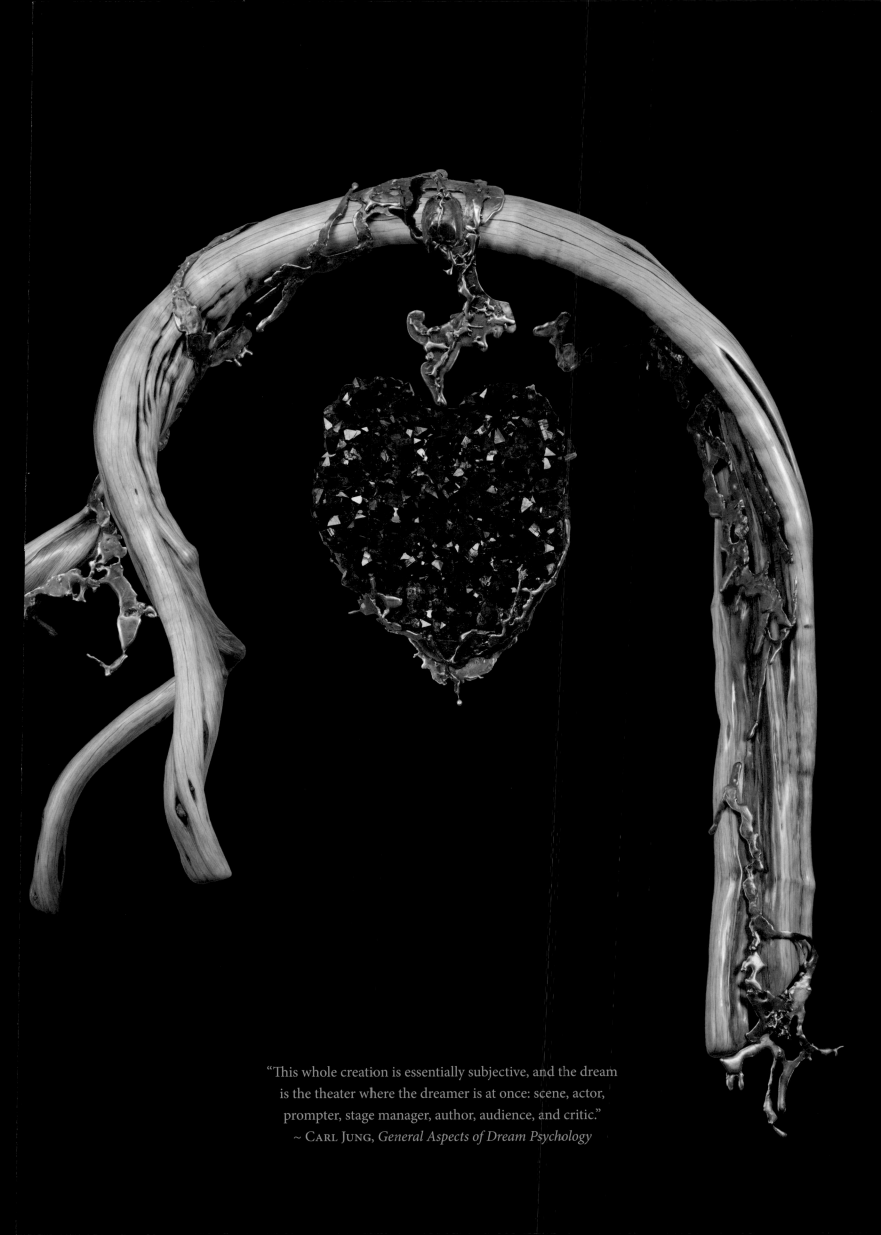

"This whole creation is essentially subjective, and the dream
is the theater where the dreamer is at once: scene, actor,
prompter, stage manager, author, audience, and critic."
~ Carl Jung, *General Aspects of Dream Psychology*

Ghost Writer, carved Madagascar quartz and agate skull, 4″ (h)

Most original thoughts aren't original.
But if they feel original, then that's good enough.

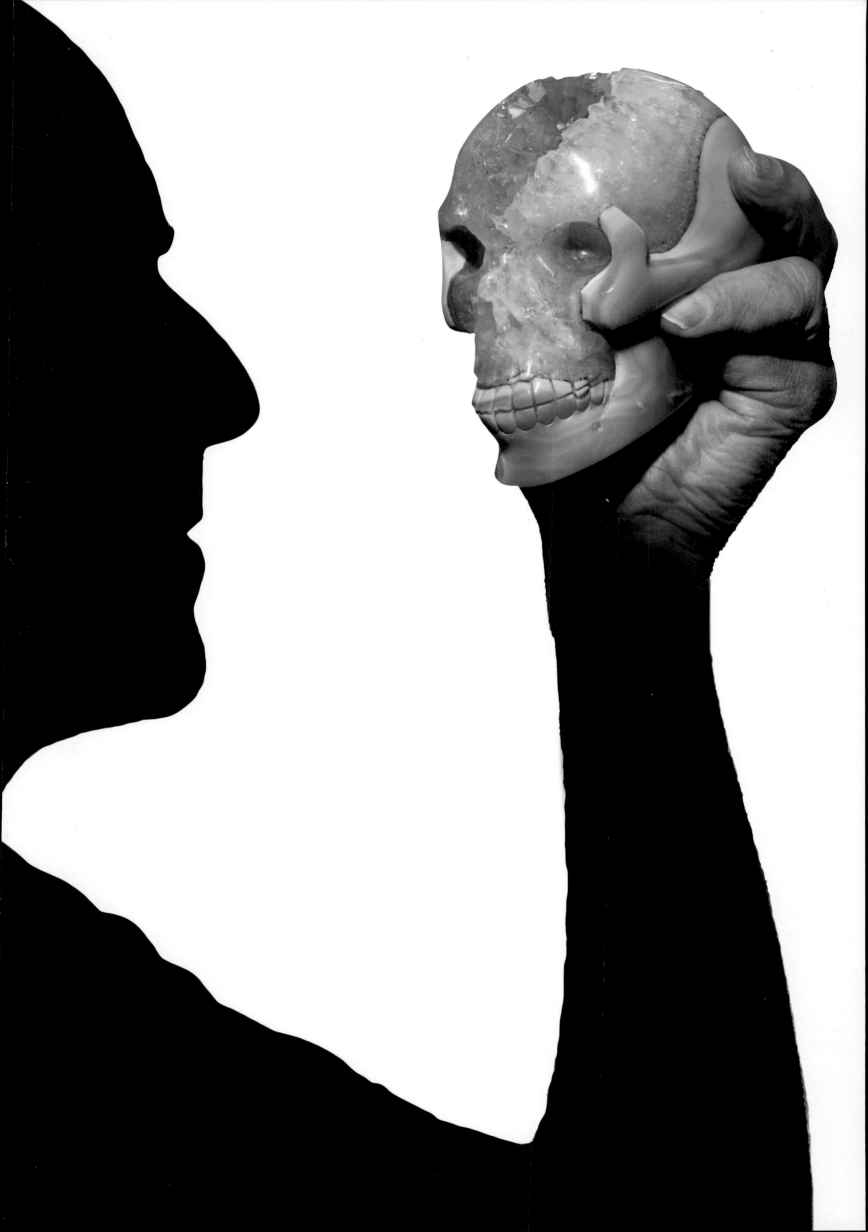

[ABOVE] *Spanning Time with Bob and Peter*, amethyst geode and bronze dining room table

"Live as if you were to die tomorrow. Learn as if you will live forever."
~ Attributed to MAHATMA GANDHI

[OPPOSITE] *Learning to Fly*, Madagascar quartz with bronze, 63″ (h)

"To seek freedom is the only driving force I know. Freedom to fly off into
that infinity out there. Freedom to dissolve; to lift off; to be like the flame of a
candle, which, in spite of being up against the light of a billion stars, remains
intact, because it never pretended to be more than what it is: a mere candle."
~ DON JUAN, in CARLOS CASTANEDA's *The Art of Dreaming*

ACKNOWLEDGMENTS

"I get by with a little help from my friends" ~ The Beatles

Each of my works is a collaboration: a synergy where the collective efforts of many combine to create singular works of beauty.

It starts with Nature, who has done the masterwork over geological eons to create the quintessential crystal.

The miner digs crystals from their buried earthen womb and carries them above ground, into the first light of their existence. The miner passes them on to couriers of commerce, who move the crystals around the planet. And a select few make their way to me and the CrystalWorks studio.

The crystals and I form a relationship, and we commit, together, to find their highest expression. The lapidary work of cutting, shaping, pre-polishing, polishing, and the subsequent bronze work, can take from days to years for any given piece.

My talented and devoted team assists with every one of them.

Like a band, each player performs their part with mastery, and the harmony of our collective daily commitment of care, attention to detail, and love for the medium fills the pages of this book.

The core of the success of my work begins with my wife, Sunni, who eternally supports my lifelong pursuit of innovating beauty.

I owe a debt of gratitude to the band, most prominently Timothy Turco and Ingrid Mrencso, two of the world's finest crystal artisans. Their imprint is on every piece.

Justin Kelchak, Peter W. Small (no longer with us), and Roy Swan have lent their artistry to the foundry bronze work that so beautifully presents the crystals as works of art.

Photography is its own art form. Getting the three-dimensional crystals (and bases) to speak in two-dimensional photography is a challenging process, and the person who has clicked the most shutter for this book is Gary Alvis, with additional creative micro/macro photography works by Nick Prince, who has been supporting my work for most of my career. Additional thanks to the other photographers: James Elliot, "Crystal Bill" Kaunitz, Sean Ryan, Brent McGregor, Jonathan Stoller, and Wernher Krutein.

My appreciation extends to Mukti Silberfein for her assistance in organizing the details of this book, as well as to Seth Silberfein, Casey Kerwin, and Patrick Jones for their dedicated contributions to CrystalWorks.

There is a long list of folks who express love and admiration for our work, and your patronage and support propels me to delve deeper into the beauty of this emerging art form.

I am perpetually hunting for exquisite crystal works of nature. There are many miners, collectors, and importers who have procured and made available rare, powerful, and wonderful natural crystals to me. Special thanks to Rui Pereira de Alemida.

And, of course, the people at Cameron + Company have assembled my images and thoughts into the substance of this book. Iain Morris's expressive and elegant design and production, Mark Burstein's editorial word polishing, Jan Hughes's proofreading, and publisher Chris Gruener have forever captured my work, preserving and presenting it to the world.

TIMOTHY TURCO

INGRID MRENSCO

JUSTIN KELCHAK

GARY ALVIS

"A man is a success if he gets up in the morning and gets to bed at night,
and in between he does what he wants to do."
~ Attributed to BOB DYLAN

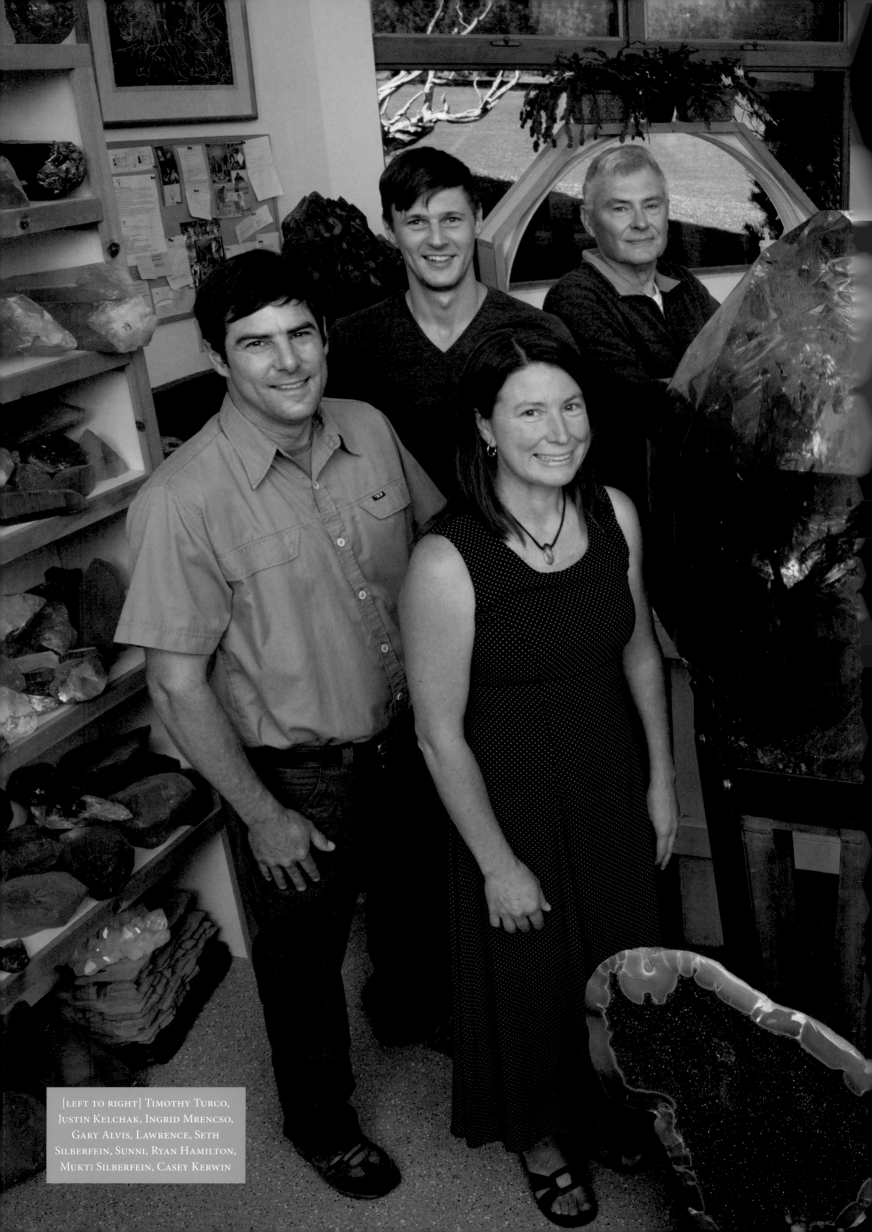

[LEFT TO RIGHT] TIMOTHY TURCO,
JUSTIN KELCHAK, INGRID MRENCSO,
GARY ALVIS, LAWRENCE, SETH
SILBERFEIN, SUNNI, RYAN HAMILTON,
MUKTI SILBERFEIN, CASEY KERWIN

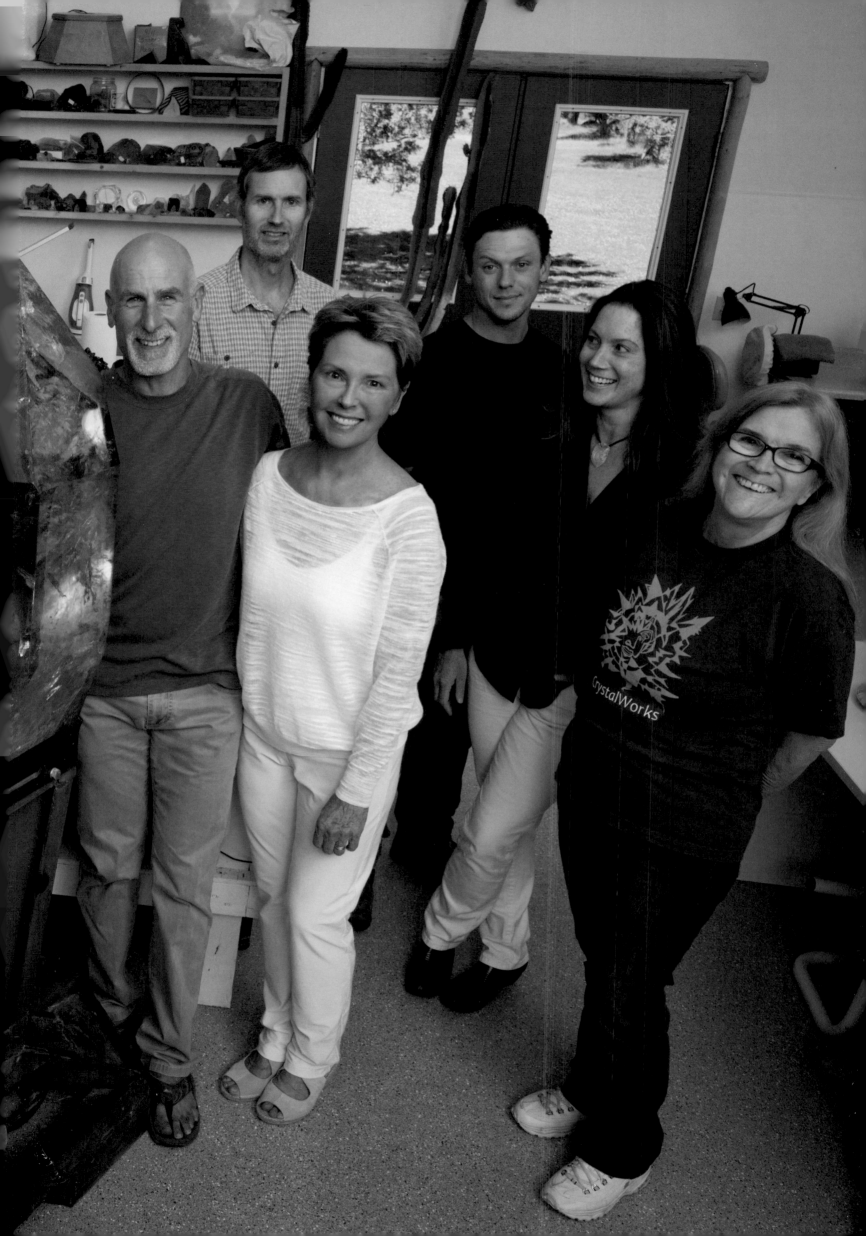

COLOPHON

CAMERON + COMPANY
6 Petaluma Blvd. North, Suite B-6
Petaluma, CA 94952
www.cameronbooks.com

Publisher: *Chris Gruener*
Creative Director & Designer: *Iain R. Morris*
Editor: *Mark Burstein*
Proofreaders: *Jan Hughes and Cristal Cardenas*

All photographs are © 2017 Lawrence Stoller, and were taken by Gary Alvis of Studio 7 in Bend, Oregon, except the following: endpapers, pp. 2–3, 12–13, 18, 22, 80–81, 90, 116–117, 154–155, 187 © Nick Prince, (princefinephotography@mindspring.com); pp. 1, 20, 78–79, 113, 124 taken by James Elliot; pp. 33 © "Crystal Bill" Kaunitz (www.ElegantRainbows.com); p. 62 © Sean Ryan; pp. 65–66 © Brent McGregor; pp. 69, 110 © Jonathan W. Stoller (www.jwstoller.com); pp. 203 taken by Robert J. Stoller; pp. 205 taken by Sunni Kerwin; pp. 208 taken by Wernher Krutein (www.photovault.com).

Library of Congress Cataloging-in-Publication Data available.

ISBN: 978-1-944903-05-3 • Printed in China • 10 9 8 7 6 5 4 3 2 1

CAMERON + COMPANY would like to thank Mark Burstein for his editorial oversight throughout this project; Iain Morris for his brilliant creative direction and design; Jan Hughes for her proofreading; Cristal Cardenas Sanchez for her additional proofreading; Mukti Silberfein for her helpful support; and most importantly Lawrence Stoller, for entrusting us with his incredibly beautiful crystal sculpture artwork and putting it into book form. • www.crystalworks.com

[BELOW] *Face from the World of Other*, carved quartz with black tourmaline, 3″ (h)